Max Ernst · Loplop

The Artist in the Third Person

Max Ernst · Loplop

The Artist in the Third Person

Werner Spies

George Braziller New York

For Peter Schamoni

The Publisher is grateful to Dorothea Tanning Ernst and Jimmy Ernst
for their kind permission to reproduce the works of Max Ernst.

Published in the United States in 1983 by George Braziller, Inc.

English translation by John W. Gabriel

© 1983 by George Braziller, Inc.
Originally published in Germany under the title
Max Ernst: Loplop: Die Selbstdarstellung des Künstlers
© by Prestel Verlag, Munich 1982. Copyright of works by Max Ernst by
Bild-Kunst Publications, Bonn.

For information address the publisher:

George Braziller, Inc.
One Park Avenue
New York, New York 10016
Library of Congress Catalogue Card Number: 83–45032.

ISBN 0-8076-1065-8

Typeset: Fertigsatz, Munich
Plate lithography: Repro Dörfel, Munich
Black and white lithography: Brend'amour, Munich
Printed and bound by Passavia, Passau
Printed in West Germany
First United States Edition

Jacket illustration: Loplop présente, 1932. (see plate 20)

Contents

*Le vautour, dont on avait signalé
la présence insolite dans ''La Vierge
aux rochers'' de Léonard, vient de
prendre son vol (c'était déjà Loplop
au XVᵉ siècle).*[1]

ANDRÉ BRETON

Foreword

This book is devoted to a series of collages, mostly large in format, which appeared in the work of Max Ernst at the beginning of the 1930s. A single figure dominates the cycle, a creature by the name of Loplop. His entrance upon the scene was announced by frottages and a number of oils which Max Ernst executed a few months before beginning the collage suite. Several of these paintings are illustrated here, since they introduce Loplop in essence—his anthropomorphic configuration and his showing of images.

The works of the Loplop suite might be termed Max Ernst's encyclopedic collages, for if we review the variations on this theme, we see that the images that Loplop presents to us recapitulate the œuvre. All its multifarious aspects turn up in the motifs that Loplop tries on, one after the other, like a mannequin. One figure only stands center stage, but in this one figure the genres are embodied and the boundaries between them dissolved. Figures, landscapes, shell-flowers, dramatic aperçus put in their appearance, often simultaneously. Mixture is the aim of the Loplop suite and underlying the combining and coupling of different motifs is the prime purpose of Surrealism, a sense-baffling expansion of the world of imagery.

These collages are given here in their entirety, for the first time outside the œuvre catalogue.[2] Our inquiry concerns Loplop foremost. Obviously the artist himself is hidden in the guise of this figure, subordinating himself to it as to a miniature superego. In the works that form this series, problems are touched upon that concern the visual artist's place in Surrealism, and not least Max Ernst's own stance within an antagonistic group.

It is striking that during the months in which Max Ernst worked on this collage cycle, he also drafted a ''Traité de la peinture surréaliste,''[3] that was excerpted in 1932, in the English-language journal *This Quarter*.[4] In this text, Max Ernst revealed insights into his methods and techniques and even secrets that up to then he had kept carefully to himself. At a time when André Breton, in the Second Surrealist Manifesto, attempted to redefine the Surrealist position, and when Salvador

Dali so spectacularly and eccentrically pushed his way into the fore-ground, the first painter of the group to do so—Max Ernst felt the need to clarify and comment on his relationship to the Surrealists. Thus his "Traité de la peinture surréaliste" can be used valuably to interpret the Loplop series. In it Max Ernst was concerned to define his imagery and to set things right, as he saw them, and to explain the significance of Surrealist art. Finally, we can show that behind the figure of Loplop there is a concealed reflection that can be traced back to Max Ernst's reading of Freud's essay on Leonardo da Vinci—Leonardo, the "vul-ture's child." Max Ernst's identification with Loplop and his study of Leonardo's *Trattato*—these may well lead us to see an epoch of twen-tieth-century art with new eyes.

For hints and suggestions I am grateful to Heino Heine, Muséum National d'Histoire Naturelle, Paris; to Marie-Laure Tardieu; and to my collaborators on the Max Ernst catalogue raisonné, Günter and Sigrid Metken. I am particularly indebted to Monika Steinhauser, who sub-jected the original text to critical review. W. S.

Loplop: this neologism, whose origin has been the subject of much speculation, turned up for the first time toward the end of the 1920s. Essentially *Loplop* follows the rule that the titles Max Ernst chose for his works were inspired by encounters with language, encounters that baffled and amused him. Recollections of his readings in Freud surface again and again in these titles, like the complex richness of dream-thoughts concealed in a few laconic dream elements. And as in the dense stuff of a dream, a single ambiguous element may embody any number of ideas. His *Belle Jardinière,* for example, is a play on the words that the title of Raphael's madonna shares with the Paris department store of the same name. The title *Aux 100,000 colombes* echoes the *100,000 chemises* of the French chain store. And *Loplop* is a similar instance. On the face of it, the word probably alludes to Ferdinand Lop, a *poète public* of Paris of the 1930s who was the continual butt of the students' admiring laughter.[5] The air of the Latin Quarter is said to have rung with the cry "Lop Lop!" during those years. The symmetry of the two syllables, the echolalia of "Loplop" may have reminded Max Ernst of the word "dada," or of Jarry's "Ubu," or perhaps even of Kurt Schwitters's "Grimm glimm gnimm bimbimm."

In any event, the word "Loplop" surfaced first among the legends in *La femme 100 têtes,* Max Ernst's collage-novel, where it occurs a total of eleven times.[6] Loplop himself appears in this novel in pictures both as actor and narrator. *"Loplop, le supérieur des oiseaux,"* Bird Superior or Head Bird, was obviously from the outset a creature with which Max Ernst identified.

This is how he described him, in entry No. 35 of an exhibition catalogue issued for his show in 1930 at Galerie Vignon in Paris: "Loplop introduces Loplop (a private phantom attached to Max Ernst's person, sometimes winged, invariably male)." In the special number which *Cahiers d'Art* devoted to him in 1937, he wrote:

> In 1930, after having furiously and methodically composed my novel
> *"La femme 100 têtes"* I was visited almost daily by Loplop, *Bird Superior,*
> a private phantom very much attached and devoted to me.[7]

And under the heading "Max Ernst" in the *Dictionnaire abrégé du Surréalisme* there is this information: "'Loplop, Bird Superior.' Painter, poet and surrealist theoretician from the origins of the movement to the present day."[8] In his *Notes pour une biographie,* the artist tells us the following about the years 1929 and 1930:

> *La femme 100 têtes,* a novel containing about one hundred and fifty
> pasted-paper pictures, accompanying text and a "Note to the Reader"
> by André Breton, appeared from Editions du Carrefour. ... The second
> important character in the novel, Loplop, Bird Superior, became more

and more central: *Loplop introduces a young girl; A human being; The sea in a cage; A young chimera in evening dress.*[9]

His identification with this bird figure also comes out in some of the legends to *La femme 100 têtes,* in the seventh chapter of which this text occurs: "Loplop, drunk with fear and fury, retrieves his bird's head and remains immobile for twelve days on both sides of the door."

He can be traced far back, this autobiographically tinged bird-creature dubbed Loplop. Max Ernst mentioned his self-identification with birds in many places; in his early *Biographical Notes* for instance we read:

> 1906. Head Bird Hornebom. A friend by the name of Hornebom, an intelligent, piebald, faithful bird dies during the night; the same night a baby, number six, enters life. Confusion in the brain of this otherwise quite healthy boy—a kind of interpretation mania, as if newborn innocence, sister Loni, had in her lust for life taken possession of the vital fluids of his favorite bird. The crisis is soon overcome. Yet in the boy's mind there remains a voluntary if irrational confounding of the images of human beings with birds and other creatures; and this is reflected in the emblems of his art.[10]

Though his identification with Loplop may have been "Max Ernst's" own affair, part of his private mythology, this did not for a moment deter his Surrealist friends from seeing the creature as his alter ego, as any number of statements and allusions show. Among the earliest of these is a poem Paul Eluard wrote in 1926, entitled "Max Ernst". It contains these lines: "Devoured by feathers and left to the sea / He has let his shadow pass into flight / Of the birds of freedom. . . ."[11] Also worth quoting is a text by Jacques Viot in which he writes: "There are other birds outside the coop. But not many of them are birds of prey. . . . And how do the painters come off, now that everybody has started painting?"[12] Max Ernst qualifies as a bird of prey, since he "... has gone off alone into a forest the likes of which is not found in hunting stories."[13] And Viot adds: "What he has taught us turns every opinion upside down. Most people, for instance, think that birds fly. I give only one example but add that, according to Max Ernst, even men might fly if only they stopped letting themselves be tamed."[14] Yet another example is Man Ray's portrait entitled *Max Ernst, Painter, Birdman.*

A further identification of artist with bird may be of interest here. Max Ernst must have been aware of it; at least Breton mentioned it in the later edition of *Le Surréalisme et la Peinture.* In Apollinaire's *Le poète assassiné* we are introduced to the "Oiseau du Bénin," Bird of Bénin, an artist who is to erect a monument to the dead poet, Croniamantal. This book, which first appeared in 1916, was published in a new edition in 1927 by two members of the Surrealist group, Louis Aragon and Philippe Soupault. By this time the key to the characters was in everybody's possession—Croniamantal was Apollinaire; l'Oiseau du Bénin,

Picasso; and Tristouse, Marie Laurencin. And it was just at this time, 1928–29, that l'Oiseau du Bénin/Picasso, at the behest of Apollinaire's friends, began working out suggestions for a monument to his friend Croniamantal/Apollinaire.[15]

The Return to Collage

Though we can trace the neologism Loplop and thus Max Ernst's doppelgänger back to the year 1929, the Loplop collages themselves did not put in an appearance until 1930. In late autumn (21 November) of that year, a one-man exhibition of Max Ernst's work opened at Galerie Vignon in Paris. The catalogue comprised forty-five numbers; thirteen of these had the word "Loplop" in their title.[16] Most of the works on show were collages and it is very likely they had been finished only a short time before, since Max Ernst cannot have begun making images of this size until March 1930, at the earliest. Back then, Galerie Goemans in Paris had shown an exhibition of forty collages by Arp, Braque, Dali, Duchamp, Max Ernst, Gris, Magritte, Man Ray, Miró, Picabia, Picasso, and Tanguy. And in this retrospective of the collage genre Max Ernst was represented, with two exceptions, which came from *La femme 100 têtes*, solely by early works from the Dada period.

Up until about 1922 he did a great deal of work in collage; however, in the course of that year, after his move to Paris, he ceased using the technique and was not to take it up again until many years later. Toward the end of the 1920s collage enjoyed a surge of general popularity, due in large part, it seems, to Picasso. As Louis Aragon wrote in a text entitled *La peinture au défi*, which came out in conjunction with the show at Galerie Goemans, "Picasso . . . had an attack about two years ago, a veritable attack of collage."[17] And about Miró we read: "He arrived very naturally at a point last year where he made nothing but collages."[18] Max Ernst too returned to the medium of collage at about that time, putting together the first novel ever "written" in that medium, *La femme 100 têtes*. As in Cologne, for the books *Répétitions* and *Les malheurs des immortels*, he again based his work on material taken from publications of the nineteenth century. As before, he limited himself to wood engravings, which insured perfect formal integration of the different elements and which also allowed him easily to conceal the joints and laps between those elements.

At the Goemans exhibition, his new style was made public by "Le Fantôme de la repopulation," an image from *La femme 100 têtes*. Narrative elements predominated in this new style and were related to the new concerns and reorientations of Surrealism. Among the catalogue illustrations there is a collage entitled *L'autel de la patrie* which was intended for an ironic history of France, *Morceaux choisis de l'histoire de France*, which however never materialized.

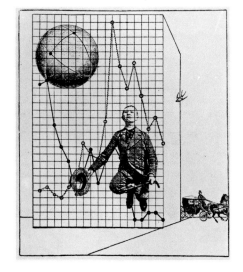

1 Max Ernst. *L'aveugle prédestiné tourne le dos aux passants.* 1922. Present location unknown. (S/M 475)

2 From *La Nature*, 1897.

11

Aragon's study *La peinture au défi* contains an analysis of various works and techniques; perhaps the most significant theoretical statement he makes touches on the difference between the papier collé of the Cubists and collage, which according to Aragon, Max Ernst was the first artist ever to use. There can be no doubt that this essay challenged Max Ernst to rethink his position. About 1912 the Cubists had begun employing the technique of pasted paper—quotations from reality in the shape of bits of wallpaper, newspaper clippings, product labels—to help link the *fait pictural* of the Analytic style, in which content had been reduced to a minimum, more strongly to the real world.[19] Yet with these pasted-in elements the Cubists did not intend to give rise to iconographic shock. The fundamental subject of Cubist art, still life, remained unchanged by them. The semantic meaning of the pasted-in material remained subordinate to, as it was transmitted by, the image as a whole. Now when Max Ernst turned to collage, during the Cologne Dada period, it was with indifference to the content of Cubist papiers collés; for his and the Dadaists' intention was to reject Art, and the art business, as radically as they knew how. This rejection did not stop short of the vanguard—a dictum like "Dada is not modern" indicates how serious they were about breaking with social and historical subordination of every kind.

In a few works of the Cologne period elements do appear that recall those used in the papiers collés of Synthetic Cubism: the patterned wallpaper in *Forêt* and in *La petite fistule lacrimale qui dit tic tac*, for instance. Yet unlike the Cubists, who would introduce a piece of wallpaper at that very point in the all-important context of their *fait pictural* where otherwise a painted rendering of wallpaper would have appeared, Max Ernst transformed that piece of wallpaper in his collages by linking its meaning to that of a dominating idea—so that the vertical pattern of the wallpaper becomes a forest because over it hovers the disk of a sun. In this way he brought about shifts and displacements of meaning which accelerated the crisis of identity that Dada aimed to set in motion. Almost from the beginning, a very personal, inimitable principle informed Max Ernst's collages, namely to create from a juxtaposition of disparate elements, removed from their original context of meaning, images which balked logical interpretation. He defined his tactic in these words: "...the exploiting of *the fortuitous encounter upon a non-suitable plane of two mutually distant realities.*"[20] His entire œuvre rests on this principle of a collage that involves semantic elements in an inextricable play of meanings; oils, drawings, collages, frottages, sculptures, writings, all spring from a coupling of images and structures/textures which though they may have been at the disposal of anyone who chose to cut them out of the universe of mechanical imagery, remained bound to their practical, emotion-free signification until Max Ernst released them from it.

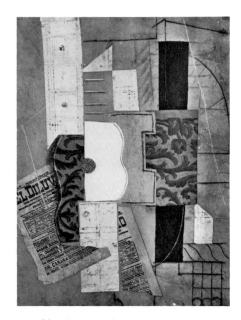

3 Pablo Picasso. *The Guitar.* 1913. New York, The Museum of Modern Art.

4 Max Ernst. *La petite fistule lacrimale qui dit tic tac.* 1920. New York, The Museum of Modern Art. (S/M 353)

12

Aragon realized and stated that Max Ernst's collages differed fundamentally from Cubist papiers collés. This is true of their alogical connection of quotations from reality, and it is true of their formal character. Nevertheless, when we come to the Loplop suite, the distinction between papiers collés and Max Ernst's collage technique begins to waver.[21] Why this should be so is worth investigating.

Doubtless his reacquaintance, in 1930, with Cubist work in pasted paper was very important to his own development. It roused him to try to synthesize his own collage method with that of the Cubists. How conscious he was of a reorientation in his work may be gathered from the altered terminology in his writings of the day. In his *Notes pour une biographie,* for instance, he mentions an exhibition at Galerie Pierre in Paris, saying that he had shown "papiers collés" there—meaning the Loplop collages. In 1930, when he embarked upon this new series, it was not the specific aesthetic message of Cubist papier collé that interested him. What challenged him was the overall disposition of the work of Picasso and Braque.

Let me explain. In the work of Picasso and Braque we see a balance, against the white background of the sheet, between pasted elements and graphic structure. And like these papiers collés, the effect of the Loplop collages depends largely on an equilibrium between white paper and color-contrasted, sharply contoured shapes. At a key point papiers collés and Loplop collages converged; and in Max Ernst's work the textural values of the pasted elements now came to the fore. This richness of texture and structure was new in the field of true collage. Up to then, Max Ernst had done everything to draw our attention away from the variety of his original material, to prevent our verifying the elements of his collages. It is no accident that we are confronted by a great variety of relieflike, "palpable" material in the Loplop collages. Max Ernst had taken a cue from his own painting, in which the harsh contours of the early "painted collages" had begun to give way, in about 1925, to more variety of texture. Nor did this marked change in his work escape the eyes of his contemporaries. In an article on his *Exposition de Collages* at Galerie Pierre in 1932, at which several Loplops were shown, the *Cahiers d'Art* reviewer noted:

> Max Ernst brings a certain comic spirit to his subjects to which the Cubists were not attuned, being too preoccupied with formal problems. He often succeeds in pointing up unexpected similarities. And this comic spirit that things exude does not prevent the work from impressing the viewer with its plastic qualities.[22]

This reference to plastic qualities seems significant. Thanks to these qualities, the writer of the article was able to establish correspondences between Cubist papiers collés and the images of the Loplop suite.

This recourse to geometric structure and to sharply delineated contour which inspired the critic, an advocate of Cubism, to speak of plastic qualities, soon took on symbolic value for Max Ernst's stance within the Surrealist movement. With the Loplop compositions Max Ernst clearly distanced himself from the linear tangle of *écriture automatique*. His interest in Cubist papiers collés concealed an inner break with Surrealist automatism.

Yet even though his contemporaries could not help noticing a crucial stylistic change in the Loplop suite, today, looking back at the œuvre as a whole, this phase cannot be judged nearly so apodictically. To speak of a radical turnabout is not really just. After all, constructivist elements had long played a certain and necessary role in Max Ernst's work. This arose from the circumstance that his work—built up as it was of preexisting, cut-out elements—depended on consistent patterns of procedure, geometric invariables that determined the structure of his collages. The development of his work shows how rapidly, even from the first months of Cologne Dada, he arrived at criteria by which he sifted the boundless material at his disposal; criteria that regulated the tectonic integration of this material, its placement on the picture plane.

5 Max Ernst. *Trophée hypertrophique.* Circa 1919–20. Krefeld, Ernst O. E. Fischer. (S/M 302)

Making a collage, after all, is not just a matter of mixing images spontaneously, in an attempt to produce a maximum of formal innovation and thematic irritation. Max Ernst's early work shows quite clearly how he devised schemes which linked each work to the next in stylistic consistency. Such series are to be found in his work from the outset—the rubbings and monotype prints made from commercial plates are cases in point.[23] This working in series lessened the arbitrariness that might otherwise attach to a procedure that aimed at pure spontaneity and hence at the destruction of aesthetic norms, of *style*.

Working in series: in practice this means repetition and the use of basic materials that possess a certain innate consistency. This kind of approach brings forth constellations of imagery which are recognized by comparison. Each image can be grasped in terms of its similarity in content and formal allusion to the next. Repetition of motif and variation on themes culminate gradually in a body of work that reveals an internal, inexorable logic. Hence we can say that the mode in which Max Ernst presents his irritating images is, within each series, entirely rational. Not that the images sacrifice any of their illogicalness or strangeness; we merely accept them on their own terms as right and consistent. Since his aesthetic depended on the use of redundancy, Max Ernst's preference was understandably for collections of material that had an encyclopedic or at least repetitive character.[24] Here, in the domain of classification, he found motifs that were fundamentally *alike*.

Max Ernst's collages were marked almost from the beginning by a

14

constructive tendency. If we look at the placement of the cut-out elements in the wood-engraving collages from 1921 on, we see how these excerpts from books and periodicals remained subordinate to a visual plan, and moreover how size relationships and proportions determined what could and could not be used. Structure and a repetition of constants limited the contingency, the arbitrariness of his work. This reliance on a guiding conception is particularly obvious when we come to the Loplop collages. Here it may be helpful to recall that already in the Dada period Max Ernst was interested in Mondrian's procedure of developing variants from the simplest geometric elements and most basic colors.[25] The surprising inscription on Max Ernst's painting *Oedipus Rex*—"ce tableau en trois couleurs élémentaires"—can be taken to show his concern for combining constants, a combination that in this instance relies on a very few narrative elements (the picture was based on a *concetto* of collage material) to give rise to a highly complex configuration. This configuration, like Mondrian's paintings, is much more than the sum of its parts.

6 Max Ernst. *Ça me fait pisser.* 1919. Milan, Arturo Schwarz Gallery and Geneva, Jan Krugier Gallery. (S/M 312)

The First ''Original'' Collages

To compare Max Ernst's early collages with the Loplop collages, two observations suggest themselves: first, these are collages that are characterized by their very *autonomy* as collages; and second, they are *large in format*. Simple as these statements may seem, they point to something quite unprecedented in Max Ernst's work of the time. The term autonomy in this connection means no more and no less than that here, in this group of works, the collage method was employed as a *recognizable* medium for the first time. With his Loplops Max Ernst gave us, strictly speaking, his first ''original'' collages.

This paradox can be explained by remembering that Max Ernst's collages from about 1920 were not conceived as original, autonomous works. The cut edges and joints in these collages were concealed in various ways—for instance, when working with photographic material, by having prints made of the paste-ups. This insured that the separate elements would merge into one continuous image, an image that confronted the spectator with a mystery as to its origin. Because he could not see how the picture had been made, he was distracted from its collage character.[26] The enigma was deepened still further by the tiny additions Max Ernst made, either in collage or pen and ink, to the pictorial continuum thus obtained. These small changes were the only material clues which the eye could detect. So while collage per se had been limited to minuscule traces, the procedure which had given rise to the image proper was concealed, having been obliterated when the paste-up was reproduced.

The same holds true for the black and white wood engravings that

Max Ernst began to use more and more for his collage work from 1921 on. These came from popular science publications, catalogues and magazines of the nineteenth century. The collages he made of this illustrative material—he referred to them as maquettes—were handed over to the printer, who made plates from them; line etchings in which, once proofs were taken, the joints visible in the "originals" could no longer be seen. In some cases the printer, at Max Ernst's instruction, made slight corrections to ensure smooth transitions between the elements. The final prints, in which the different tones of black of the engravings had now been unified, gave rise, like the earlier "photographics," to an illusion of stylistic consistency and technical plausibility in what otherwise were highly illogical and mysterious images. Max Ernst did not show his maquettes; they belonged to his studio secrets. Whenever he made a gift of one of these "originals" to a friend, especially in the early years of his career, he would first subject it to revision. He heightened with colored gouache, for instance, paste-ups from which the plates for *Répétitions* and *Les malheurs des immortels* had been made, obscuring the cut edges in the process.

The foolproof way to produce collages that denied being collages, however, was to paint them in oils. Probably realizing this, Max Ernst returned to the oil medium in the winter of 1921. He began painting after collage sketches, which enabled him to overcome the second handicap of wood-engraving collages, namely their small size. Because engravings were rarely larger than average book format, the collages made from them could hardly be any larger; even the prints for *La femme 100 têtes*, *Rêve d'une petite fille qui voulut entrer au Carmel*, and *Une semaine de bonté*, begun in 1929, were necessarily limited to medium book-size. In this regard, the Loplop suite brought a decisive turn: the images were large. And large they could be, since it was no longer a matter of achieving a perfect amalgam of found images. Here for the first time, collage was allowed to speak with its own voice: joints, edges, breaks, the spaces that separate the elements, and the diverse origin of those elements themselves, all now contributed to a polyphonic variety; and in place of a pictorial continuum now appeared images built up of multifaceted material, conscious collages.

7 Max Ernst. *Ein lustgreis vor gewehr schützt die museale frühlingstoilette vor dadaistischen eingriffen (l'état c'est MOI!).* *(A Dirty Old Man presents Arms Protecting the Museum's Spring Fashion from Dadaist Attacks [l'état c'est MOI!]).* 1920. Destroyed. (S/M 338)

Anthropomorphic Figuration and the Collector Motif

Reviewing the entire Loplop series, we come across two typical traits: the obviously *anthropomorphic figuration* on which these images are based, and the *motif of the collector*. Both derive from what has been suggested before, namely that Loplop would seem to be an embodiment of the artist, and that the markedly additive nature of these compositions is a result of a use of collage that, for the first time, makes it a medium expressive of discontinuity. And these built-up configurations

16

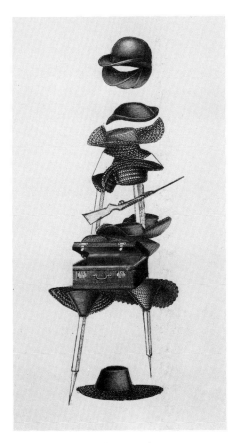

8 Max Ernst. *Ein junger Kölner. (A Young Man from Cologne.)* 1920–1970. Paris, Private Collection.

9 Pablo Picasso. *The American Manager.* 1917. Paris.

10 Pablo Picasso. *Wire Construction.* 1928. Paris, Musée Picasso.

11 Pablo Picasso. *The Studio.* 1927–28. New York, The Museum of Modern Art.

now appear as allegories of the collage and montage doctrine, in which statements about reality are made only in terms of dissociation, refraction rather than reflection. A number of forerunners in the œuvre could be cited by way of comparison, pictures in which the collector motif, this playful inventory so typical of Loplop, is combined with a schematic anthropomorphic figure. The earliest of these, not pictures but sculptures which we know only from documents, were executed in the early months of 1920 for the exhibition *Dada-Vorfrühling* (Dada-Early Spring) in Cologne.

A short time previously Max Ernst had spent six weeks as acting manager of the hat-blocking firm owned by his father-in-law, Jacob Straus. Using the hat molds he discovered there and various other wooden parts including artist's easels, he assembled sculptures, bolting and screwing his finds together into human semblance. These figures were further embellished with other found objects. The most provocative of the group, judging by the description, seems to have been an assemblage entitled *A Young Man of Cologne*. (The autobiographical overtones of the title are unmistakable.) The young man's skeleton, fleshed out with hat blocks, was formed by a three-legged easel; beneath what represented his penis a serving tray was suspended, and on this Max Ernst had spilled red paint. The figure even sported a medal: a reproduction of Dürer's engraving, *Adam and Eve.*[27]

Anthropomorphic constructions, automata—these of course are one of the main themes of twentieth-century figurative art. The motif is found in *pittura metafisica,* which Max Ernst began to come to grips with in about 1919. The reproductions of the paintings by de Chirico and Carrà which Max Ernst found in the pages of *Valori plastici* led him, in the winter of 1919, to give his more abstract and mechanical skeleton-figures biomorphic (and ironic) overtones. The *Fiat modes* suite of lithographs exemplifies this reorientation. Besides the human dolls of de Chirico, who lean in torpid melancholy on a seemingly endless series of easels, we can cite in comparison the masks Picasso created for the

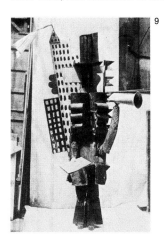

9

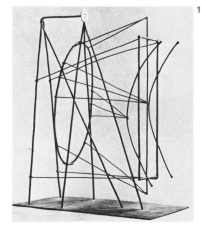

10

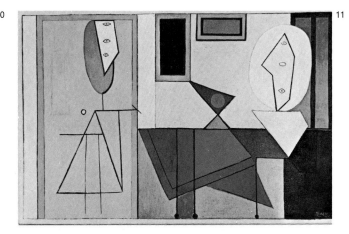

11

ballet *La Parade*. These dance-masks go back to the papiers collés of Synthetic Cubism. A similarity might also be detected between Loplop's shape and the "drawings in space" that Picasso made in 1929; here too, linear structures that echo Synthetic Cubism are given human configuration. A Loplop so stringently constructed as *Loplop présente* (fig. 68, plate 9) particularly invites comparison to the space-defining webs of line that Picasso executed in iron wire at the time. Picasso in turn used his own three-dimensional linear scaffoldings in a number of paintings in which, as in the Loplop collages, a confrontation is staged between lines and regular, geometric planes. Moreover, many of these paintings depict an artist in his studio—an artist introducing his works and his models to the public.

Another example from the Dada period which seems crucial to the derivation of the "artist presents work" theme is dated 1921. This is a design, in collage, which Max Ernst made for an exhibition poster. Since the aim was to advertise his own work, the idea of giving a kind of visual inventory of his various activities suggested itself. Near the bottom of this sketch is a photograph of the artist; above this rises a capacious hexagon into which any number of self-quotations have been packed. Here is Max Ernst opening his sample case for the customer's perusal. His intention is clearly, even in this early piece, to lend order to what he presents—an order given by the anthropomorphic scheme.

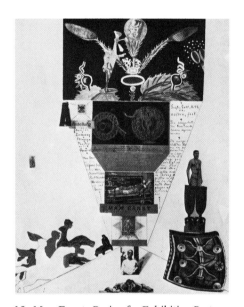

12 Max Ernst. *Design for Exhibition Poster.* 1921. Turin, Museo Civico di Torino–Galleria d'Arte Moderna. (S/M 437)

What is seen, without too much difficulty, is a head wearing a hat. The round shapes of the *relief tricoté* which has been worked into the design represent the eyes, and since small cut-out hats have been pasted into the square above them, there is really no choice but to read it as a hat. Many parallels can be cited for such symbolic naming, for the anthropomorphic scheme and for the subject of the artist as hawker of his own wares, all of which culminated in Max Ernst's work at the start of the 1930s, with Loplop.[28] Anthropomorphic constructions, found throughout the history of art, crop up whenever an artist undertakes to define a canon of human proportions. In his monotypes of the Dada period, Max Ernst recalls such schematic figures as those of Bracelli or Larmessin,[29] Erhard Schön, Luca Cambiaso, or Walter Crane. Masquerades are another parallel, as well as the subject of artist/easel-figure, as Günter Metken pointed out, that can be found among the caricatures of artists which the nineteenth century turned out in such great numbers.[30] Astonishingly similar to Loplop, for instance, is a composition by Cornelis Gysbrecht, in which by emphasizing their contours he has transformed an easel and the canvases piled up before it into a human figure. Above the easel projects a shape which one instinctively reads as a head.

Another delightful precursor of Loplop is in *Magasin Pittoresque*, which was one of the earliest and richest sources of the wood engravings Max Ernst employed in his collages. This is a self-portrait by Boiel-

18

13 From *La Révolution Surréaliste,* no. 3, 1925.

14 *Mascarades à la grecque. La vivandière.* From *Magasin Pittoresque,* 1874.

15 Max Ernst. *Femme belle et femme debout.* 1919. Switzerland, Private Collection. (S/M 317)

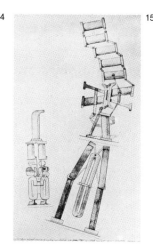

16 Cornelis Gysbrecht. *The Easel.* Circa 1670. Copenhagen, Statens Museum for Kunst.

17 *Flying Dealer* After Bonnard. Circa 1860. From *Magasin Pittoresque,* 1882.

18 Boieldieu. *Boieldieu Returning from a Picture Sale.* From *Magasin Pittoresque,* 1882.

dieu, which shows the artist returning from a sale of his pictures. Not a gratifying sale, obviously, because he is so loaded down with paintings that he even has to carry one on the top of his hat. Here again is the artist as door-to-door salesman, carrying a mixed bag of his imaginative products for the buyers' approval—a genre scene the like of which Max Ernst told me he had himself once witnessed in Cologne. The traveling salesman in his story was none other than Kurt Schwitters, making his rounds with two suitcases in hand, in each a different line of goods: insipid landscapes and still lifes for over the sofa in the one, and in the other—his *Merz* collages. Reaction and vanguard—the dialectic of the period could not have been illustrated more poignantly. Art, Max Ernst knew, could go on being practiced only as a continual break with both extremes.

Another parallel worth noting here is a work by Marcel Duchamp, his *Obligations pour la Roulette de Monte-Carlo* of 1924. It shows Duchamp's own head, his hair jutting out like diabolical wings, crown-

ing a body made of an "obligation," a coupon for the Monte Carlo casino. This conjoining of artist's head and a body/coupon standing for a system with which Duchamp hoped to beat the game by a slight margin, must have amused Max Ernst. It probably reminded him of some of his own early things, the rubbings and prints made from commercial plates in Cologne, in many of which he had likewise incorporated elements of roulette. One of these bore the title *Chilisalpeterlein . . . every number wins.* Duchamp's collage was on view in the exhibition of collages at Galerie Goemans in March 1930, and it prompted Louis Aragon, in the catalogue, to write that ". . . his latest picture is an example of a limited share in the exploitation of that system [of gambling], consisting of a collage with the author's photograph."[31]

Loplop and Cadavre Exquis

One striking affinity between the Loplop figure and a product of Surrealist group activity remains to be mentioned. The images collectively produced in the game called *cadavre exquis* show both formal and ideological parallels. In his essay "Comment on force l'inspiration" Max Ernst emphasized the positive aspect of such group work, calling it a means by which the chance character that ought primarily to determine a Surrealist work could be guaranteed.

> In the hope of augmenting the fortuitousness of the elements on which the composition of a drawing is based, and also of increasing the abruptness of their associations, the surrealists have resorted to the procedure called "cadavre exquis," divulged elsewhere in this number. The large share chance has in this is only limited by the role played, for the first time, by a contagion of ideas.[32]

Along the same lines Breton had earlier noted in the Second Surrealist Manifesto that he thought the Surrealists had ". . . coaxed out a curious possibility of thought, one involving *collective creation.*"[33]

Here again, in these collectively produced *cadavres exquis,* there is a consistently anthropomorphic scheme—the human shape turned up with regularity in the *cadavres exquis* drawn by Breton, Eluard, Max Ernst, Tzara, Tanguy, Miró, Man Ray, Morise and others between 1925 and 1939. To begin the game the first player, apparently because it was appropriate, would draw a head or something resembling a head in the top section of the sheet, usually allowing the lines to converge toward the bottom to represent the neck. The paper was then folded and the second player continued on from there, quite automatically broadening out from the neck into shoulders and trunk. A third and sometimes fourth contribution followed, the last player, having to wind things up, typically allowing the trunk to narrow to a pedestal or an evocation of legs. The variations achieved were amusing and extreme, yet all of

20

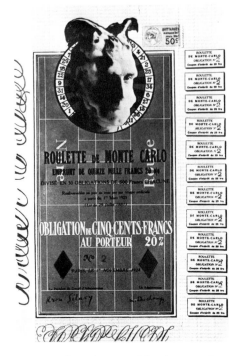

19 Marcel Duchamp. *Obligations pour la Roulette de Monte-Carlo.* 1924. Villiers-sous-Grez, Mme. Marcel Duchamp.

20 Max Ernst, Max Morise, André Breton and Marie-Berthe Aurenche, *Cadavre exquis.* 17.3.1927. Paris, Private Collection. (S/M 1197)

them remained more or less within the bounds of a rudimentary human shape.

The circumstance that the majority of those who played *cadavre exquis* were not painters goes far toward explaining this predilection for a schematic figure. People who are untrained in art tend to make stick-men of one kind or another when they begin doodling. How fascinated the Surrealists were by stereotypes of this kind may be seen from their publication of *Les buvards du conseil des ministres* (Blotters from a Cabinet Meeting).[34] This was a two-page spread of blotter doodles, most of them not surprisingly anthropomorphic. (It should be noted, too, that the head-trunk-legs division seen in all the graphic *cadavres exquis* corresponds to the equally consistent sentence structure of subject-verb-object to which the written version of the game gave rise.[35]) The division seen in Loplop, head-showcard-feet, seems likewise to echo these collective products.

The *mise en commun* which in Breton's words leads to collective work, played a part in another type of composition—the arrangement of Paul Eluard's collection of picture postcards. He had thousands of them, and the arrangers (one of whom was Max Ernst) set out to paste them into a series of albums, their aim being to compose single and double pages with unusual and disquieting confrontations of subject, style, and color. These album pages indeed work like collages with their deliberate jumbling of techniques and themes; the most incongruous images impinge on one another, message is played off against message in often perverse innuendo. Religious subjects, military motifs, idylls, flower-

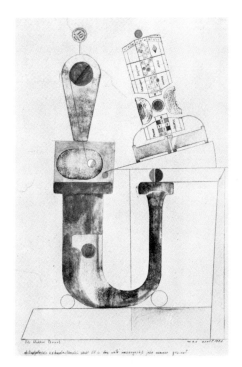

21 Max Ernst. *Chilisalpeterlein . . . jede nummer gewinnt. (Chilisalpeterlein . . . every number wins.)* 1920. Hamburg, Private Collection. (S/M 320)

LES BUVARDS DU CONSEIL DES MINISTRES

22 *Blotters from a Cabinet Meeting.* From "La Révolution Surréaliste," no. 6, 1926.

21

pieces, romances recounted in entire series of cards, are coupled with erotic and pornographic picture-stories; paradoxes arise whose abrupt breaks and accelerated plots recall the arbitrariness and compression of dreams. The contrasts in the pages of these postcard albums likewise call to mind the paratactic accumulation of themes in the Loplop col-

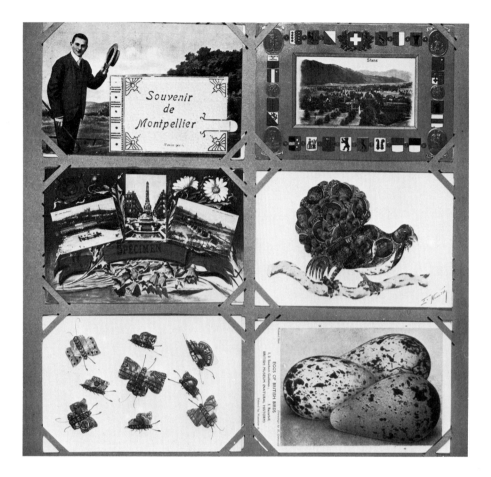

23 From "Postcard Collection Eluard." Paris, Private Collection.

lages. Now and then in the Loplop suite, pictorial elements have been inserted into the composition as if into actual slots—a motif, common in *trompe-l'œil* and still-life painting, which probably derives from postcard albums with their slots arranged to hold the cards at their four corners.

Precursors, points of reference—the list could go on indefinitely. However, the Loplop motif concerns us primarily for other reasons, the main one being the fact that beyond its anthropomorphic variation of a constructivist, Cubist theme it was to become a figure that reflected Max Ernst himself and his aesthetic concerns.

22

24 Max Ernst. *Du verre.* 1932. Stuttgart, Private Collection. (S/M 1853)

We cannot pretend to reconstruct the exact chronology of the various Loplop collages and depictions of Loplop in other media. Not only are they rarely dated, they cannot be arranged in any even approximate order with the aid of exhibition catalogues. It would surely lead us astray to equate a growing complexity of image, for instance, with development of the series. What we can assume is that the large majority of the Loplops—both those in collage and those made solely by frottage—were executed within a short period of time. This is suggested, if nothing else, by Max Ernst's usual working rhythm —whenever he took up a new technique or worked out some new principle to guide him, he applied that technique or principle to a broad range of variations. This holds as much for the series of frottages of *Histoire Naturelle* as it does for the narrative collages of engravings with which he compiled, from 1929 on, entire collage-novels.

Roughly speaking, the depictions of Loplop in collage can be grouped into two categories. The first contains images that, for all their reduction to front view and planar articulation of the personage or personages involved, are based on a clearly stated anthropomorphic scheme (*Loplop présente* [plate 3], *Figure humaine et fleur* [plate 63]). The Loplops of the second group by contrast look less corporeal. This category includes works in which only one or the other attribute alludes, epigrammatically, to the central figure of Loplop. Among these rank *Jeune homme debout* (plate 61), *Main humaine et papillons pétrifiés* (plate 15), *Papillons* (S/M 1780), *Schmetterlingssammlung* (plate 16), *Untitled* (plate 18), *Loplop présente* (plate 23), *Colombes et corail* (plate 33), and *Pronostics* (plate 25). There also are a number of images in which the head, or even a schematic suggestion of a head, is missing, for example, *Loplop présente chimaera* (plate 5), *Loplop aux papillons* (plate 14), *Loplop présente* (plate 19), *Forêt et personnage* (plate 22), *Loplop présente Loplop* (plate 55), *Loplop présente* (plate 67), *Untitled* (plate 69), *Loplop présente* (plate 28), *Loplop présente* (plate 27), and *Loplop présente* (plate 26).

This reduction to a schematic figure is also found in numerous painted versions of the Loplop theme. Yet here the simplification is seldom carried so far as it is in the collages, perhaps because the abbreviated nature of the collage-Loplop can be offset by what he introduces. Largely absent in the oils as well are the sharply outlined planes, the geometry with which Loplop's body is given throughout the collage sequence. In the oils there are instead complex, curvilinear contours which go back to an involvement with floral motifs, motifs that were very prevalent in Max Ernst's painting of the time. Such motifs found their way into the Loplop collages, yet there they appear not in silhouette but together with a section of the background of the page from which they were taken. In the collages these arabesques are

23

embedded in a field of color that contrasts with its new background, and is set off sharply from the remainder of the composition.

Similarities to Cubist papiers collés have been mentioned. The geometry of the Loplop images, however, differs in an important respect from its Cubist relative—the lines serve to create an illusion of depth, and an illusion based on perspective at that. The planar elements (Loplop, his companion, his works) are juxtaposed and made to overlap so that they appear to be performing on a stage, with various backdrops let down behind them. Wherever Loplop and his companion, or merely two dominating rectangular shapes, appear, these are disposed so that the displacement of their axes brings about a movement that is perceived spatially. In this case Max Ernst returned to the technique of counterpoint that enlivened the monotypes and rubbings of the Cologne Dada period. Indeed, geometric simplification and bundles of lines made to converge sharply in one-point perspective had already characterized many works of the Cologne years in which Max Ernst painted over parts of the image with gouache. In one picture of 1928, *Loplop, le Supérieur des oiseaux* (a title given at a later date), this supergeometry was used to project an anthropomorphic figure. And among the Loplop collages three may be cited in which the painter puts on perspective like some liturgical vestment: *Loplop présente* (plate 64), *La fleur d'oranger*, (fig. 25, plate 65), and *Loplop présente une fleur* (plate 24).

In *La fleur d'oranger*, the wedge-shaped head serves as a "vanishing point" in which an exploded field of vision seems to reconcentrate. Something that should not be overlooked is that such abrupt foreshortenings and jarring collisions of form were also part of the design arsenal of Art Déco. Lines shooting like vectors toward a vanishing point are found, for example, in the book bindings of Louis Creuzevault (one of which made in 1929 even sported a schematic Loplop hand), in René Lalique's famous *Radiator Cap* of 1930, or in the intarsia work with which Léon and Maurice Jallot decorated their furniture. In the contemporaneous work of Léger, too, this fan motif frequently held a central place.

25 Max Ernst. *La fleur d'oranger.* 1931. Paris, Private Collection. (S/M 1793)

26 René Lalique. *Radiator Mascot Victoire.* Circa 1930. Private Collection.

27 Louis Creuzevault. *Book Cover.* 1929.

28 Fernand Léger. *Composition.* 1929. From *Documents,* 1930.

25

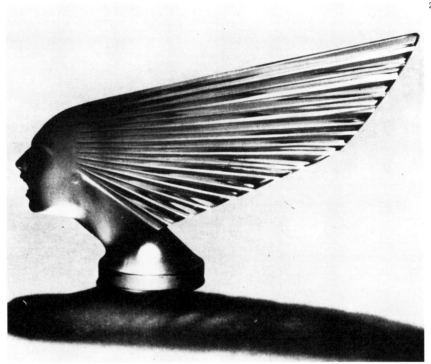

26

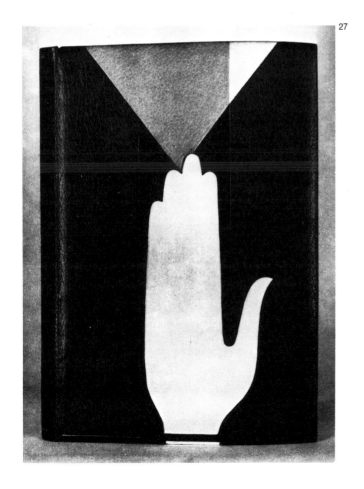

27

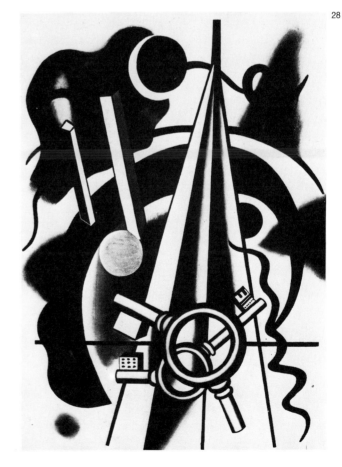

28

Another motif that is well-nigh ubiquitous in the Loplop sequence is that of hands. First of all, this repetition of large hand shapes contributes to the suite's unity; as a basic, serial motif, next to the constructivist torso, it plays probably the most important and consistent role. The hands are usually given in silhouette, with four outspread fingers, recalling the four-fingered hands in Man Ray's *Rayograms*. (Another, if remoter, parallel to these hands which lead a life of their own in the Loplop collages is found in Georges Bataille's essay, "Le gros orteil," published in the magazine *Documents* in 1929.[36] The text was accompanied by three full-page photographs—of a big toe!) Generally Loplop's hands are of equal size; often they have been drawn by tracing around a pattern, reducing them to silhouettes. Now and then one of these hand shapes has been cut out of marbled paper.

This gave rise to both positive and negative shapes, and Max Ernst used them alternately. Into some pictures he pasted the cut-out shape (e.g., *Loplop présente* (plate 9), *Papillons* (S/M 1780), *Schmetterlingssammlung* (plate 16a), *Huits portraits spectraux* (plate 12), and *Loplop présente* (plate 20), while in others he mounted, on a lighter background, the rectangular piece of paper from which the hand had been cut. In *Loplop présente* (fig. 31), finally, both positive and negative forms appear. This repetition of form—as presence and absence, positive and negative—is among the constants of his œuvre. This echo effect is found even in the context of *Histoire Naturelle* ("Caesar's Palette"). The twin use of the hand, once as figure and again as ground, anticipates an approach to collage which Matisse was later to follow systematically in his *papiers découpés*.

This collage hand is more than a formal device, however. It has symbolic meaning, referring as it does to the showmaster or the artist. The predominance of hands in Max Ernst's work certainly invites interpretation—among the Loplop depictions there is even one in which Loplop introduces nothing but a disembodied hand (*Loplop*, plate 47).

Fascination with hands and their gestures can be traced back to Max Ernst's childhood. His father was a teacher of the deaf and dumb; young Max learned his language and later made effective use of it in his paintings. Particularly in *Au rendez-vous des amis* this symbolic play with the speech of the deaf underlines the Surrealists' hope of expressing an inner voice as yet unarticulated and unheard. In reviewing the sources which Max Ernst tapped for collage material, it is surprising how many of them, even the earliest, contain depictions of hands. Loplop's hand, hovering over the images he presents to us, juggling with them, is the same hand found in the plates of the *Encyclopédie* and in thousands of technical illustrations of the nineteenth century. These are hands gone independent, separated from head and body, hands in action. Manual

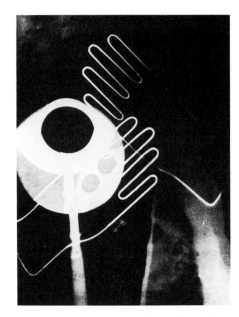

29 Man Ray. *Photogram*. From Franz Roh and Jan Tschihold, "fotoauge," 1929.

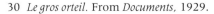

30 *Le gros orteil*. From *Documents*, 1929.

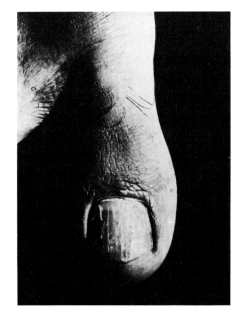

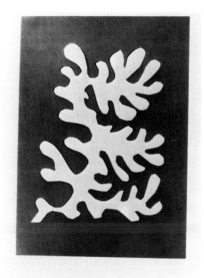

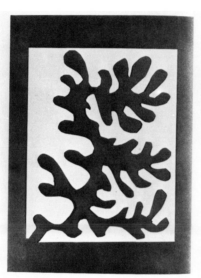

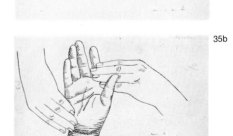

31 Max Ernst. *Loplop présente.* 1931–32.
Munich, Peter Schamoni. (S/M 1786)

32 Max Ernst. *La palette de César. Histoire
Naturelle,* Leaf 20, 1925. Present location
unknown. (S/M 809)

33 Henri Matisse. *No Title.* 1947. Paris,
The Régine Pernoud Collection.

34 Poyet. *Experiment with Bottle.*

35 Max Ernst. a. *il n'y a pas à sortir de là;*
b. *l'herbage rouge;* c. *le buvard de cendre.*
1923. Krefeld, Ernst O. E. Fischer. (S/M
544, 546, 545)

dexterity is central to many other of the depictions from which Max Ernst frequently took motifs for his collages—pictures of magicians performing tricks, for example. Many of Loplop's gestures show a similar sleight of hand as he conjures up flowers, ribbons and animals.

The hands in the Loplop collages are hands without bodies, hands with a life of their own. In his foreword to *La femme 100 têtes* André Breton wrote, a year before the inception of those collages, "You can alienate a hand by severing it from the arm. It gains thereby '*qua* hand'."[37] Max Ernst quoted this statement in his essay "Comment on force l'inspiration." The image of a severed hand may be taken as an emblem for collage, for estrangement, for the tearing of things from their usual context to lend them a new manner of visibility. Thus the hand can be interpreted in the figurative sense that Breton gives it in his *Introduction au discours sur le peu de réalité:* as the executive organ of poetry, a poetry which would not rest until it had extended its "*main négativiste*" over the entire universe.[38]

36 William Blake. *The Complaint and the Consolation.* Illustration to Edward Young, "Night Thoughts," 1797. Cambridge, Fitzwilliam Museum.

37 Max Klinger. *A Glove.* Opus VI, Leaf 6, 1881.

38 Giorgio de Chirico. *Le chant d'amour.* 1914. New York, The Museum of Modern Art.

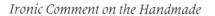

Ironic Comment on the Handmade

Yet a further meaning of this ever-present hand, written large throughout the Loplop suite, remains to be mentioned. It is closely related to the theoretical considerations which Max Ernst noted in his essay in connection with his self-depiction as an artist. The significance is this: in his collages, Max Ernst constantly points up the question of the handmade. Recall the games of hide-and-seek he plays with the spectator. The methods he used and the titles he inscribed on his works of the Dada period were designed not only to mislead but to make fun of the public's expectations. (It should be remembered that these works had no market value at the time.) It was Aragon, in his *La peinture au défi* of 1930, who pointed out the aggressive attack that collage mounted on traditional connoisseurship. The poverty of the means used and the reproducibility of the results would put collectors off, Aragon said, con-

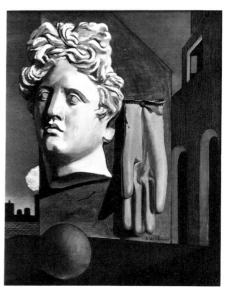

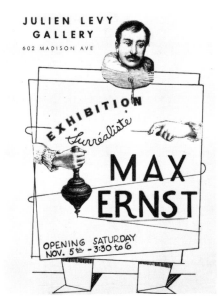

39 Invitation to Max Ernst's first exhibition at the Julien Levy Gallery, New York, 1932.

demning the aesthetic stylization which had so angered him at the Art Déco exhibition in Paris. Aragon's wrath culminated in the statement that this "*style du café du Dôme*" found its decorative appendage in the work of Brancusi and Miró. He then added:

> Painting's going soft, flattering the man of taste who pays for it. It's a luxury. Paintings are baubles. And here lies a chance for artists to shake off the collar of money. Collages are poor. They will be denied any value for a long time to come. They are said to be absolutely reproducible. Everybody thinks he can do them just as well.[39]

Among the Loplop collages is one that well illustrates this condemnation of the handmade objet d'art. It was executed in 1932 as an invitation for Max Ernst's first show in the United States, at the Julien Levy gallery in New York. On a simplified, geometric Loplop body a head is perched; hands appear to the right and left. The right hand holds a top; the left hand holds the string that is pulled to spin the top. These stand for the tools of Loplop, the artist's trade. A few lines have been traced by this implement, geometrically regular paths created by its oscillations. There is no clearer statement of Max Ernst's negative view of handwork. Over against the one-off original he sets his indirect methods. This appearance of mathematically describable paths which take the place of freehand lines is highly significant since it heralds the dripping technique of the early 1940s. In this method, which Max Ernst worked out while in the United States, he filled empty cans with paint and swung them over a canvas laid out horizontally. The paint dripped onto the canvas from a small hole in the bottom of the can.[40]

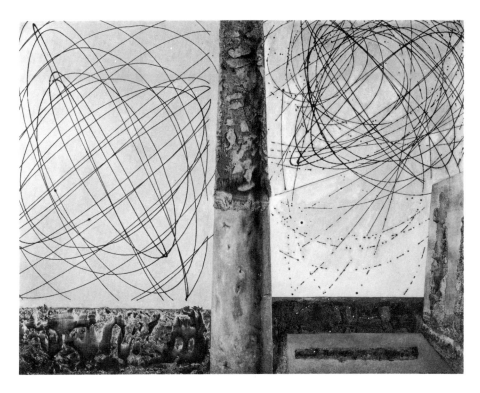

40 Max Ernst, *The bewildered planet*, 1942. Tel Aviv Museum, Tel Aviv

During the years of his involvement with the Loplop collages Max Ernst studied the writings of Leonardo da Vinci. There is a statement in Leonardo's *Codex Atlanticus* that applies very well to his admirer's working tactics: "L'ordinare è opera signorile, l'operare è atto servile." This is precisely what Loplop the conductor, the magician, the master of ceremonies demonstrates in the collages—that Max Ernst limited himself largely to this very "ordinare."

Loplop's schematic hands were surely intended as ironic comments on handmade artifacts, seeing that Max Ernst himself largely waived invention in favor of quoting the inventions of others. Compiling and combining took the place of spontaneity. Loplop's gestures are gestures of introduction, of showing; he presents each image like a card in a continuing game. (It is no accident that in one of the last pictures of the suite actual playing cards were employed.) This is one explanation for the fact that in a cycle so devoted to self-representation, Loplop should nowhere be shown at work in his studio. Neither should it be forgotten that at the time he began this allegory with easel, Max Ernst himself had almost no use for an easel in his studio any more.[41] His grattages were made on some flat surface, a table usually, and the canvas, rather than being mounted on stretchers, was draped loosely over the objects he wished to take rubbings of. Not until the 1940s was Loplop surprised in his studio: in a painting entitled *Le Surréalisme et la Peinture.*

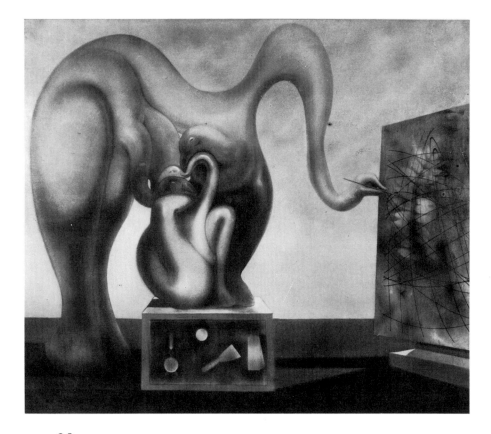

41 Max Ernst. *Le Surréalisme et la Peinture.* 1942. Houston, Texas, Menil Foundation.

Loplop présente, Loplop introduces or presents, is a title that turns up frequently in this series of works. The gesture it describes is one of objectifying, of making material. The artist shows pictures within pictures; the elements are presented singly and they challenge the observer, who perceives them separately, to adopt a kind of simultaneous vision. This effect arises because here for the first time collages have been conceived *as collages.* These are collages which consciously make use of the gap between both different levels of meaning and different materials. The structure of the Loplop collages introduces, highly conspicuously, the quality of isolation into the medium of collage.

In the earlier collages, the overpainted prints, and the plates for *La femme 100 têtes* and for *Rêve d'une petite fille qui voulut entrer au Carmel,* the various elements had been seamlessly merged, and gaps and empty spaces avoided. No breaks occurred within the composition that the observer might be inclined to read as disturbances in the homogeneity of the image. The plane of illusion was held to tenaciously; the most diverse original media had been leveled to conform to that plane. Now, with Loplop, these media began to speak out with their own voice, as if the strict censorship prompted by the desire for a homogeneous image had been lifted. And not having before him a transitionless, plausible image the observer was now able (putting the case positively now) to experience the material and structural richness in which these works abound. This sensuousness of surface relates back to Max Ernst's own work in another medium, the grattage paintings in heavy impasto which he had begun making a few years earlier. It also relates to something which by then had become central to Surrealism—the object.

Max Ernst's involvement with the papiers collés of Picasso and Braque suggested lines of approach to him, and not only as regards formal composition but as regards a polyphonic variety of the elements of composition. In an essay written in 1921, "Le papier collé ou le proverbe en peinture," Tristan Tzara pointed out the material variety to be found in Cubist work in pasted paper:

> A shape cut out of a newspaper and worked into a drawing or painting incorporates a home truth, a slice of everyday reality that compared to the other reality constructed by the mind is common knowledge. The contrast of materials, which the eye transforms into tactile sensation, lends a new depth to the image.[42]

In the Loplop suite this richness of material contrast reaches an apex. Indeed, in some of the collages Max Ernst pulled all the stops at his disposal. *Loplop présente* (plate 20) uses drawing (Loplop's head), hands cut out of paper, frottage, photography, marbled endpaper, marble patterning imitated by grattage, and paper butterflies (gouache on paper). In *Le facteur Cheval* (plate 17) we are confronted by a similar abundance

31

of methods and materials. Frottage is not among them this time, but the image is compensated by postcards and a cellophane-windowed envelope. This mixing of media—drawing, collage, frottage, grattage, photography, even bas relief—activates vision, challenges the eye to follow the artist's sleight of hand and discover how the trick is done.

The object-nature of these works is tied up with something which has already been mentioned in various contexts, namely that with this suite Max Ernst created his first collages that were not meant for reproduction. All the tactile values of his materials, the different hues of the paper, the very substance of the elements, could come to the fore, and even such materials and visual quotations could be used which previously he had had to shy away from. Up to that point, the requirements of printing by an inexpensive method like line etching precluded the use of materials and images that were in any way painterly, that had a rich scale of tonal values. Now, however, color missing in the tableaux of the collage-novels could be employed without qualms, and in a starring role. If the collages designed for reproduction had succeeded by their very limitation to easily combined material, with the Loplop suite we enter the dazzling realm of mixed media. The basic elements could not be more disparate—it is Loplop's job to integrate them. And Max Ernst made some of this pasted-in material himself, for the first time in any collage of his; another feat of prestidigitation for us to unravel, since Cubist papiers collés have accustomed us to assuming that every scrap of paper the artist adds to his composition must stem from some outside context.

44 Max Ernst. *Le cygne est bien paisible . . .* 1920. New York, Mrs. Alfred H. Barr, Jr. (S/M 396)

45 Max Ernst. *Paul and Gala Eluard.* 1926. Present location unknown. (S/M 1063)

46 Max Ernst. *Le chasseur.* 1926−27. Brussels, Max Janlet (S/M 1084)

47 Max Ernst. *L'armée céleste.* 1925. Pratteln at Basel, Maja Sacher. (S/M 1031)

48 Max Ernst. *Monument aux oiseaux.* 1927. Fontainebleau, Natalie de Noailles. (S/M 1216)

Veristic Pictorial Syntax: Loplop as ''Reflective Figure''

It is clear that the effect of the Loplop collages is based on a confrontation with the images which Loplop shows us. Pictures stand side by side, are compared, weighed against one another. In the late 1920s we

42 René Magritte. *Le musée d'une nuit.* 1927. Rhode-St-Genèse, Belgium, Marcel Mabille.

43 Salvador Dali. *Les plaisirs illuminés.* 1929. New York, The Museum of Modern Art.

42

43

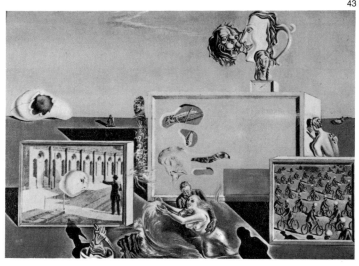

32

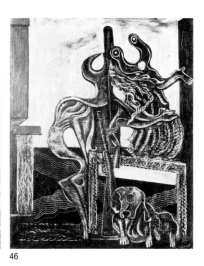

44 45 46

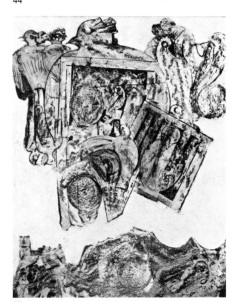

47

48

often come across this kind of accumulation of motifs, in the work of Magritte, say (*Le musée d'une nuit, La clef des songes, Au seuil de la liberté*), or in that of Dali (*Les plaisirs illuminés, Les premiers jours du printemps*). The Surrealism of the day was oriented to a veristic pictorial syntax, and the sharp-focus dream images which had once materialized, for a short time in 1920–21, in Max Ernst's collages and paintings grown out of a fascination by de Chirico, now rose to the surface again in this new phase of Surrealism. The mode of presentation was the "picture-within-a-picture." It was a mode that had appeared only sporadically in Max Ernst's earlier work.

In *Le cygne est bien paisible* (fig. 44), for instance, he mounted on a biplane a picture frame from which three little angels peep. Throughout his work of the 1920s there are internal picture frames enclosing motifs and, as in *Feuilleton* (fig. 116), holding them up against an unbounded pictorial space. In the frottage *Paul and Gala Eluard* (fig. 45), too, the portraits are not embedded in a defined space; they are contrasted to that space as drawings, as self-contained works on sheets of drawing paper. The picture-within-a-picture motif begins to crop up in Max Ernst's paintings toward the close of the 1920s, shortly before the Loplops. In *Le chasseur* (fig. 46) and *Gestes sauvages pour le charme* (S/M 1085) a hunter shows off his bag—of framed paintings. The birds flying heavenwards in *L'armée céleste* (fig. 47) carry with them tiny paintings. Interestingly, this motif occurs in a series entitled *Bird Monuments*. The shape of these birds, inflated and tethered like observation balloons, suggests that Max Ernst had glanced at the work of Constantin Brancusi.

Maiastra, Bird in Space, Three Penguins, Chimera—Brancusi treated the subject of birds in countless variations:

> More and more, all ties to the shape of an ideal bird-creature are loosed, in order to concentrate, in a simple form striving upwards into space, the symbol of flight. The resiliency becomes more intense, the sublimation of mass ever more cogent. "My whole life long I have wanted to express the essence of flight".[43]

33

The closeness of motif between *Maiastra,* the Dream Bird, and Loplop is evident. Brancusi's simplification of form is not only echoed in the *Bird Monuments* of Max Ernst; Brancusi's sculptures also had a strong influence on his own work in that medium, which he took up in the early 1930s. Yet there is something else here which concerns Loplop: Looking over the many photographs which Brancusi took of his works in the studio, we very rarely find one of a sculpture in isolation. He preferred to show them in the context of their surroundings, together with other works. Here, too, we might speak of the collector motif which we mentioned as one of Loplop's most salient traits. Among Brancusi's photographs there are a few that deserve singling out—pictures of cast sculptures polished to a mirror finish, whose surfaces reflect the surroundings including other sculptures, which appear distorted as in a convex mirror. *L'armée céleste* transmutes this optical phenomenon into an image, as picture within a picture, of a precursor

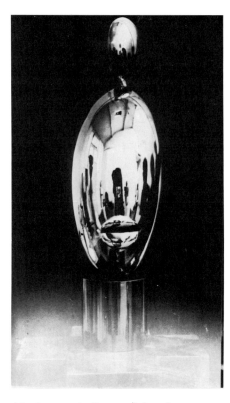

49 Constantin Brancusi. *La négresse blonde.* 1926. Photo Constantin Brancusi.

50 Salvador Dali. *Apparitions aéro-dynamiques des ''Etres-Objets.''* 1935. From *Minotaure.*

51 Max Ernst. *Widow, Husband at her Feet.* 1937—38. Destroyed. (S/M 2295)

50

51

52 Model for Plate 54. ▷

53 Model for Plate 55

54 Max Ernst. *La cour du dragon, Une semaine de bonté,* Leaf 31, 1934. Paris, Private Collection. (S/M 1996)

55 Max Ernst. *La cour du dragon, Une semaine de bonté,* Leaf 32, 1934. Paris, Private Collection. (S/M 1997)

34

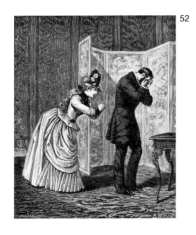

of Loplop—who himself was to become a "figure of reflection" in two different senses.

As far as Loplop's successors are concerned, any number of images might be mentioned that have recourse to his anthropomorphic construction. Examples of this are Dali's illustrations to his text, "Apparitions aérodynamiques des 'Etre-Objets'" and the mannequins which the Surrealists garnished for the *Exposition Internationale du Surréalisme*, held in 1938 at the Beaux-Arts gallery in Paris.[44]

Picture Within Picture as Wish Fulfillment

As a reference in the shape of a visual commentary grafted onto the narrative structure, the picture within a picture still played almost no role to speak of in the collage-novels *La femme 100 têtes* and *Rêve d'une petite fille qui voulut entrer au Carmel.* The associations that arise from the pages of those books were intended to weave an inextricable web of unrelatedness. Every autonomous image is engulfed in general visual contamination. The Loplop sequence brought a definite change, since there the dimensions of space and time were severed. This circumstance and its effects carried over into the later novel in collage, *Une semaine de bonté,* where, as in the Loplop collages, separate pictorial units appeared in additive juxtaposition. And to achieve this Max Ernst again chose the picture-within-a-picture topos, as can be seen particularly in the third and fourth chapters, "La cour du dragon" and "Le rire du coq." The

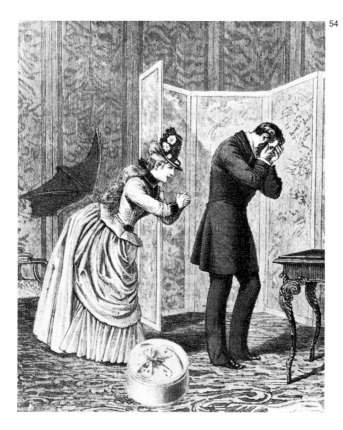

separation and apposition of the information-bearing elements in these chapters make use of a structural order inherent in the original material—the illusionary world of middle-class interiors with their mirrors, oil paintings, and folding screens. What in the original prints was tasteful decor becomes a frame for introspection. Paintings and screens lose their value as decorative foils, symbols of status and proprietorship. In the collages Max Ernst has turned them into peepshows in which we are given to see, in the existences of those who spent their lives in such rooms, a demoniacal aspect.

An example of such a dramatic transformation is found in a pair of images, Nos. 31 and 32, from "La cour du dragon." Here two scenes were used that in the original book had also appeared consecutively. The passionate meeting in the first is expanded to a troubled triangle in the second; and by way of commentary the folding screen, still empty in the first plate, is now inscribed with a broil of organic entanglements. Another pair of images (plates 13 and 14, also in chapter three) demonstrates how these inserts may sometimes anticipate future events—picture within a picture becomes the Writing on the Wall. Since they originated from the same source, the interior images belong both in terms of form and substance to the scenes in which they are now embedded. Thus the image within an image underlines the narrative character of the collage-novels. To the working out of these polyfocal, multiperspective images Loplop contributed unmistakably.

56 Plate of the *Museum Wormianum,* 1655.

57 *The Pomerainian Art Chest.* Formerly Berlin, Kunstgewerbemuseum.

58 Marcel Duchamp. *La Boîte-en-Valise.* 1936–41.

59 Max Ernst. *Vox Angelica.* 1943. New York, Acquavella Galleries, Inc.

Many of the shapes and objects that Loplop introduces in the collages recall those found in scientific publications or in pattern books, encyclopedic registers of forms, objects, skills, compilations of nineteenth-century know-how. This was the context from which Max Ernst drew his raw material. He himself once told of the shock he felt at discovering this superabundance of incongruities, an experience and an insight that opened up for him the possibility of using this new world as a means to fulfill his own wishes ("Transforming them into a drama that fulfills our most secret desires"). We read of his encounter with this descriptive, objective distillation of the world of appearances in his essay, "Comment on force l'inspiration," where he describes how these diagrams of the real may suddenly flip over into irreality, how the explicable and understandable loses itself in enigma:

> In the days when we were especially excited by our research and our first discoveries in the field of collage, we used to come by chance, or what seemed by chance, on (for example) the pages of a catalogue illustrating objects for anatomical or physical demonstrations, and we found that they united such mutually distant figurative elements that the very absurdity of the array called forth in us a hallucinating succession of contradictory images, superimposed on one another with the persistence and rapidity of remembered lovemaking.[45]

Max Ernst built on his meeting with this world of jarring appearances which both repelled him and challenged him to hallucinatory interpretation. Digesting such varied material brought forth work in which, again and again, signs of a pictorial genre appear that is closely tied to the history of man's knowledge of the world and its visualization. The modes of presentation in the Loplop collages call to mind those paintings of *Wunderkammern,* cabinets of curiosities of the Renaissance.

About the time of Loplop's birth the Surrealists had become fascinated by objects. Painters and poets had begun to collect what eventu-

56

57

58

59

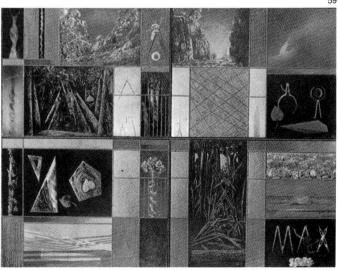

ally amounted almost to Treasures of the Temple. What interested them most from the beginning about these objects was not so much their formal qualities as their fetish character, and thus the collections they amassed over the years soon came to resemble late-Renaissance *Kunstkammern* of the type described by Julius von Schlosser in 1923. Many of the *lusus naturae* and *artificialia* which Loplop spreads out before us recall those agglomerations of strange things in the Ambrase Collection, the Rudolfin *Kunstkammer* in Prague or the Museum Wormianum: cut stones, adder tongues, mandrake root, printing types. The open definition of art propounded by Dada and Surrealism, with its turn to objects, had more in common with the spirit of these chambers of curiosities than it did with later museums. The game of collecting as many and as odd things as possible continued all the way up to Duchamp's *La boîte-en-valise* and Max Ernst's *Vox angelica,* where the chambers' contents were provided by the artists' own lives. The role that boxes, containers, showcases played in Surrealism was tremendously wide-ranging; and it was Duchamp who took it furthest. With his *boîte* he created, probably consciously, an equivalent to one of those seventeenth-century chambers of art. An appropriate description is given by Julius von Schlosser:

> Not less jumbled were the things the Pomeranian Cabinet concealed within. There were astronomical, optical and mathematical instruments; toilet, writing and table articles; craftsman's tools and hunting and fishing gear. Then games of all descriptions and finally even a complete household apothecary . . . all rich in association and artistically arranged, stowed and hidden in a hundred drawers large and small, so that taking them out and putting them back in again was by itself an occupation of many hours, and one which was to be performed according to instructions provided for that purpose; not to mention the secret drawers, well stocked, for of course that era did so highly enjoy reading secrets into things, titillating mysteries, games of Now You See Me, Now You Don't. And all of these objects were tiny, like models. . . .[46]

Such collections of the marvels and monsters of the earth aimed at more than simply registering appearances. By staging contrasts and attempting to render visible things that had never before been seen, their creators were out for dramatic effects. The persons who appear in paintings of curiosity cabinets are surrounded by loud—and calculated —discords. Side by side hang examples of all the painting genres, from historical painting to still life. And the presentation of natural objects, of the Elements, of Temperaments and Senses aims as fully as possible to encompass the universe. Fidelity to nature at that period was not a matter of a realistic attitude, as it was to become for the art of the nineteenth century, which realism drove ever farther into realms apart from nature; before such techniques of reproduction as surveying and photography grew autonomous, the arts had contributed actively to describing the world and making it known. Not until the revolutionary

60 William Blake. *Newton.* 1795. London, Tate Gallery.

61 Giorgio de Chirico. *The Great Metaphysician.* 1917. New York, Museum of Modern Art.

62 Max Ernst. Leaf No. VI from the folio ''*Fiat modes pereat ars.''* 1919. Cologne. (S/L 7)

63 Max Ernst. *Le grand mastodonde,* also: *Loplop présente Paul Eluard.* 1932. New York, Harold Diamond. (S/M 1866)

64 Page from the *Encyclopédie.* Entry ''Dessin''.

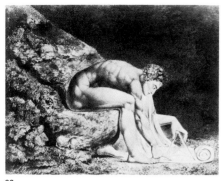

60

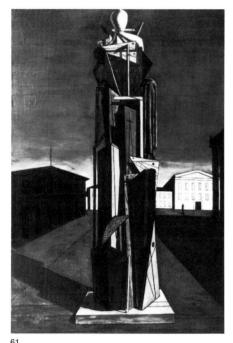

61

62

and all-encompassing visualization of the world which the *Encyclopédie* achieved in its plates, did a rift occur. The work of Chardin, a contemporary of the Encyclopedists, shows how still-life painting withdrew from a portrayal of abundance to the contemplation of essence, an attitude of mind which unprepossessing, mundane objects can do much to foster. The antiworlds sketched by the Romantics, by Lautréamont, Rimbaud, and Baudelaire and which served the Surrealists as their point of departure, were revolts against *explainability*. With de Chirico this escape from positivism took the form of critical melancholy, which in turn was carried over into Surrealism as a lament on the *peu de réalité*. There can be no doubt that in those paintings by de Chirico which still belong to *pittura metafisica* he turned back to the austere, sharply contoured style of the quattrocento because there, thanks to the invention of the laws of perspective and of proportion, the man-centered universe had been founded. And the validity of that notion was precisely what de Chirico questioned. It is striking that in his "metaphysical interiors" he should by preference quote just those tools which figure as the most cogent vehicles of an anthropocentric, rational world: the surveyor's instruments, the painter's easel, maps and anatomical diagrams and architectural sections. There is also a parallel worth mentioning in the work of Blake: his enslaving Urizen. Like Blake's, de Chirico's nostalgia was a revolt against a materialistic view that would mark out the ends of the earth with the compass of science, a tool which Blake, in his depiction of the tormented Newton, turned as no other into an image of damnation and melancholy.

Measurement and Melancholy

Just such harsh geometric figures as emblems of melancholy can be found everywhere in the work of Max Ernst. From about 1919, after his encounter with de Chirico, he began to represent measurement as one of man's most paralyzing skills. Already in the lithographs of the early

63

64

Fiat Modes portfolio we see him commenting ironically on the aids the artist has at his disposal for dealing with reality. References to camera lucida and camera obscura are obvious. Soon dummies and marionettes, pantographs and draftsman's curves began to elbow everything and everybody else off the stage. Again and again he worked this kind of artist's crutch into his collages.

In the Loplop suite his involvement with artists' implements was raised almost to a principle. Again, schemes turn up for calculating the proportions of the human figure. For *Le grand mastodonde* (fig. 63, plate 29) he drew upon a page from the Encyclopedia, from the chapter entitled "Dessin," which contained teaching material of the sort passed down through the generations from the time of Frederik de Wit or Crispyn van de Passe. The back view of a head in *Hommage à une enfant nommée Violette* (plate 31), which varies the motif of the earlier *Eve, la seule qui nous reste* (S/M 823) might have been done after a page from the drawing manual of J. O. Preissler. In another picture of the series too, one that he subjected to a quite complicated graphic retouch, *Facilité* (plate 10), Max Ernst took the seminal image—mother and child (Venus and Amor) and the child's skeleton—from a pattern for studies in proportion. A good number of the Loplop heads, so varied in shape, owe their inception to the use of draftsman's curves in different combinations. Max Ernst also sometimes cut stencils himself to produce still other contours, as we can in see in works as early as 1923 (e.g. *L'ombre* (fig. 65) and *Un homme en peut cacher un autre*, S/M 594).

This obvious interest in templates and patterns and other tricks of the studio is merely one aspect of Max Ernst's continuous interest in questions of art history. On someone who attempted to go beyond painting—"au-delà de la peinture"—by going back to the image making of the dilettante or of the mentally ill, to the art of savages and to the highly sophisticated but nonartistic methods of technical illustration, patterns and aids of this kind must have exerted a great fascination. Once meant to help beginners learn the ropes of art and now discredited and obsolete, in his hands these methods led to new, involuntary effects. In the Loplop suite he continued his critique of the measurable and explainable. What Loplop–Max Ernst borrowed from the scientific inventory of the world he also subtly corrected, playing registration and classification like a game. His answer to the positivistic inventory was the make-believe collection.

In the Loplop collages he presents, with feigned objectiveness, showcases full of unknown butterflies, never-seen Medusalike creatures, entire bestiaries. The genesis of this parallel universe had already been prefigured in the frottages of *Histoire Naturelle*. Some of the natural products exhibited in the Loplop showcases Max Ernst made himself, particularly the butterflies. These may have been meant as an allusion to the "papillons" of the Surrealists, those bright leaflets they distri-

65 Max Ernst. *L'ombre*. Circa 1923. Paris, Aram D. Mouradian. (S/M 593)

40

66 *La décalcomanie des papillons.* From *La Nature*, 1888.

buted all over Paris from their headquarters on Rue de Grenelle. Or he may have been inspired by the butterflies made of postage stamps that turn up so frequently in Paul Eluard's collection of postcards, their bodies and wings cut out of stamps, with feelers and legs added in ink.

How decidedly Max Ernst turned against the classification that kills with his imaginary collections might be illustrated by comparing them to an article he had read in *La Nature* on decalcomania—how to take impressions on paper from real butterflies. This was *trompe-l'œil* with a vengeance.[47] Deceiving the eye, imitating nature—for these the genre of still-life painting provides us probably with the closest references to his work, for there such subtle feints are continually demonstrated. Yet though he used them again and again in the Loplop suite, in his hands these methods evoke the reality of the *unreal*. Indeed the veristic phase of Surrealism, which came into its own at the end of the 1920s, was a style intended to depict not reality so much as pseudorealities—the real element, realism of detail, entered the picture only marginally, and always in mixtures with the improbable. Here an antagonism to nature—as a condition for transcending nature—that can be traced back to Baudelaire's propaganda for the Modern, found its continuation. Baudelaire used frequently to refer to his talks with Delacroix, and among his memories was this: "Nature is nothing but a dictionary, he often repeated. . . . Those who have no imagination copy the dictionary. This results in a very great vice, the vice of banality."

These words describe Max Ernst's point of departure perfectly. The copied and tamed reality he found in catalogues and didactic publications of the nineteenth century served him as his dictionary. In another statement which Baudelaire likewise attributes to Delacroix, that artist describes the mechanism of inspiration that can be triggered by an "incitement" from banal reality:

> The outside world merely provides the artist a chance, repeated again and again, to cultivate this germ; it is nothing but a mass of incoherent materials which invite the artist to associate and put them in order, an *incitamentum,* a trumpet blast to sleeping faculties.

In the Loplop collages, a play with *trompe-l'œil* and artificiality is expressed which can be traced as an underlying principle throughout the œuvre. How deeply this complex and multifarious system of illusion challenged Max Ernst, has been discussed in detail elsewhere. The examples could be multiplied endlessly.

Labyrinth of Illusion and Feigned Illusion

Loplop–Max Ernst, bird and bird-catcher, tempted the spectator deeper and deeper into a labyrinth of illusion and feigned illusion. Louis Aragon, who was the only one of his circle to see through his confounding mixture of takeovers from others and painting and drawing by his own

41

hand, called Max Ernst a "peintre des illusions" as early as 1923.[48] Now when I speak of a web of illusion and feigned illusion in the work of Max Ernst, I refer to the means he used to preserve a state of ambiguity between his own manipulations and the material he took from other sources. His procedure gave rise to tension-packed visual dilemmas. One key to the meaning of Aragon's phrase, "painter of illusions," is found in a work entitled *L'as de pique* of 1924 (fig. 67), in which Max Ernst alludes to the contest between Zeuxis and Parrhasius. There the legend of the painted grapes comes alive again, but with a difference —the tempting grapes are not painted but lifted from a nineteenth-century manual of botany. The illusory painted curtain with which Parrhasius managed to get back at Zeuxis, however, does appear in *L'as de pique,* to the right of the printed grapes.

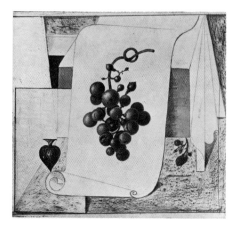

67 Max Ernst. *L'as de pique.* 1924. Paris, Private Collection. (S/M 781)

68 Max Ernst. *Loplop présente.* 1931. Private Collection. (S/M 1767)

69 From *Dictionnaire des sciences médicales,* Paris, 1814.

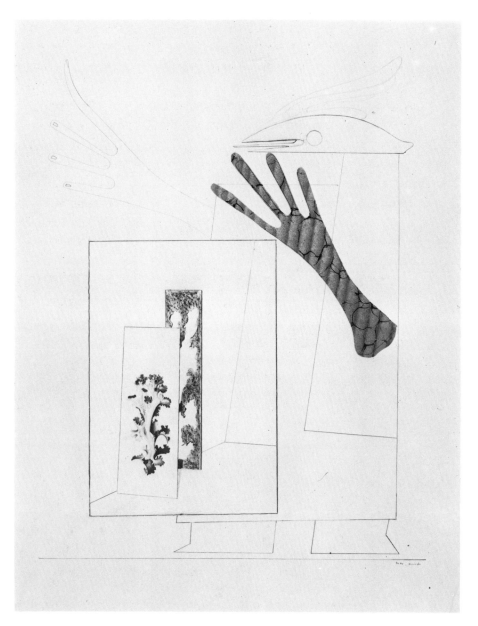

Puzzles and bewilderments of this kind appear throughout the Loplop suite, visual conundrums in which the line between invented and quoted form has been purposely blurred. Take that striking, elongated shape on the left in *Loplop présente* (fig. 68, plate 9), for instance. It certainly looks like an early example of that decalcomania technique which Dominguez, Breton, and finally Max Ernst himself were to use to such good effect in the late 1930s. Yet this apparent "impression" is actually a quotation and an integral part of the image. It is set off and echoed by a shadowy frottage—done by hand. Max Ernst took the motif from a botanical volume entitled *Flore du dictionnaire des sciences médicales*, an illustration of "Lichen d'Islande" or Iceland moss.[49]

He was not of course interested in this plant as a subject, but for the evocative qualities of its shape—a shape that resembles mandrake, the human-looking root of *Mandragora officinalis*, which was included as a talisman in early collections of oddities and natural wonders. The motif—of a form open to interpretation by the artist/observer—belongs in the category of Leonardesque vehicles of inspiration on which Max Ernst's theory of art was partly based. It is conceivable that this mandrake is a sign of his having read *Isabella von Ägypten* by Achim von Arnim, one of the novellas to which André Breton wrote a lengthy introduction when a new edition appeared on the centennial of Arnim's death, in 1931.[50] The proliferating open form in which we recognize an allusion to mandrake, calls to mind another Surrealist totem of death, the "poulpe au regard de soie" (or octopus with the velvet eye) which Max Ernst worked into the collages of his *La femme 100 têtes* and later into *La dame ovale*. It was Breton, in his "Le message

70 Max Ernst. *Suite.* 1929. Preliminary sketches for *La femme 100 têtes.* Fontaine-bleau, Natalie de Noailles.
(S/M 1548)

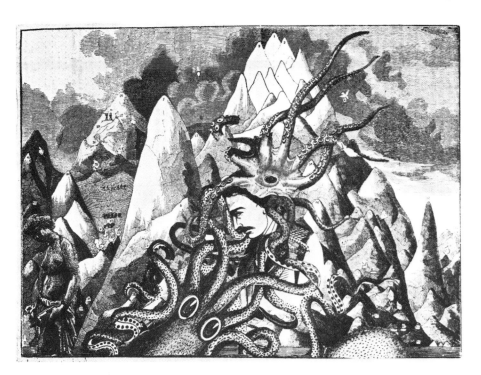

automatique," who pointed out that in drawings made under the influence of mediums, erotically proliferating plant- and animal-like shapes often turned up; and in his "Introduction à la réédition française des *Contes Bizarres*" by Arnim, he devoted much space to the discussions of parapsychology, cabalism, and physics to which Arnim had been deeply drawn by Johann Wilhelm Ritter. This merely as an indication of the wider context, the place in the history of ideas, in which we might see Max Ernst's vegetable extravagances of the 1930s (not to mention Dali's fascination by the "edible" organic forms of Art Nouveau). "Now and then this leads," says Breton,

> in formal terms, even down to the brushstrokes themselves, to a triumph of the equivocal, and in terms of interpretation . . . to a triumph of the complex. This arises not lastly from the fact that, to the point of nausea, the subjects are taken more or less from the vegetable realm. . . .[51]

I have said that Max Ernst toyed with *trompe-l'œil* effects; as a "painter of illusions" he took them through countless variations, and continued to do so in the Loplop collages. Yet he was not really out to create the kind of effect we usually associate with the term *trompe-l'œil*. Visual puzzles that delude the eye are a key constituent of the Surrealist aesthetic. Looking at such images we adjust our visual expectations to the evidence provided, though it be illusionary, and our brain, promptly falling into the trap, is now prepared to accept images for which it can find no equivalent in reality. This amounts to an expansion of vision, an opening out that is due to the "capacité d'irritabilité de l'esprit" which Max Ernst described. The word Jean Cocteau invented, *"trompe-l'esprit,"* very aptly captures this challenge to our perception, and perhaps best elucidates the way in which Max Ernst's surreal illusionism differs from a mere confusion of the eye, from *trompe-l'œil* as an end in itself.[52]

Use of Frottage: Original Narrative Material

Among the Loplop collages there are a number that employ frottage. Here however we must differentiate between those in which frottage is used as one means among many, and those that are pure frottage. These latter ones are much smaller in size than the others, simply because of the small size of the objects from which the rubbings were taken. The style of the frottages that occur within the Loplop context also diverges in significant ways from that of the earlier frottages of *Histoire Naturelle*. Like the collages Max Ernst made for *La femme 100 têtes* and *Rêve d'une petite fille qui voulut entrer au Carmel*, these frottages too are distinguished by veristic, narrative elements. In fact the preciseness of these elements, their sharply defined details, are quite striking. In the frottages of *Histoire Naturelle* the rubbed images, like the textures

73 Unused preliminary sketch for René Crevel, *Mr. Knife and Miss Fork*. 1931. Paris, Private Collection. (S/M 1745)

74 Max Ernst. *Le Portrait*. 1930. USA, Private Collection. (S/M 1714)

71 Max Ernst. . . . *it is two little birds she has closed up in her dress.* 1931. Paris, Private Collection. (S/M 1731)

72 Max Ernst. *What is Death?* 1931. Private Collection. (S/M 1725)

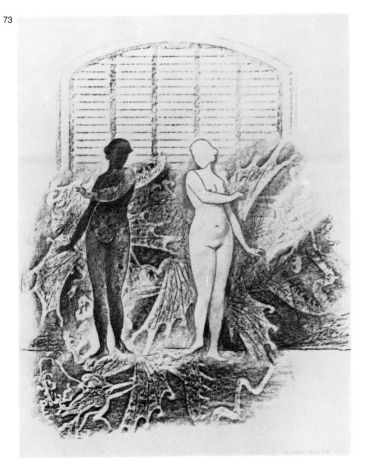

and structures used to produce them, are more "open" than in Loplop. Only rarely do identifiable individual shapes speak out with their own voice, despite the fact that such familiar objects as leaves and shells have been used to produce them—their high-contrast patterns have been integrated into the overall composition. Just as the collages of wood engravings made good use of the standardization of the black and white patterns of the originals to give rise to a harmonious whole, the frottages of *Histoire Naturelle* achieve a perfect integration of the different forms and textures placed beneath the paper. The graphic character of these textures remains ambiguous in terms of content and origin; the final impression rests on the clarity and focus of the whole.

The difference between these earlier frottages and those of the Loplop period is conspicuous. To see how Max Ernst went beyond the technique employed for *Histoire Naturelle,* let us consult *Le portrait* (fig. 74, plate 46). I tend to believe that this composition was among the first depictions of Loplop Max Ernst ever made. Here he still uses a comparatively neutral material to begin with, a material that has high *textural contrasts.* In what follows there is a *mixing and superimposition of forms.* The images grow more complex; the transition from one texture to another more rapid. The execution of the narrative frottages depends on the use of a new kind of material. Superseding the open textures of *Histoire Naturelle,* which were placed in their iconographic context only by being worked over and into one another, we now find textures that often possess, in themselves, a recognizably figurative character. The personages, animals, and objects have been taken from depictions, complete and in relief, made by other hands. For the first time Max Ernst now begins using embossed postcards and bookcovers.

Now though these originals were extremely detailed, their coloring adding to their verisimilitude, the frottage procedure brought about a radical alienation. To make clear why this was so, I selected a few postcards from the context in which Max Ernst had found his originals—Eluard's album—and took rubbings of them. These illustrate very strikingly what was new about the material Max Ernst now began using for his frottages.

Two different effects arise when impressions are taken from cards of this kind, depending on the depth of relief. In the case of cards where the composition is embossed in relatively flat, just tangible relief, the resulting frottage has gradual, barely detectable painterly transitions. The motif appears to be slightly out of focus. With cards into which the motifs have been stamped sharply and are raised high above the surface, the pencil as it glides over the paper reveals a stronger and more sharply defined contrast between positive and negative parts of the depiction. In both cases the tonal values are reversed and an illusion arises of palpability. This seeing-in-relief—one of the most significant approaches Max Ernst gave to Surrealism—was intended: it increased

75 Max Ernst. *Les mœurs des feuilles.* From *Histoire Naturelle,* Leaf 18, 1925. Krefeld, Ernst O. E. Fischer. (S/M 807)

76 Relief Postcard from "Postcard Collection Eluard." Paris, Private Collection.

77 Frottage of Relief Postcard in Plate 76, for elucidation of Max Ernst's technique.

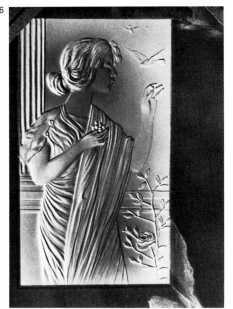

78 *S. Cecilia.* From "Postcard Collection Eluard."

79 Frottage of Relief Postcard in Plate 78, for elucidation of Max Ernst's technique.

the sensuousness of the image. And as in the case of the wood-engraving collages, the intrinsic nature of the original material—conventional patterning there, and conventionally realistic, embossed depiction here—played a not unimportant role. In the transformation to which Max Ernst subjected these prints and postcards and book bindings, their intrinsic character represented an objective resistance that set certain limits to his own creative contribution.

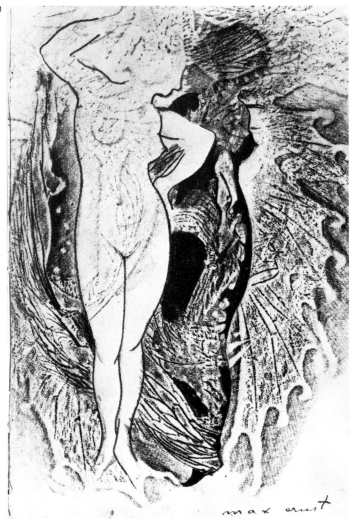

The Erotization of Technique

Not only did his style begin to change at about this time, but thanks to the modified frottage technique of the Loplop period, new themes entered his work as well. The frottages Loplop introduces were made at a time when Max Ernst had begun applying that procedure to fascinating book illustrations. For the English edition of the introductory chapter of René Crevel's novel *Babylone*, originally published in 1927, he made nineteen frottages. From these the Man Ray studio prepared an edition of photograms, by placing each sheet face-down on light-sensitive photograph paper and exposing it 250 times for each image. When the photographs were developed the drawings appeared white on a black ground. (The photographic images were of course also reversed laterally with respect to the original frottages.) Reversal of the tonal values brought about effects very similar to those seen in Blake's etchings for *Jerusalem, The Emanation of the Giant Albion.* In the single-color

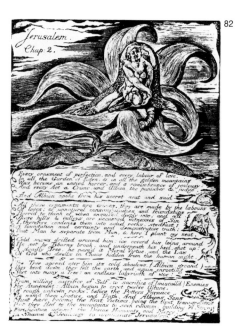

48

80 Max Ernst. *Death is something like Cousin Cynthia.* 1931. Private Collection. (S/M 1727)

81 Max Ernst. *Death is something like Cousin Cynthia.* 1931. (S/L 13)

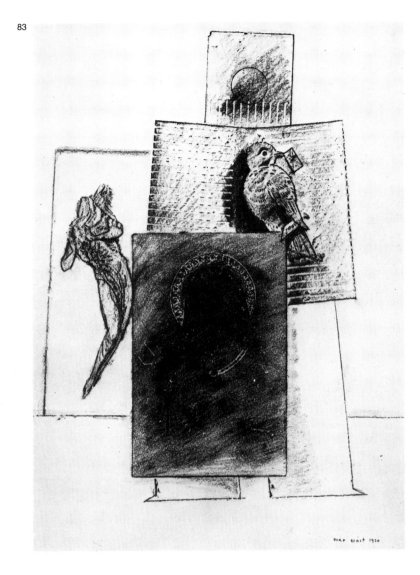

83

82 William Blake. *Jerusalem, The Emanation of the Giant Albion.* 1804. London, British Museum.

83 Max Ernst. *Loplop.* 1930. Paris, Private Collection.

84 Odilon Redon. *Béatrice.* 1897.

prints of Blake's relief etchings there is this illumination *ex negativo* of an imagined world, which is seen again in the illustrations for *Mr. Knife and Miss Fork.* The characteristic lineaments that grow and melt into one another also evoke Blake—substances opening out like fans, nerve systems, veins of some indeterminate matter that intermingle to a boiling magma of form, a sensual brew from which precise forms begin to take shape. Parallels with the work of Odilon Redon likewise suggest themselves. The silhouette that appears in one Loplop frottage is seemingly a quotation of Redon's *Béatrice* (1897).

The obvious stylistic differences between the prints for *Mr. Knife and Miss Fork* and the earlier *Histoire Naturelle* frottages derive in part from their differences in content. Like the texts they illustrate, these later works emanate passion, the obsession with Eros and death into which the young woman narrator of Crevel's *Babylone* projects herself when she sees her bourgeois world collapsing all around her. In a certain

49

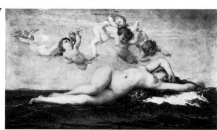

85 Max Ernst. *La puberté proche*
1921. Paris, Private Collection. (S/M 418)

86 Jacopo Tintoretto. *Birth of the Milky
Way.* 1575–1580 (?). London, The
National Gallery.

87 Cabanel. *Birth of Venus.* 1862.

sense the stifling, sultry atmosphere and the girl's passionate attempt to escape it will appear again, two years later, in chapter three of the picture-novel *Une semaine de bonté,* this time in the medium of collage.

Erotic overtones are common in many of the motifs and titles of Max Ernst's early period. Yet the blatantly sexual associations to which he resorted by way of provocation in his early work, were toned down later. Besides the ironic and aggressive innuendoes, we find him giving expression to amazement and fascination. The change in attitude is suggested by the titles of his pictures. One Dada piece for instance bears the lyric title: "Above the clouds passes midnight. Above midnight flies the invisible bird of day. Just above the bird the ether spreads and there walls and roofs float."

A work like *Les pléiades* sounds a completely new and ecstatic tone. It treats a favorite motif of late Surrealism, the motif of transgression and visionary antiworlds. What set off this change in Max Ernst was his meeting with Gala Eluard; the nude figure floating in space in *Les pléiades* is dedicated to her.

The motif came from a photograph of a woman lying on a sofa. By turning the picture ninety degrees and painting over the sofa in shades of blue, Max Ernst suspended the nude figure in the sky—and created a visual pun on the *Birth of the Milky Way* by Tintoretto. He also reckoned

88 Max Ernst. *Le jardin de la France.* 1962.
Paris, Centre Georges Pompidou, Musée
National d'Art Moderne.

89 Odilon Redon. *Birth of Venus.* 1912.
Paris, Private Collection.

50

up, as it were, with the nudes of fashionable salon painting. It is interesting to compare his *Les pléiades* for example, with Bouguereau's *La Naissance de Vénus* of 1863. The consciously critical intent with which Max Ernst painted out the nineteenth century in this image, is underscored best, perhaps, by one of his major works of the 1960s. I am referring to *Le Jardin de la France,* which was based on a copy of *La Naissance de Vénus* by Cabanel. Here Max Ernst painted over the figure of Venus slumbering on the waves, leaving only legs and breasts to emerge from the landscape. And though perhaps a coincidence, he staged this partial rebirth exactly 100 years after the date of Cabanel's composition, 1862. There can be no doubt, however, that all the shell-flowers that blossomed in the late 1920s to spin webs around the intruder like the flowers of Klingsor's enchanted garden, belong to Max Ernst's *Song of Solomon.* His confrontation with Odilon Redon's paintings *The Shell* and *Birth of Venus* (both 1912) may well stand in direct relation to that series of works (both paintings were on view in 1926 at the Redon exhibition at the Musée des Arts Décoratifs in Paris).

Shell-flowers appear frequently in the Loplop collages, among them those in which Loplop introduces his companion. This companion, like Loplop himself, is reduced to a simple formula: a rectangular abbreviation for the body fitted out with a shell-flower or similar floral ornament. The first such frank depiction in Max Ernst's work of the erotic

51

passion which had begun to cast an ever stronger spell on the Surrealists, is found in *La femme 100 têtes* of 1929, which continued that series of mythically experienced rendezvous begun by Breton's *Nadja.* Recall Breton's words in the Second Manifesto: "The problem that woman poses is the most marvellous and difficult in the world."

Eros and Death-drive

Seldom in Surrealism did image and inchoate accompanying text merge to such an evocation of the unity of sex- and death-drive as in the illustrations to *Mr. Knife and Miss Fork*—they are among the most superb the Surrealist song of love ever produced. The attitude to love expressed in these pages is close to that of Georges Bataille or Michel Leiris (who by that time had already left the group). For Bataille the idea of transgression, the crossing of closed frontiers and the breaking of taboos, was to become central. Love as transgression remains tied to the notion of sin and censorship, because transgression, as Bataille put it, lifts the prohibition without eliminating it. In *Mr. Knife and Miss Fork* this is evoked in a phrase which Max Ernst took from Crevel's text and used as a legend to one of the illustrations: *Death is something like Cousin Cynthia* (fig. 80). In this conjunction of darkness with the female nude, which mirrored by its negative is projected into the ineffable, a fascination is expressed that (in the case of Bataille again) can be traced back to de Sade and to his words: "There is no better way to acquaint oneself with death than to connect it with the idea of libertinage."

One can understand these illustrations to *Mr. Knife and Miss Fork*, like the other frottages of the Loplop period that evoked the dark realm, as marking the path of a transgression of life into another, tragic, calcinified state—as expressions of a fascination with the nocturnal. The impenetrable forests and deadly paradises that from now on Max Ernst more and more frequently took as his theme, live from the attraction we all feel for a realm into which none may enter. In this regard there is an evocative phrase in Crevel's book. Speaking of the fatal Medusalike beauty of Cynthia he writes "that she was born in a country that you, you'll never go . . ."

Things that cannot be experienced, things beyond the borderline—we find them increasingly becoming a central motif of Surrealism. Anxiously avoiding the touch of the banal, the Surrealists plunge into escapist ideas and images. Breton comes back again and again to this notion of overleaping the confines. One of his favorite images is passage through a mirror, and he associates it with one of the Surrealists' strongest psychovisual experiences, namely the sentence that appears on the screen to describe Hutter's eerie journey through the Carpathian Mountains to Nosferatu's castle: "When he reached the far side of the bridge, the phantoms came out to meet him."[53] Reversal of

90 Max Ernst. *. . . that she was born in a country that you, you'll never go* 1931. (S/L 13)

91 *Au tournant du petit pont.* Still from Murnau's *Nosferatu.* Plate from André Breton, *Les vases communicants.* 1932.

reality; submersion in an antiworld: what the photograms of the frottages for *Mr. Knife and Miss Fork* evoke, had already been achieved in *Nosferatu*. And Murnau achieved it in that astonishing passage where the traveler descends into a nightmare—Murnau spliced this scene in negative into the copy of his film.

L'Amour fou, the passion that consumes: this plays a leading role in Loplop–Max Ernst's imaginary world. When we read the titles, leaf through the collage-novels, pass his obsessions in review, and read the texts in which he handed us the keys to his œuvre and his working tactics, what opens out before us is a panerotic vision. It proclaims a sensuality that is not out only to possess the object of lust sexually but that, thirsting for knowledge, would establish contact with everything that exists and with the phantasms of what might exist. Much of the writing in the Surrealist publications of the late 1920s and early 1930s is a reckoning up with middle-class and church morality, of course; Max Ernst himself mounted one such attack in his collage-novel, *Rêve d'une petite fille qui voulut entrer au Carmel.* In his contribution to "Enquête sur l'amour" he stated that "there can be no true moral conflict between love and freedom."[54] And two years later in the pamphlet "Danger de pollution" he gave us one of the starkest and most uncompromising statements on the subject of sexual freedom ever formulated by a Surrealist.[55] Here the man who in his paintings and writings, much in contrast to, say, Dali or Bellmer, made only tentative or veiled references to sex, spoke out in the clearest, and sometimes crudest, terms.

Eroticism was one of the Surrealists' most compelling motives for challenging social norms. Any discussion of their work that overlooks the almost magic power of Eros, defuses the movement and censors it. The Surrealists delved into the libido as a path to insight; yet at the same time Surrealist art sublimated Freud's pansexuality—the knowledge of the mechanisms that govern our mental household—reforging the liberating character of Freud's achievement into a means to produce stark images loaded with contrast and contrariness. And these were images that communicated that very "oceanic feeling" which Freud, in his *Civilization and its Discontents,* alleged never himself to have experienced.

If the Loplop sequence is reviewed in all its variety, we eventually come to an observation that serves as a kind of frame for the whole: that within unbounded possibilities of variation Max Ernst set himself bounds. This is the point at which Loplop–Max Ernst exerted his authority, creating order from contingency and setting limits on chance.

Here let me give a few examples to show how a "dictionary of forms" was compiled during the Loplop period. If we start with the material that offered itself to Max Ernst in the shape of embossed postcards and book bindings, we can maintain that as regards these original models, the possible permutations of form and motif seem nearly endless. If he had been intending solely to exploit such material he could have created countless frottages, each different from the next in form

92 Max Ernst. *Loplop présente.* 1930. USA, Private Collection. (S/M 1716)

93 Max Ernst. *Loplop présente.* 1930. Bridgewater, Conn., Private Collection. (S/M 1719)

94 Max Ernst. *But at this moment the apocalyptic beast was death... .* 1931. Paris, Private Collection. (S/M 1730)

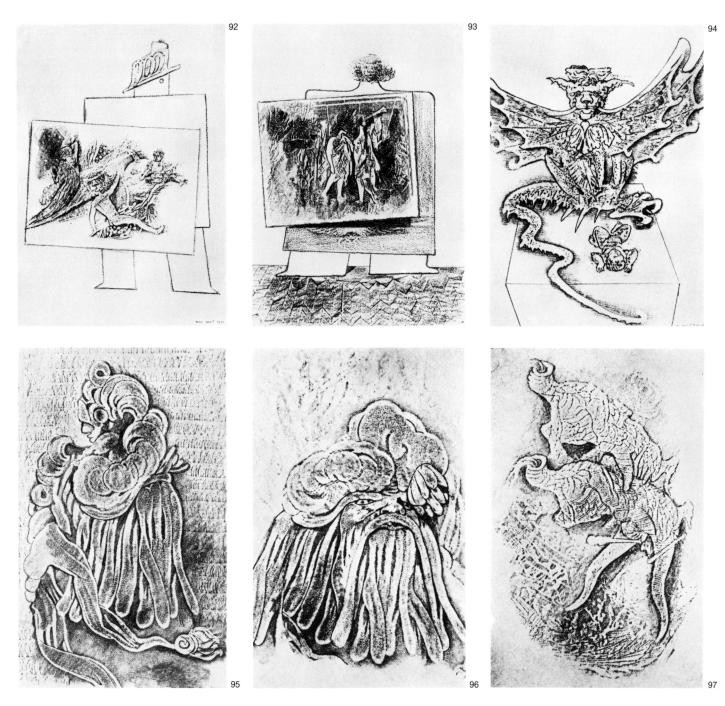

and content. Yet his choice fell on motifs for which his previous work and the series he now began in a sense provided a structural scaffolding. The selection was made, in other words, on the basis of his own œuvre—as a function of memory. Among the frottages he made after 1930, certain parallels to earlier work can be detected, even though they are not at all apparent at first sight. Yet, even when these similarities, as is often the case, remain below the threshold of perception, they nonetheless contribute to a feeling of relatedness.

One underlying principle here is the repeated use of certain basic materials. The lion's head, for instance, that appears as the head of Loplop in *Loplop présente* (fig. 93, plate 51), turns up again in two further works, in *Loplop présente* (fig. 92, plate 48) and, as the head of the apocalyptic beast in *But at this moment the apocalyptic beast was death* ... (fig. 94). The fanned-out shapes in *Loplop présente* (plate 49) confront us again in *Loplop présente* (plate 67), *Loplop présente* (plate 68), and *Illustration rough for the French edition of Franz Kafka's "Beim Bau der chinesischen Mauer—La grande muraille de Chine," Paris, 1937, Frontispiece* (fig. 99). The pear that appears in *Loplop présente* (plate 49), also crops up in the frottage *Unused illustration rough for René Crevel, "Mr. Knife and Miss Fork"* (fig. 103). Cross-references of form and content connect *What is a whore* (fig. 95) with *Pater familias* (fig. 96); *Death is something like Cousin Cynthia* (fig. 111) with ...*preferring above all the fabulous animals*...(S/M 1729) and with *But at this moment the apocalyptic beast was death*... (fig. 94); *Death is something like Cousin Cynthia (fig. 111)* with ...*it is two little birds she has closed up in her dress (fig. 71)*; and the last-named work with...*on handsome postcards...(S/M 1733)*. Reuse of a basic form may also be seen in the two *Loplop présente la Marseillaise* (plates 50 and 53),...*that she was born in a country that you, you'll never go*... (fig. 102) and in the two pieces entitled *Unused illustration rough for René Crevel, "Mr. Knife and Miss Fork"* (figs. 105 and 103), *Forest and sun* (fig. 104), as well as *Untitled* (plate 32).

In one or the other case an image is repeated almost verbatim, for example, a variation of ... *were composed of such high and such preemptory phantoms*...(fig. 97) is given in *Loplop présente* (fig. 98, plate 52). The woman's torso which is seen in the *Unused illustration rough for René Crevel, "Mr. Knife and Miss Fork"* (fig. 103) is tripled in *Unused illustration rough*... (fig. 105), and will appear again years later in *Que tous les petits génies de l'enfance* ... (S/M 2240). In slight variation achieved by interpretative change in the basic form, the same motif likewise appears in *Nude* (S/M 1743) and in *Loplop présente* (plate 68).

To this might be added an observation of such importance that I feel it enables a precise analysis of the materials on which this suite of frottages was based. In *Max Ernst Collagen—Inventar und Widerspruch* I referred to the fact that Max Ernst made a point of drawing his collage material from a largely constant store.

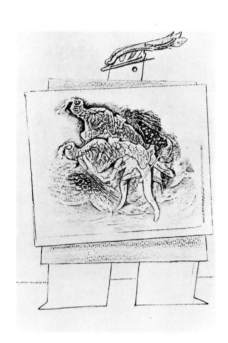

98 Max Ernst. *Loplop présente.* 1930. Present location unknown. (S/M 1722)

95 Max Ernst. *What is a whore?* 1931. Private Collection. (S/M 1726)

96 Max Ernst. *Pater familias.* 1931. Present location unknown. (S/M 1734)

97 Max Ernst. ...*were composed of such high and such preemptory phantoms....* 1931. Present location unknown. (S/M 1738)

A look over his sources, his inventory, while noting the limits set by his "personality that chooses," can help us to characterize Max Ernst's style. The further we follow the growth of his *œuvre*, seeing work by work appear and merge into the continuum, the more each separate work loses its summarizing nature. Seen isolated, each collage though it does not yield to interpretation does have its place in a graspable structure of meaning, a structure that is evoked by repetition of motifs and basic compositions. Disparateness becomes unity; each collage contributes to a whole recognizable as a potential Max Ernst image.[56]

99 Preliminary sketch to the French edition of Kafka's *The Great Wall of China—La grande muraille de Chine*, Paris, 1937. Frontispiece. Paris, Private Collection. (S/M 2294)

100 Max Ernst. *Arrivée des voyageurs.* Preliminary sketch for Paul Eluard and Max Ernst, *Les malheurs des immortels.* 1922. Paris, Galerie Le Bateau Lavoir. (SM 484)

99

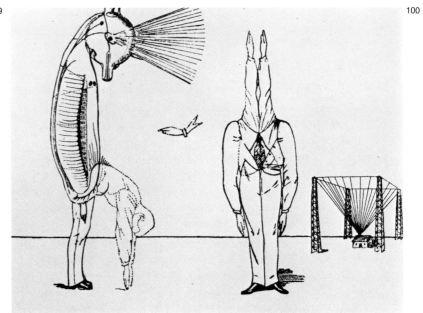
100

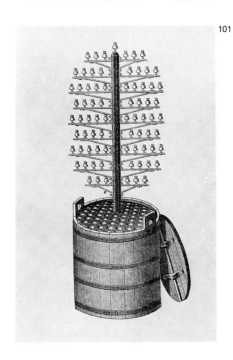
101

102

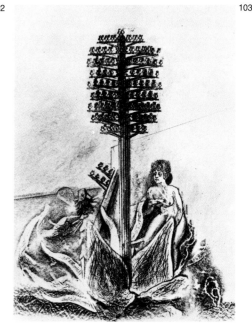
103

104 Max Ernst. *Forest and sun.* 1931. New York. The Museum of Modern Art. (S/M 1747)

105 Max Ernst. Unused preliminary sketch for René Crevel, *Mr. Knife and Miss Fork.* 1931. Bridgewater, Conn., Private Collection. (S/M 1744)

◁ 101 Max Ernst. *No Title.* 1922. Preliminary sketch for Paul Eluard and Max Ernst, *Les malheurs des immortels.* 1922. Present location unknown. (S/M 471)

102 Max Ernst. *. . . that she was born in a country that you, you'll never go* 1931. Paris, Private Collection. (S/M 1728)

103 Max Ernst. Unused preliminary sketch for René Crevel, *Mr. Knife and Miss Fork.* 1931. Hanover, Galerie Dieter Brusberg. (S/M 1746)

This sometimes included motifs taken from collages which he had made years earlier. Now in the Loplop period, he returned over and over again to motifs that he had already employed in 1921–22 for his second cycle of wood-engraving collages, *Les malheurs des immortels.* Apparently he brought out the plates made at the time from those collage-drawings; these plates, being mechanical line engravings, had lines in flat sharp relief which when rubbed, like the embossed postcards, produced clearly defined, graphic contours. The form visible in *Loplop présente* (plate 49), *Loplop présente* (plate 68), and in *Illustration rough for French edition of Franz Kafka's "Beim Bau der chinesischen Mauer—La grande muraille de Chine," Paris, 1937, Frontispiece* (fig. 99) can be traced back, for instance, to the plate from which *Arrivée des voyageurs* (fig. 100) had been printed. The upper portion of that plate, the mast with insulators, is found in the two images entitled *Loplop présente la Marseillaise* (plates 50 and 53), in *. . . that she was born in a country that you, you'll never go . . .* (fig. 102), in both *Unused illustration roughs for René Crevel, "Mr. Knife and Miss Fork"* (figs. 105 and 103), and in *Forest and sun* (fig. 104). In these he often rubbed over the engraved plate several different times, giving rise for instance to the dense forest in *Forest and sun.* Finally, the lower part of the illustration on the title page of *Les malheurs des immortels,* the vessel sprouting insulators, crops up again in *Mr. Knife and Miss Fork.*

In one untitled Loplop (fig. 107, plate 69), a shape has been used to represent the sun which also can be seen in *Les malheurs des immortels.* We find it—mounted as a convex mirror in a depiction of Vanitas—in *Entres les deux pôles de la politesse* (fig. 106). Cross-references of this kind,

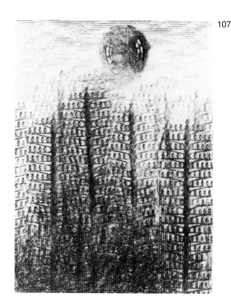

106 Max Ernst. *Entre les deux pôles de la politesse.* 1922. Present location unknown. (S/M 486)

107 Max Ernst. *No Title.* 1932. London, The Mayor Gallery. (S/M 1851)

which Max Ernst inserted like quotations to point the close observer of his work to some of his *leitmotifs,* can be followed up by comparing the images of *La femme 100 têtes* with the Loplop frottages which were executed shortly thereafter. Leafing through that collage-novel we note how often Max Ernst contrasts the white silhouette of a female nude with the densely crosshatched masses of the scenes. This figure hovers through the book like an apparition.[57] *La femme 100/sans têtes,* hundred-headed, headless, headstrong, elusive, vampirelike—all these meanings flicker in the homonym of the French title. This woman is indeed "cut from different wood" than the backgrounds against which she acts. Her figure is classic, its contours melodiously erotic (echoed in Picasso's etchings, made at about the same time, for Balzac's *Le chef-d'œuvre inconnu*)—much in contrast to the stifling detail of her surroundings. Many of these girlish and ephebelike figures stem from a lavishly illustrated nineteenth-century version, in verse, of the Amor and Psyche legend, in which John Flaxman's influence on the pictures is very much in evidence.

Now once again Max Ernst took up this silhouette and its echoes. The silhouette in *Suite* (fig. 108) reverberates, now disrobed to a contour, in . . . *Cynthia, her pearls, her feathers, her miracles . . .* (fig. 109). And the nude in *Perturbation, ma sœur, la femme 100 têtes* (fig. 110) reappears in *Death is something like Cousin Cynthia* (fig. 111), doubled to presence and absence. The rubbed passage in *Loplop présente* (plate 20) likewise goes back to this repeated motif. Max Ernst probably possessed two or more examples of many collage elements, certainly of that which he worked into *Perturbation,* because he pasted a second copy of that element into the landscape which Loplop holds in front of him in *Bonnes vacances* (plate 62).

108 Max Ernst. *Suite.* 1929. Fontainebleau, Natalie de Noailles. (S/M 1442)

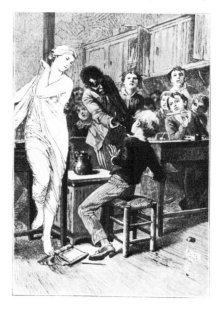

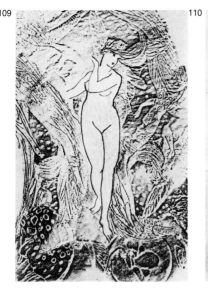

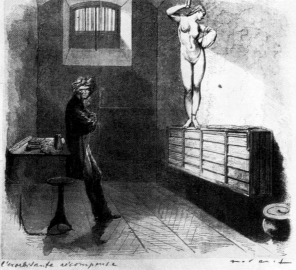

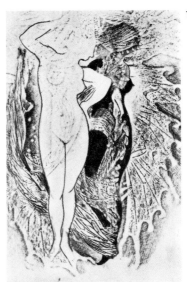

109 Max Ernst.... *Cynthia, her pearls, her feathers, her miracles....* 1931. Present location unknown. (S/M 1742)

110 Max Ernst. *Perturbation ma sœur, la femme 100 têtes.* 1929. Fontainebleau, Natalie de Noailles. (S/M 1451)

111 Max Ernst. *Death is something like Cousin Cynthia.* 1931. Private Collection. (S/M 1727)

112 Max Ernst. For André Breton, *Le château étoilé.* 1936. (S/L 17)

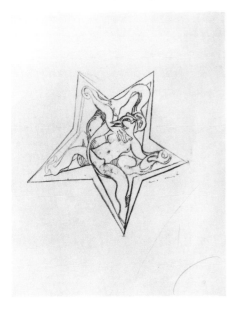

For the silhouettes he borrowed from *La femme 100/sans têtes* he employed, probably for the first time, a procedure that was to become central to his frottage work and particularly to those lithographs on transfer paper, the first of which surfaced toward the end of the 1930s for Paul Eluard's *Chanson complète.* Instead of working with found material he now began to have line engravings made of collages composed of printed material with additions by hand. These he then transferred to paper by rubbing. He used this procedure to make the editions of frottages for *Je sublime* (S/L 16) and *Le château étoilé* (fig. 112). Thus it was that formal parallels and cross-references came to be so frequent during the Loplop period; employed with great subtlety, they helped lend coherence to these diverse works. What also helped was a thorough bass of structure which gave unity to the appearance of the series—that nervous, flickering stroke that calls tissue sections to mind, or proliferating vegetation. Correspondences and visual rhyme-schemes go far toward determining the look of the Loplop sequence as a whole.

In a series of bas reliefs that crop up in the Loplop suite, Loplop lets us in on his methods, even on some of his best-kept studio secrets. These low reliefs, ornaments stamped in thick cardboard, turn up in several collages of the Loplop suite, sometimes partially spray-painted to heighten the illusion of depth. Examples are found in *Loplop présente trois feuilles* (S/M 1707), *Loplop présente des raisins* (fig. 115, plate 2), *Loplop présente* (plate 4), *Loplop présente* (plate 3), *Loplop présente* (fig. 113, plate 7), and *Loplop présente* (plate 26). These elements are simple, schematic ornaments originally used for decorative purposes; Loplop presents them as emblems. Yet we can say that he also quotes them, because they possess a general significance for many for the drawings (in frottage) and the paintings (with grattage) of Max Ernst's œuvre.

The oak leaf in *Loplop présente* (fig. 113, plate 7), before being included as a souvenir or trophy in a representation of Loplop, served as a model for the frottage *Ich bin wie eine Eiche . . .* (fig. 114, plate 6). Apparently Max Ernst had already had such relief elements at his disposal for several years, because the tablet depicting grapes and grape leaves in *Loplop présente des raisins* (fig. 115, plate 2) had already put in an appearance in the grattage *Feuilleton*, (fig. 116), done five or six years earlier. For that picture he had placed the die-cut piece face-down beneath the canvas, giving a mirror image of the contour in *Loplop présente des raisins* when he scratched through the wet red paint with a palette knife, exposing the white of the canvas in those areas that offered resistance

113

114

115

116

113 Max Ernst. *Loplop présente.* 1931. Bridgewater, Conn., Julien Levy. (S/M 1765)

114 Max Ernst. *I am like an oak . . .* 1931. USA, Private Collection. (S/M 1760)

115 Max Ernst. *Loplop présente des raisins.* 1931. Paris, Jean-Yves Mock. (S/M 1762)

116 Max Ernst. *Feuilleton.* 1925. Houston, Texas, Dominique de Menil. (S/M 940)

117 Illustration for Georges Bataille, *Le bas matérialisme et la gnose.* 1930. From *Documents,* no. 1.

118 From *La Révolution Surréaliste,* no. 1, 1925.

to the rubbing. This is of particular interest since *Feuilleton* is one of the earliest examples of the picture-within-a-picture motif which was to become central to the Loplop series.

The use of such convex, relief elements came at a time when Surrealism in general had begun to discover the magic of objects. The reliefs introduced by Loplop can also be connected with an essay by Georges Bataille which appeared during those years in *Documents.* In this essay Bataille discussed imprints taken from the *pierres gnostiques* of the Cabinet des Médailles at the Bibliothèque Nationale. Illustrations of them accompanied his text, which was entitled "Base materialism and gnosis."[58]

Attack on Clichés

A look at the material that appears in the Loplop images has served to reveal some of the means which Max Ernst used in shaping his style. Central among them were repetition and reuse of similar elements. Another contribution was obviously made by decorative, calligraphic cards that may be discovered in eight works: *Du verre* (fig. 24), *Pronostics* (plate 25), *Bon-Mot* (plate 71), *Le grand mastodonde* (fig. 63, plate 29), *Loplop présente Bons-Mots* (plate 70), *La Nature à l'Aurore* (fig. 119), *Le chant du pinson* (plate 30), *Hommage à une enfant nommée Violette* (plate 31). Cards of this type were often printed with homilies for the edification of the young, and Max Ernst took them over unchanged into his Loplop collages. The most important of these, and incidentally the largest in size, was executed in late 1933, and in a certain sense it sums up the suite—*Hommage à une enfant nommée Violette* (plate 31). In this collage he stated his position on an affair that had managed to mobilize the entire Surrealist group. Alongside his *Loplop présente les membres du groupe surréaliste (Au Rendez-vous des Amis 1931)* (plate 72), this is the one work of the Loplop period which refers most directly to a subject that shows his solidarity with the group. The Surrealists had given their support to Violette Nozières, a girl accused of murdering her father. Once before, in the first issue of *La Révolution Surréaliste,* they had printed their portraits grouped around that of Germaine Berton, who had assassinated the leader of Camelots du Roy, a right-wing extremist organization. Max Ernst's homage to Violette Nozières, who testified that her father had seduced her, was based partly on calligraphic cards whose texts—"Love Thy Parents" and "La Violette," a pun on the girl's name and the French word for rape—obviously referred to the case.

An attack on clichés, that is doubtless what the frequency of such texts in the Loplop collages was meant to convey. Challenging conventional language and behavior was of course one of the Surrealists' main occupations. Was not the task of the hour, as Aragon said, "de tourner au bien ce qui a été écrit au mal"?[59] Aragon's essay appeared during

those months in *Le Surréalisme au Service de la Révolution,* and it is worth comparing it to Breton's and Eluard's reversal, in their "Notes de la poésie," of the aphorisms which Paul Valéry had just published.[60] Aragon's omissions show how much in the foreground, even now, the influence of Lautréamont continued to be felt—the Lautréamont of *Chants de Maldoror* rather than the Lautréamont of *Poésies.* The *Chants de Maldoror,* with their recourse to a world of the banal, their vocabulary that in an era imbued with science and technology remained cut off from high literary language, find their partial equivalent in Max Ernst's interest in the recording and classifying images, the visual jargon, of the nineteenth century. By contrast, the reversals of meaning to which Lautréamont in his *Poésies* subjected those books typically awarded to model pupils, such corrections undertaken in the language of the elite, remained limited to literary Surrealism. About the significance of such linguistic distortion Aragon writes: "Thereby we recognize Lautréamont's universe as a universe of difference."[61]

The idea of correction or distortion is related here to the use of a significant, poetically codified language. Aragon's statement should be underlined, since its meaning is crucial to that phase of Surrealism under discussion. The more Surrealism, following the Second Manifesto, began distancing itself from automatic writing, the more central became an involvement with objective models of speech. The verb "to correct" is obviously a key concept here. Breton too, in his "Le message automatique," emphasizes the notion of improving existing speech forms, writing "Correct, correct *yourself,* polish, rewrite, criticize and stop simply delving blindly into the subjective stockpile. . . ."[62] Max Ernst quotes this demand for "correction" in a collage made within the force-field of his *Hommage à une enfant nommée Violette,* namely in *La Nature à l'Aurore* (fig. 119), where we find the words "l'enfant qui se corrige" (the child that disciplines itself). Yet while Eluard, Breton, and Aragon started with the "wingéd words" of poetry which every educated man and woman in France knew by heart, Ernst generally declined to rework the visual equivalents of this literary heritage: he never based his work on reproductions from the realm of fine art.

"Au Rendez-vous des Amis 1931"

Even after the publication of the Second Manifesto, Max Ernst remained a member of the group around Breton. Although he did not care much for group discipline, as his many notes to himself on the subject show, he was aware that his true place was within Surrealism as defined by André Breton. The group meant support; its collective projects gave his own work, experimental as it was, a certain objectiveness. Even though his *Shell-flowers* had brought him first commercial success

at the end of the 1920s, still there was nothing to tempt him into establishing himself as an independent artist. Proximity to literary Surrealism remained a necessary challenge. Twice in his life Max Ernst depicted the group he felt a part of. The first of these group portraits, *Au rendez-vous des amis* (fig. 120), a portrayal of friendship based on the scheme of Raphael's *Disputà,* was executed in 1922, a few months after his move from Cologne to Paris. Then in 1931, in the December issue of *Le Surréalisme au Service de la Révolution,* he gave us a second view of his friends,[63] this time relying for visual coherence on the Loplop scheme.

This portrayal of Loplop introducing the Surrealists bears the title *Au Rendez-vous des Amis 1931.* The reference to the earlier, painted version is conscious; and the inclusion of the date, 1931, points to corrections—omissions from and additions to the group. Unlike the earlier *Rendez-vous,* which pictured among others Raphael, Dostoevski, and de Chirico, there are no references to forerunners or ideal figures. Only seven of the original friends remain; eleven new ones have been added. All of the group members depicted in this collage had contributed to the review *Le Surréalisme au Service de la Révolution.* It is interesting to run down the index to the issues of that publication that had up to then appeared. The group portrait came out in Number 4 (which had appeared simultaneously with Number 3, in 1931). Of those who had worked on Number 1, Max Ernst has left out Albert Valentin, Francis Ponge, Marcel Fourrier, and Jacques Viot; of the contributors to the second issue Maurice Heine, Albert Valentin, Jean Frois-Wittmann, and Marcel Duchamp; and of those who contributed to Number 3, Maurice Heine, Joan Miró, Valentin Hugo, and Clovis Trouille are missing. Yet

119 Max Ernst. *La Nature à l'Aurore.* 1932. Present location unknown. (S/M 1868)

120 Max Ernst. *Au Rendez-vous des Amis.* 1922. Cologne, Museum Ludwig. (S/M 505)

his collection of friends includes all the contributors to Issue 4, in which the collage itself was reproduced.

Most surprising perhaps is the omission of Miró and Duchamp. Apparently the picture mirrors precisely who was taking part in the group activities at the time. Arp and Picasso are missing, too. Arp was not to be represented with a work in the magazine until the last issue, Number 6. Picasso never crops up in the review at all, in contrast to the earlier *La Révolution Surréaliste*. Finally, one might wonder why Magritte has not been included in the group portrait—he too would have to wait until the sixth issue to have a work of his illustrated.

This image is one of a kind within the Loplop suite, being composed almost exclusively of photographic material. In terms of structure it is closer to the photomontages of Berlin Dada or the collages of Alexander Rodchenko than to the other Loplops. (Aragon, by the way, had illustrated his *La peinture au défi* among other things with a work by Rodchenko, his collage *Encore une tasse de thé*.)

There is no second collage in the work of Max Ernst in which he *had* to integrate such a multitude of elements. The group of friends had to appear in full; and to manage this Max Ernst needed portraits that could be built into a composition such that a consistent scale was maintained. Although employing a type of agitation completely alien to him, photomontage, Max Ernst held as closely as he could to the principle of plausible formal integration on which his own photocollages and collages of engravings were based. Hence the size of one portrait head never differs considerably from that of the next; in the one case where only a small portrait was available (that of Buñuel), he made an exception to his principle and included the whole figure in order to achieve a quantitative balance.

Max Ernst affixed to his *Au Rendez-vous des Amis 1931* a text which read:

> From top to bottom, following the serpentine line of the heads: Whistling through his fingers, Yves Tanguy; on the hand, wearing a cap, Aragon; in the bend of the elbow, Giacometti; in front of a woman's portrait, Max Ernst; upright before him, Dali; to his right, Tzara and Péret; in front of the man in chains, his hands in his pockets, Buñuel; then Eluard, lighting his cigarette; above him, Thirion, and to his left, raising his hand, Char; behind the hand closing over Unik, Alexandre; lower down, Man Ray; then, sunk into his shoulders, Breton. On the wall, you see a portrait of Crevel and right at the top, turning his back on us, Georges Sadoul.[64]

Rather than a description, this is simply a list of the group members represented. The woman's portrait behind Max Ernst is that of Gala; another woman's head appears next to Breton. For Breton's portrait Max Ernst used a photograph that had been published in *Nadja*, and in the unidentified woman with her gaze directed upward one might see

121 Photoportrait of André Breton. From André Breton, *Nadja*. 1928.

122 Alexander Rodchenko. *Encore une tasse de thé*. From Louis Aragon, *La peinture au défi*. 1930.

an image of Breton's heroine. The only figure that does not belong to the group but has the character of an attribute, is the man bound in chains. The legend refers him to Buñuel. Next to him we see an array of knives and on the same level but on the opposite side of the picture, an eyeball. These can be taken as a reference to that famous opening scene of *Le Chien andalou*—the razor slicing an eyeball. This motif of poetic cruelty can be traced back to Max Ernst himself—to his Dadaist reflections on the "physical eye" and "inner sight." The legend gives a further clue to the image in that it asks us to read it from top to bottom, following the snaky line formed by the heads. This serpentine works as a structuring factor, and the snake which we inadvertly project into the image—beginning with the head of Tanguy, "whistling through his

123

124

123 Still from Luis Buñuel, *Le chien andalou*. 1929.

124 Max Ernst. *No Title.* Present location unknown. (S/M 438, I)

125 Announcement from *La Révolution Surréaliste*, 1926.

126 Man Ray. *Marie-Berthe Aurenche, Max Ernst, Lee Miller, Man Ray.* 1928.

125

126

65

fingers"—is to be found in a picture entitled *Matin et soir* (plate 35), an extremely simplified painted version of Loplop.[65]

Comparison is invited as well by an advertisement in *La Révolution Surréaliste* that, in the tradition of poetic anagrams, consists of ten names arranged such that the word "Surrealism" appears as a crossword. A famous photograph by Man Ray, taken in 1928, likewise shows a series of heads arranged to form a continuous line. The gestures of the hands and arms—like those which had already played such a striking role in the 1922 *Rendez-vous*—further underscore the serpentine movement. Continuity of line, flexibility, subordination of the parts to the whole: these might serve to characterize the snake as a formal symbol. The motif of temptation and original sin sounds here, and its overtones may be detected in the general disposition of the picture, which calls up associations with fallen angels, or even the Last Judgment. A final topical theme is brought in, at the upper right, by a view of a (revolutionary) crowd, a reference—impossible to overlook—to the political intentions of a "Surrealism in the service of revolution."[66]

Loplop's Theoretical Position

The sequence of Loplop collages cannot be equated simply with a stylistic reorientation in Max Ernst's work; the messages that they were designed to transmit must also be considered. What comes most readily to mind about this construct is that it appeared at a time when the positions of Surrealist art as a whole were being more and more clearly defined.

In the *Dictionnaire abrégé du Surréalisme* of 1938, for instance, the article devoted to Max Ernst says that besides being a painter and a poet he was also a "theoretician of surrealism from the origins of the movement to the present day." Of course his début as a theoretician, as far as texts from his own hand are concerned, did not really occur until the Loplop period. His "Comment on force l'inspiration" ("Inspiration to Order"), an essay written in 1932 as part of a planned and broader "Traité," is highly significant in this regard. In order better to understand his theoretical contribution, a few comments about the role of painting in Surrealism might prove helpful. Max Ernst's "Inspiration to Order" was written, among other reasons, to set two things straight. The first was the misapprehension about Surrealist art under which members of the group themselves labored. Second, his explanations were directed against a complete lack of understanding on the part of outside observers, particularly those advocates of the vanguard who found it hard to digest the significant share the subconscious mind had in the creation of Surrealist imagery. This is the thrust of Max Ernst's famous statement that "needless to say, this has been a great blow to art

critics, who are terrified to see the importance of the 'author' reduced to a minimum and the conception of 'talent' abolished."[67]

Cahiers d'Art, which was more or less the house organ of the Cubists, Picasso, and Matisse, had little space to spare for the art of Surrealism. They quite categorically refused to countenance its importance, a refusal that had as its target literary painting per se. Any painting style that depended largely on ideology, in the eyes of Christian Zervos, was simply on the wrong track. Thus the editor of *Cahiers d'Art* could write in a serialized essay of 1930 on the role of the object in recent painting:

> Picasso never lies in ambush for the extravagant apparitions that beset us as much by day as they do in our dreams and whose ambiguity can remain hidden only to those who have lost all sense of the coordinated nature of things. Even on the borderline of the unknown, Picasso is aware that we possess no ability whatsoever to put before our eyes what is not contained in objects themselves, nor to take objects as the cause of fantastic visions. In this he differs from all those who, following his example, would draw on the resources of the imagination but who, entangling themselves in the incoherence of dreams, fix arbitrary images on canvas.[68]

Tériade too, at the time still coeditor of the journal, expressly condemned Surrealism the same year. And in his essay, "Une nouvelle heure des peintres," he congratulated André Masson on having given up Surrealism and returned to geometric Cubist composition.[69] This reference to the saving order of geometry on which Cubism built, did not remain without its effect, as we have seen, on the Loplop series.

Max Ernst's encounter with Cubist papiers collés at Galerie Goemans fell in the same year as Zervos's and Tériade's sharp put-downs of Surrealism. At bottom their journal's untiring attempts to play off Picasso's "qualités plastiques" against the diffuse reveries in paint of the Surrealists has prevented to this day any serious comparison between Surrealist art and the work of Picasso. The attempt completely to dissociate Picasso from Surrealism reminds one of the assertion that before finishing his *Les Demoiselles d'Avignon,* Picasso had no knowledge of African sculpture. The biomorphism and distortion of contour that in 1925 (with *La Danse*) began to compete so spectacularly in Picasso's work with cool neoclassic outline, cannot of course be explained merely by referring to the "ecstatic moment" which Breton so emphasized in his First Manifesto. Picasso's convulsive figuration has its own history, a history of coming to grips with the autonomy of line achieved by Matisse. And this autonomous line, which Kandinsky discovered when he came to Paris, led through *Composition IV* and *Picture with White Forms* to Arp and his biomorphic configurations, which in turn were suffused in the work of Miró, Tanguy, and Dali.

Even though it is largely true of the period to which Zervos and Tériade refer that Picasso's work did not partake of the alogic of Surreal-

ist imagery, it is just as true that here already certain experiences of conflict—Olga's hysteria and the by contrast so soothing plantlike quietism of Marie-Thérèse Walter—played a very crucial role in the dualism of distortion and calm that informed his work. This precipitated, toward the close of the 1920s, one of the harshest and most impassioned debates the Surrealists ever had, exemplified by their questionnaire, "What hope do you place in love?"[70] Yet by the 1930s, no one could overlook Picasso's proximity to Surrealism, a closeness of theme expressed so poignantly in his syncretistic and autobiographical reinterpretation of the myth of the Minotaur. His monumental print *Minotauromachie* of 1935, his design for a curtain for Romain Rolland's *Le 14 juillet* of 1936, or his *Minotaur, Horse and Bird* of the same year, all partook of the same inexplicable and libidinal realm in which Max Ernst's visions of *Une semaine de bonté* have their domain.

The Legitimacy of Surrealist Art

What was more decisive for Max Ernst, however, back in the mid-1920s, was the attack on Surrealist painting mounted from among the ranks of the group itself. In his "Inspiration to Order" he belatedly entered a dispute that must have touched him deeply. The question as to the legitimacy and the look of Surrealist visual art had been in the air from the beginning; the answers had been mostly skeptical. Particularly vehement was an attack heard from Pierre Naville. In the third issue of *La Révolution Surréaliste* of April 1925, Naville had written under the heading "Les Beaux-Arts": "Everybody knows that there can be no such thing as *surrealist painting.* Neither pencil strokes made by random gesture nor images that reconstruct the outlines of a dream or an imaginative fantasy can qualify for that appellation."[71] This statement, which amounts to a ban on Surrealist painting, was quoted and requoted, and it surely must have had a traumatic effect on Max Ernst. It may even have put him on the track of that indirect technique, frottage, which he began to work out only a few weeks later. And as much as seven years later, writing his "Traité de peinture surréaliste," he was to return again to Naville's rankling words. André Breton at first held himself out of the dispute, not attempting to justify the place of painters within the movement until much later. What he did eventually say vindicated Max Ernst in particular:

> In early 1925, several months after the publication of the *Manifesto of Surrealism* and several years after the first surrealist texts had appeared (*Les Champs magnétiques* began running in *Littérature* in 1919), we were still discussing whether painting could satisfy surrealist intentions. Some denied that surrealist painting could exist at all; others inclined to think that potentially it was there in certain recent works or that it

128

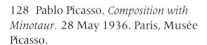
127 Max Ernst. *Le lion de Belfort, Une semaine de bonté*, Leaf 21. 1924. Paris, Private Collection. (S/M 1934)

128 Pablo Picasso. *Composition with Minotaur*. 28 May 1936. Paris, Musée Picasso.

actually existed already. Regardless of what it might have owed, at that point, in the way of dreams to de Chirico or in the way of acceptance of risk to Duchamp or to Arp, or to Man Ray for his X-ray-like photographs or to Klee for his (partial) automatism, it is plain to see at this distance in time that it had already emerged, full blown, in the work of Max Ernst. Indeed, surrealism had found immediate confirmation in his *collages* of 1920, in which a totally new apprehension of the visible orders had crystallized. . . .[72]

The Surrealist ''Mother Tongue'' and Painting

Actually, the harsh words of Pierre Naville only recapitulated what Max Morise had already said in the first issue of *La Révolution Surréaliste*, under the same heading, ''Les Beaux-Arts.''[73] Morise was in a position to shore up his argument by references to the First Manifesto, in which Breton, provokingly, had kept his silence on the subject of the role of painters in Surrealism. The footnote in which he named a handful of artists ought not to tempt us into overlooking the fact that, as far as Breton was concerned, examples of true Surrealist activity were to be found almost solely in the field of writing. In the revised opinion quoted above, Breton admits that he had realized only belatedly—''à distance''—that Surrealist painting had already been realized in the work of Max Ernst. If we follow Naville's arguments, taking into account

Breton's initial silence on the question, then we can say that the art of the Surrealist painters was in a sense hindered by the material nature of the medium itself from participating in the development of the movement. The dispute that temporarily split Surrealism was one of paragons. Even when Breton, a few months after the Manifesto came out, again took up the question of painting, it was under the cautious and vacillating title of "Le Surréalisme et la Peinture." Rather than discussing painting as an integral part of Surrealism, he described and weighed the medium as a possibility *contingent on* the Surrealist "mother tongue."

Now what actually were the arguments of the disbelievers in Surrealist painting, of those members of the group Max Ernst felt called upon to answer? Max Morise begins by maintaining that a "plastique surréaliste"—surrealist design—ought to do for painting and photography what "écriture surréaliste" could say it had achieved with respect to literature. And Morise, who like all the writers in Breton's circle had clearly discovered in automatic writing the prime, objective principle of production, then goes on to ask himself where a test can be found for this Surrealist "plastique" that would prove its authenticity. First Morise cites the basic experience which literary Surrealism had hitherto successfully taken as its starting point, namely a reliance on rapidity of transcription, which he says will automatically set off a precipitous rush of imagery. The aim of Surrealism, he continues, is to be recognized solely in the speed of this flow which will lead inexorably to a continual and reciprocal erasure of one image by the next. Naville agrees with this view. The task, he says, is to show up the unreality of a world that is only apparently solidly within our grasp. The best medium to this end is an uncontrolled and uncensored stream of consciousness in which images overlap and dissolve. This dissolution or mutual erasure of images seems to Breton, in the critique of positivism he formulated in the First Manifesto, to be the lever that when applied to language would tear its stereotyped, fixed links apart.

Yet all these are stipulations that still apply only to literature. Their application to painting, if we follow Morise and Naville, had yet to occur. Morise writes:

> It would not seem that a painter has managed yet to render a train of images, because we cannot be satisfied with the procedure of the primitive masters who represented successive scenes on different parts of their canvas.[74]

Opposed to the spontaneity of automatic writing then, which at the time still reigned unchallenged as *the* authentic method of literary Surrealism, stands painting as a medium which, in practice and by its very nature, always remains subject to the drag of mechanical thought. The laws governing the creation of a pictorial work of art, in other words, run counter to any imaginable Surrealist "plastique," the visual equiva-

70

lent of what can be done with language. Spontaneity is a spice that does not stand mixing with paint. In the execution of any painting, memory, which unavoidably censors the image, which tells the artist what is depictable and what is not, has too overwhelming a share. The resistance of the material, which the painter must overcome, is recognized a priori as his handicap. Even the path suggested by André Masson, graphic automatism, developed in analogy to automatic writing, remains in the eyes of Morise too much determined by the retarding and reflecting role the painter's technical means force him to assume.

Automatism: A Digression

Let me here digress a little to explain the meaning for Surrealism of the term "automatism" and the "écriture automatique" or automatic writing derived from it. Knowledge of the methods and insights of psychiatry and psychoanalysis was of prime importance to the development of Surrealism, as becomes obvious when we consider the main concepts that Breton and his circle worked out. The key stipulation of the First Surrealist Manifesto—a reference to "automatisme psychique pur"—goes back to the psychiatric literature of the day, in which a discussion of automatism played a very wide-ranging part. With this as background, the inception and the role of automatism in Surrealist painting becomes clearer. With their "automatic writing" the Surrealists consciously built on what in analyses of psychopathological art was called "graphomania."[75] In the literature that deals with the picture-making of the mentally ill—a literature Breton knew well—there are long and exhaustive discussions of this compulsive need to express oneself in graphic terms.

In the case of André Masson, we can assume that his interest had existential reasons. In 1918, suffering from shell shock, he had been interned for some months in a psychiatric clinic. This traumatic experience must surely have heightened his susceptibility to publications on psychopathological art, and especially graphomania. At all events, this autistic, automatic process was discussed in textbooks of psychiatry to which both Breton and Masson had access. In one such volume, *Les écrits et les dessins dans les maladies mentales et nerveuses* of 1905, the author, Rogues de Fursac, writes: "The hand moves as if guided by outside force and the shapes put themselves down on paper without the intervention of the subject's will."[76] It is also of interest to note that following the publication of Prinzhorn's *The Artistry of the Mentally Ill*, Vinchon concentrated his efforts on just these "scribblings." Certainly one of Breton's aims was to make use of models of this kind for artistic purposes, models that in the France of the day were still largely taboo. Moreover, the formal side of this automatism contradicted everything the French vanguard had yet done by way of attacking aesthetic norms.

129 Hans Prinzhorn. Case 194 from *The Artistry of the Mentally Ill*. 1922.

Fall 194. Abb. 33. Dekorative Kritzelei (Hälfte, Bleistift). 36×2

Here Breton saw his chance to escape history, the determination of art by cultural ideals. "Probably because new artistic effects and curious and provocative experiences brought up exciting problems, Breton risked basing the Surrealist project on a theoretical fiction: a non-existent 'pure psychic automatism'."[77]

Now Max Ernst, in writing his "Traité," again took up the concept of "*écriture automatique.*" He used it to characterize his collages and frottages, since as far as he was concerned these fulfilled the demands made in the First Manifesto. The fact is, however, that Max Ernst never actually practiced that form of automatic drawing which Masson practiced and which was a literal takeover from the field of writing. He always subordinated the "fluency" of his line and movements of his hand to a broader pictorial continuum. Granted, the strings he placed under the canvas to produce evocative traces when he scraped through the wet paint, or the agitation of his *Hordes,* suggest the working of a stream of consciousness, what Breton called the *coulée* of automatic writing. Yet such techniques nonetheless always remained secondary to a complex and premeditated pictorial unity of color and material. The graphic elements never worked independently, as with Masson, like a calligraphic mimesis of handwriting. If Max Ernst thus consciously held back from producing a gestural equivalent of Surrealist verbal transcription, it was very likely because of his deep interest in structure and composition. But in connection with automatic writing there is a further reason that prevented him from attempting to construe that concept for purposes of drawing and painting. This was his knowledge of the "psychic improvisation" of Kandinsky. Max Ernst was quite familiar with this method, for it had once taken him close to Expressionism, a style which, after having informed his early work, he laughed off the stage with Cologne Dada. Basically his rejection of automatic drawing à la Masson involved a repression of an historic forerunner to which he felt all too attracted. His own brand of automatic drawing, frottage and the frottage-based technique of grattage, allowed him to keep his flow of ideas under control.

Dreams and Veristic Dream Images

Now what about the other possibility open to Surrealist painting, namely a recording of dream images in oversharp focus? Here, Giorgio de Chirico might well have provided the model. Yet both Morise and Naville again were skeptical that that path would lead anywhere:

> The encounter of surrealism with dreams does not give us many satisfactory results. Painting and writing are equally capable of recounting a dream. A simple effort of memory can manage that quite easily. This holds for all such apparitions; strange landscapes appeared to de

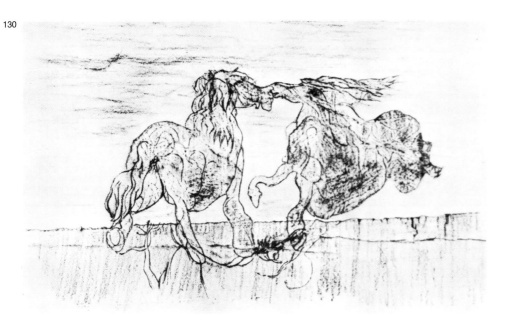

130 Max Ernst. *L'étalon et la fiancée du vent, Histoire Naturelle,* Leaf 33. 1925. Present location unknown. (S/M 822)

131 André Masson. *Dessin automatique.* From *La Révolution Surréaliste,* no. 3, 1924.

Chirico, and all he had to do was to reproduce them, relying on the interpretation furnished by his memory. But this effort at second hand is bound to deform the images by bringing them up to the surface of consciousness—which obviously means that we shall have to look elsewhere for the key to surrealist painting. In any case it is no more certain that a picture by de Chirico can pass for surrealism than the retelling of a dream. . . .[78]

It is good to remember when reading opinions like this that the central Surrealist experience of the time—dreams as a protest against the reality principle—was ideally to take shape in as fluctuating and dematerialized a manner as possible.

No wonder then that in his discussion of de Chirico, Morise should arrive at the following conclusion: "...the images are surrealist but their expression is not."[79] This distinction between vision and realization proved decisive; it was to take all the wind out of the sails of the veristic strain in Surrealist art for a long time to come. Nor was Max Ernst insensitive to this kind of criticism, as the development of his work shows. It is striking how he suddenly discontinued his work in painted collage, which had reached its high point in such pictures as *The Elephant of Celebes, Oedipus Rex, La femme chancelante,* and the cycle of paintings for Paul Eluard at Eubonne. Not until 1929, in the collages for *La femme 100/sans têtes,* was he to return to images with marked veristic and narrative traits.

There can be no doubt that Morise's opinion was more than merely personal. Since he was himself a draftsman whose work appeared in *La Révolution Surréaliste,* we can assume that he honestly tried to pin down a legitimate *plastique surréaliste* in his conversations with Max Ernst. In

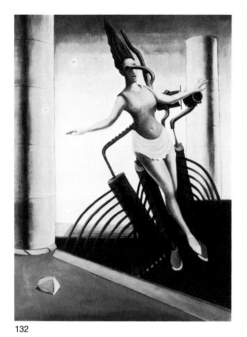

132

133

his essay we find a passage in which Morise attempts to state a general
critique of the means available to the painter:

> Pictorial expression is not in as favorable a position, because while
> vocabulary is an instrument that unites both advantages of being
> almost unlimited and at one's constant disposal, the word identifying
> with the thought, as it were, the strokes of a brush by contrast only
> indirectly transmit mental images and not what these actually repre-
> sent.[80]

This is an interesting objection. However, Morise half takes it back
again later by mentioning the quantification introduced into the picto-
rial continuum by the separate brushstroke. In Cubism, he says, the
accumulation of short, individual brushstrokes leads to an equation of
form-making with thought. Brushstroke, this is to say, equals word:

> But in reality everything points to the direct and simple element of the
> touch of a brush on canvas having an intrinsic meaning, to the equiva-
> lence of pencil stroke with word. In the first Cubist pictures no precon-
> ceived idea imposed a struggle for some portrayal or other; the lines
> organized themselves in the measure of their appearance *by chance*, if
> you will. . . . [81]

And Morise closes this section of his essay with the *mot*: "Painting had
never had more of a chip on its shoulder (en la tête plus près du
bonnet)."[82]

Here Cubism is held up more or less as an ideal, a style which had
succeeded in transforming obstinate matter into something akin to the
flow of thought and language. Now it is striking that precisely during
the months which followed his invention of frottage, Max Ernst should

74

have concerned himself increasingly with Cubist method. He began to work up structures on the painting surface, and many of the paintings done just before and simultaneously with his frottages show the monochromy and faceting typical of Analytic Cubism. His tendency, though, was to standardize the individual brushstroke which Morise had been eager to equate with the word. Put differently, Max Ernst was concerned with speeding up the act of painting by using semiautomatic techniques. Seen in this light, his fascination with structures and patterns which were to assume prime importance for his frottages, was an outgrowth of his confrontation with the materiality and intellectuality of Cubist art.

In sum, it can be said that everything that between 1925 and 1930 challenged Max Ernst to emphasize the medial, to find ways to give his works that cherished spontaneity, the seal of Surrealist quality, was counteracted by a categorical and collective doubt that such a thing as Surrealist *"plastique"* could even exist. Every attempt he made had to face the objection that the materialization of his images forced the painter, much more strongly than any Surrealist writer, to accept the chains of historic norm.

Superimposed Images

In his "Inspiration to Order," Max Ernst revealed that even in 1925, he had tried to work out a pictorial language that would conform to the mechanism of inspiration so touted by Breton. He writes there: "It remains to mention another process to which I resorted under the direct influence of the mechanisms of inspiration described in the *Manifesto of Surrealism.*"[83] What he was aiming at was not improvisation in the manner of Kandinsky, which like automatic writing would merely emphasize rapidity and calligraphic transcription. The equivalent he found, as he would later reveal during the Loplop period, was an inspiration more along the lines of Leonardo, which took the principle of activity/passivity into account. Rather than a harsh, precise style which separated various incompatible levels of meaning by sharp contours, his paintings, following the discovery of frottage, began increasingly to be characterized by superimposed imagery and suggestions of form, inseparably and fluidly interwoven. With these pictures he had finally achieved something that Max Morise, in 1925, had declared well-nigh impossible in Surrealist art—to change and free the stroke of the brush such that the act of painting could give direct expression to the mental process that had set it off.

Mémoire, Erinnerung or *Gedächtnis,* memory and recall: these are among the important concepts in Max Ernst's aesthetic. His entire lifework consists of a play with visual recollections. It was memory that enabled

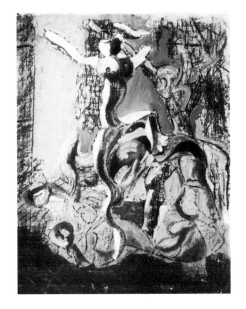

134 Max Ernst. *Facilité.* 1927. Paris, Private Collection. (S/M 1100)

him to choose from the ocean of images at his disposal, those in which he felt the tug of an undercurrent of interrelation. To the open-ended concept of automatism he opposed unchanging patterns of formal and intellectual meaning. That is why the necessity to structure an infinity of associations became for him, at the start of the 1930s, a theoretical challenge.

If we review the literature on Max Ernst up to about the end of the 1920s, we notice how seldom anyone attempted to find out what actually underlay his work. The principles were there, but Paul Eluard, André Breton, and the rest overlooked them. Not until Louis Aragon's remarks in *La peinture au défi* was a precise definition of these constants attempted. There we find mention of the variety of technical procedures that the term "collage" had been stretched to cover in Max Ernst's work; yet even Aragon limits his discussion too one-sidedly to collage in the literal sense.

One remark of his, which was to challenge Max Ernst to reply two years later in "Inspiration to Order," shows how little Aragon recognized the so important procedural side of frottage—its collage nature: "Max Ernst, who found this playing with materials could be fun and could be got by rubbing a pencil across a piece of paper under which a coin had been placed. . . ."[84]

In "Inspiration to Order" Max Ernst points unmistakably to the common origin of collage and frottage: "This procedure, which rests on nothing other than an *intensification of the capacity of the mind to be stimulated*, and which in view of its technical aspect I would call *frottage*, has had perhaps an even larger share in my own development than *collage*, which after all I don't think differs from it basically."[85]

It is worth nothing here that the word frottage appeared for the first time in this essay, years after the creation of *Histoire Naturelle*. This fact reveals much about the theoretical position that Loplop–Max Ernst now took up. If before, such terms as "automatic writing" and "spontaneity" had obscured the mechanical and conscious side of his activity, now he began to differentiate, even to the words he used, between the painter's job and that of the Surrealist writer.

The Encyclopedic Collages

What has been said up to this point about Loplop–Max Ernst has been intended to illustrate this: that with the Loplop collages as well as in the anthropomorphic paintings of the time, Max Ernst outlined his aesthetic position within the Surrealist group. The basic scaffolding of the Loplop figure, draped in ever new variations, allowed him to pass the variety of his techniques and his themes in review. That is why I have suggested the term "encyclopedic collages" to describe these works. Loplop assists in giving comprehensible order to the artist's multifarious

materials and motifs. One might quote by way of comparison something that Christian Zervos said regarding Picasso's adaptability and his continual change of style. Zervos's contemporaries were shocked by his plea for Picasso, which he couched in these memorable words, words that seem to fit Loplop perfectly: "His pictures are like clothes in a closet; he puts on what he likes. The visible world…appears to him as a series of images, and every instant a new form presents itself to his mind."[86]

Yet this statement holds more than a pretty parallel to what Max Ernst presents to us through his alter ego—it is a demonstration of the possibilities of his art. The prevalent accusation against Picasso to which Zervos replied, was one which was made also, and frequently, against Max Ernst. He continually had to field the remark that his work would be fine if only he didn't change his style so often. Only rarely was his search judged so positively as here, by André Breton:

> Guided by an incredible light, Max Ernst was the first to coax the New to appear and, in his early paintings, to enter on the grand adventure: Each painting depends minimally upon the next, the whole follows the same conception as the poems Apollinaire wrote about the War in 1913, each of which amounted to an *event*. With time, as his certainty grew of the deeper significance of his work and of the means he used to create it, Max Ernst still did not abandon the imperious need, like Baudelaire, to continually 'find the New'. His œuvre, of a power that has grown steadily over the past twenty years, is, in terms of that drive, without comparison.[87]

Max Ernst himself commented on this view of his work in his essay, "Die Nacktheit der Frau ist weiser als die Lehre des Philosophen" ("Woman's Nakedness is Wiser than Philosophers' Systems"). He writes there:

> My roamings, my itch, my impatience, my doubts, my beliefs, my hallucinations, my refusals to submit to any discipline including my own, the sporadic visits of *perturbation, ma sœur* [trouble, my sister], *La femme 100 têtes* [the hundred-headed woman] have not created a climate conducive to a serene and smiling life's work. My work is like my behavior—not harmonious in the sense of the classical composers, not even in the sense of the classic revolutionaries. Subversive, uneven and contradictory, to the specialists of art, culture, manners, logic, morals it is unacceptable.[88]

Contemporary parallels can be found for this self-analysis of 1929–1930, the time of one of the most serious crises that ever shook Surrealism. Again a comparison immediately comes to mind with one of Picasso's primary concerns. In 1927 Picasso had begun illustrating Balzac's *Le chef-d'œuvre inconnu*, itself an illustration of the impossibility of artistic realization. And in the early 1930s, concurrent with the Loplop suite, almost all the etchings for Picasso's *Suite Vollard* were

made. Both cycles deal with the psychodrama of artistic creation, both are set in Picasso's studio, and in both we are given a systematic inventory of Picasso's stylistic versatility, his different idioms.[89] Nowhere is his attempt to escape the definitive, fixed image, the ideal pictorial solution, more movingly expressed than in the table of contents to *Le chef-d'œuvre inconnu:* the final plate recapitulates all twelve of the foregoing images—Picasso collects and weighs his possibilities.

There is still another link between Picasso's self-reflection in the studio and Loplop–Max Ernst's so careless yet considered position. Picasso too felt compelled to depict himself indirectly; and he chose a figure that reveals with a certain pathos his difficulties with art and with the people who were close to him. It is not farfetched to see a parallel between the Minotaur he identified with and Max Ernst's Loplop. Picasso's first portrayal of the Minotaur fell on 1 January 1928, a meaningful day.[90] And for his first version of this theme he chose, significantly, the technique of papier collé.

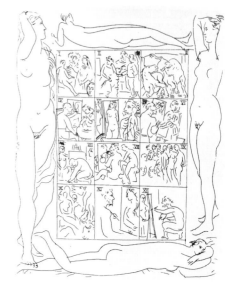

135 Pablo Picasso. Illustration for Honoré de Balzac, *Le chef-d'œuvre inconnu.* 1931.

The Artist in the Third Person

Yet even though we might describe both Loplop and Minotaur as "figures of reflection," they differ in important and conspicuous ways. Picasso's Minotaur, as complex a hybrid of mythology and personal mental state as it may be, still remains within the domain of the Mediterranean sensibility. Loplop, by contrast, takes us closer to northern Romantic models, to Alraun and Golem in Arnim's *Isabella von Ägypten,* or to Spalanzani's creature in *Der Sandmann* by E.T.A. Hoffmann. During the second half of the 1920s, this affinity becomes particularly marked—in the *Horde* pictures and in the *Windsbräuten,* those

136 Pablo Picasso. *Minotaur.* 1 January 1928. Paris, Centre National d'Art et de Culture Georges Pompidou.

137 Max Ernst. *Deux jeunes chimères nues.* 1927. Paris, Aram D. Mouradian. (S/M 1133)

136

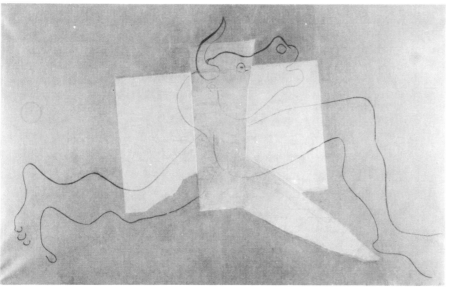

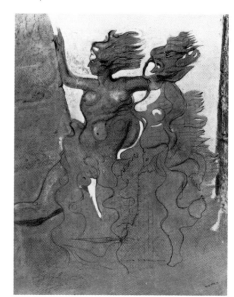

138 Marcel Duchamp. *Fresh Widow.* 1920. New York, The Museum of Modern Art.

whirlwinds which in German are literally "brides of the wind" and which call up images of the *Walpurgisnacht* ("How the wind's brides race through the air"); in the "Deux jeunes chimères nues" (fig. 137), these too a gloss on the *Walpurgisnacht*: "Now I see young witches naked and bare..."; and finally in the hunter who evokes the satanism in the opera, *Der Freischütz.*

With Loplop, Max Ernst created for himself an alter ego, a doppel-gänger, the artist in the third person. In his writings, Max Ernst almost always spoke of himself in the third person singular. His *Notes pour une biographie* make continual use of this impersonal mode. As a means of creating detachment it occurs as early as 1919, in a text he wrote about himself for the journal *Das Junge Rheinland.*[91] A comparable self-description, which maintains a critical distance on complete self-forget-fulness in inspiration, can be found again in the Loplop collages. Their reflexive character has already been noted, and we have seen that Loplop put in his appearance at a time when Max Ernst broke his reserve to formulate his aesthetic and theoretical position within Surre-alism.

Naturally this position was shot through with skepticism to a much greater degree than was Picasso's. With Max Ernst, an ironically critical severance from his "creative personality" amounted almost to princi-ple. How strictly he took this split is perhaps best shown by a compari-son with a third artist who likewise attempted to break out of his imprisoning ego.

He is Marcel Duchamp, and the means he used to bring about self-detachment were radical. His alter ego, Rrose Sélavy, was more than a mere doppelgänger. The seriousness with which he tried to break off relations with himself is revealed by a glance at the first piece he signed with his alias, that window with its "panes" of glossy black leather, *Fresh Widow,* which amounts to a last goodbye, a manner of burial rite for Marcel Duchamp. The artist of that name, one might interpret, has turned over the keys to his "widow," Rrose Sélavy. Hers is the widow's lot—including the administration of the dear departed's œuvre. Artistic suicide—that, basically, is what Duchamp's sarcastic reincarnation amounted to.

Max Ernst never went quite that far. His works and his writings show that though he was troubled by an inhibition as regards things aesthet-ic, he never managed to convert that inhibition into an aesthetic prac-tice.

Loplop as Censoring Superego

He chose a figure of detachment, a figure that in a way always remained cut off from his own self, making it an equivalent to the third person singular to which he subordinated himself in his autobiographical writ-ings. The obvious parallel to this conscious and critical division of self is

to Freud, or rather to the way in which Freud described the structure of personality. Perhaps we can agree to call this figure of Loplop, who so often appears to be an authority who decided what could and could not enter the collages, Max Ernst's superego.

The significance and genesis of the superego are described in *The Ego and the Id* (1923) and most appositely, during the very months in which Loplop first appeared, in *Civilization and its Discontents* (1930). In the latter Freud elucidates the conflict between the demands of society and individual drives. And just such a conflict between the affective, insistent id (the objects, the works, the abundance) and the censoring superego (Loplop's orderliness, his categories of choice, the strict geometry of his own shape) may be detected in this collage suite—or at least can be read into it. In *Civilization and its Discontents* Freud writes: "Hence civilization subdues the dangerous aggressive desires of the individual by weakening them, disarming them and having them watched over by an internal authority, as by the troops in a captured city."[92] In light of this very concrete image of conflict that Freud gives us, Loplop might well figure in the role of the guard who stands watch over his creations. Here the exercise of the artist's authority comes to almost the same thing as an exercise of censorship. Aragon, in his *La peinture au défi* of 1930, found an apt phrase for this: "personnalité de choix." Freudian terminology seems to echo here.

Second Manifesto of Surrealism: The Medium as Higher Authority

Questioning the artist's authority and thus the workings of inspiration —this had become a main preoccupation of Surrealism by the end of the 1920s, and the Loplop collages contributed to it. Max Ernst made them just when Surrealism, in the words of William S. Rubin, had left its "heroic period" behind.[93] In the years between the publication of the First Manifesto and 1929, a painting style had largely dominated the movement which represented an attempt to find a pictorial equivalent for *écriture automatique*. André Masson's linearism had enjoyed Breton's particular favor, for there the relinquishment of readable forms seemed to coincide most nearly with the relinquishment of narrative elements in Surrealist writing. Yet now the linguistic experiments the group had plunged into began to threaten to swallow them up. As early as 1928 Aragon, balking at the notion of a literature without rules, launched a critique of automatically produced texts in his *Traité du style*. Even more than chaos, Aragon feared that Surrealism would be vulgarized. And by 1929, when the Second Manifesto came out, Breton could write: "The undeniably stereotyped look of these texts works in an absolutely prejudicial way against the kind of transformation we had hoped to bring about with their aid."[94]

Not only in the field of Surrealist literature were voices raised against

80

automatism. In the final chapter of his essay series *Le Surréalisme et la Peinture,* Breton had pointed things to say about linear automatism in drawing and painting as well. Initially Breton had welcomed this procedure as an equivalent to automatic writing; now, while devoting by far the longest passages in his essay to Picasso and Max Ernst and expressing his fascination with their work in frankly impassioned terms, Breton has only a few sentences for Masson, whom in that footnote to the First Manifesto he had raised above his contemporaries by a flattering "si près de nous" (so close to us). Moreover, nearly half of the seventy lines dealing with Masson—they come at the very end of the four-part essay—consist of a quotation from Poe's *The Poetic Principle.* In the Second Manifesto of Surrealism Breton comes to speak of what in the meantime has become an almost insulting lack of interest in André Masson:

> The surrealist convictions so loudly advertised by M. Masson have not survived a reading of a book entitled *Surrealism and Painting,* in which the author, quite unimpressed by hierarchies, did not feel obligated, nor perhaps inclined, to prefer him to Picasso, whom M. Masson thinks is a cad, or to Max Ernst, whom he merely accuses of painting less well than himself—I have this information from his own mouth.[95]

Max Ernst, judging by several of the Loplop collages, seems to be carrying forth this attack on automatism with his own weapons.

Calligraphic missives turn up repeatedly in the Loplop collages. What these imply in terms of overcoming stereotypes, those "lieux communes" or home truths that were a Surrealist bugbear, was suggested by the use of such texts in *Hommage à une enfant nommée Violette* (plate 31). Another interpretation offers itself, however, and one which takes into account the criticism leveled at automatic writing as a passive working method. Loplop's presentation of these products seems to be an ironic stab at automatic drawing of the Masson brand. These calligraphic exercises which Max Ernst pastes into his collages, what are they if not samples of those overworked maxims from which the Surrealists wanted to liberate art? They are combined in some of the Loplop collages with demands for payment addressed to the artist. Assuming that Max Ernst did not leave such conjunctions to chance, we can see them as a final reckoning with the overworked concept of automatic writing.

The Role of Automatism

Even though Breton never fully denied the efficacy of automatic writing as a means to outflank convention and control, in the wake of the Second Manifesto the authority of the unconscious definitely dwindled. In place of "thought-dictation" with its forced spontaneity, which thanks to a close imitation of sleeplike or subliminal states was sup-

posed to demonstrate the "true workings of the mind," the Surrealists had begun to practice by the end of the 1920s a more critical and conscious type of writing. The once so vilified narrative structure of the novel with its causal connections now came to serve as a foil for personal biography. A book like Breton's *Nadja* stands for one such attempt to create a narrative style suited to Surrealist method.[96] Max Ernst too participated in this turn to the narrative mode. With his two collage-novels, *La femme 100/sans têtes* of 1929 and *Rêve d'une petite fille qui voulut entrer au Carmel* of 1930, he provided his contribution to the Surrealist involvement with that very medium which Breton, in the First Manifesto, had banned from the Surrealists' sight as a monster of positivism.

The debates that shook Surrealism during those years, and which led some of the most important members of the group to leave it and caused others to be expelled, bear the earmarks of a crisis of authority. This certainly has to do with the fact that the Surrealist program lacked binding force. Though enough principles had been set down in the First Manifesto, neither the common activities nor the individual experiments seemed to bring about the mutual trust and certainty without which no community of interest can exist. The group was further split by their inability to agree on political goals, particularly on the strategy that was to lead to a "révolution surréaliste." It turned out that the principle of automatic writing that proved so useful to the Surrealists in producing their dream transcriptions, did not prove very helpful otherwise. Indeed it goes a long way toward explaining why conflict arose—even had to arise. Breton's point of departure for the First Manifesto, the untapped resources of the subconscious mind, was certainly rooted in his personal history. It was a function of his own psychological studies as well as of the practical medical experience he picked up during the First World War. The underrating of the importance of dreams was an obvious point at which to begin his inquiry. It was the conventional wisdom of the day; even Paul Janet could still call dreaming a state of uncontrolled reverie ("état d'engouement"). Breton's reading of Freud helped him overcome this prejudice, and he soon realized that dreams and other subconscious processes were by no means merely expressions of an inferior level of consciousness. As in the case of others of his generation—not least Max Ernst, who likewise attended lectures on psychiatry—he was spurred to rebel. Now though Max Ernst may have been less interested than Breton in latent dream-thoughts or in the progressive implications of Freud's discoveries than in a poetically experienced autonomy of manifest dream-content, his detailed knowledge of Freud's writings insured that he never lost sight of the mechanisms of psychoanalysis. He would never have set out on a pilgrimage to Freud as Breton did, since he knew that Freud, unlike Breton, did not consider subconscious experience superior to that made in the light of day. For Freud both levels belonged together, insepara-

bly—an insight which Breton appeared only much later to grasp, if *Les vases communicants* is any indication.

By the end of the 1920s at the latest it had become obvious that scientific psychoanalysis, which Breton had hoped to enlist for his cause, stood counter to the fiction that was to have guaranteed the cohesion of his group. No myth like that which Breton had hoped to shape in *Nadja* could be based on any reading of Freud. Freud's realization that dream-images were shaped by the events of one's personal life was simply incompatible with the hope that dream transcriptions could amount to a collective and unifying possession. Not even a superficial and biased reader of Freud could avoid realizing that psychoanalysis negated mythic time: Into the place vacated by universal certainties stepped the individual human being with his unique life history. Since, however, collective certainty and with it group cohesion were givens for Surrealism, Breton had to stay on the lookout for the kinds of experience and security which could not be had from mere personal existence. One of the best paths to the binding, shared evidence he sought were experiences had "à deux"—Breton and Nadja were a pair that felt absolute fortuitousness and pure contingency with the force of revelation. Yet what Breton needed to save Surrealism were collective experiences, "archetypic forms." He never, it seems, turned to C.G. Jung; apparently he was unaware of his writings. Jung's notion of a collective unconscious that transcends the personal would surely have come as a godsend to Breton. To overcome the limitations of individual experience, that was the demand; and as the dilemma of individual versus group grew ever thornier, the search for an authority that would function like some collective superego became more and more important. After a phase of feverish and often disappointing experimentation Breton needed something unmovable to hold on to. And this is where one is tempted to bring in Loplop, the guard and guarantor of unchangingness, whose verdict on the acceptance or rejection of material was final, a concrete answer to Breton's call for authority.

139 The clairvoyant Mme. Sacco. From André Breton, *Nadja*. 1928.

Medium and Surrealist Stigma

What shape did this need for certainty take with Breton? In the Second Manifesto there are references to mediums, people gifted with spiritistic powers. The rhetoric that builds on the idea of a medium is not to be overlooked. Breton uses it as a symbol, to qualify the notion of an absolutely uncontrolled automatism. References to clairvoyants and crystal balls begin to multiply in Breton's writings.[97] The first signs of this change are to be found, again, in *Nadja,* and they are concrete and undeniable. In this text Breton makes us privy to a new experience of self; he describes a state in which mysterious experiences are attributed

to an unfathomable outside authority. He even begins to wonder whether he has a self at all:

> Who am I? To make an exception and quote an old adage: Why indeed isn't the whole thing basically a question of whom I 'haunt'? I admit that that word disturbs me, since it tends to establish very odd relations between myself and certain beings, a more unavoidable and troubling rapport than I should ever have thought. It says much more than it intends; it would have me play the role of a ghost during my lifetime; evidently it alludes to what I should have to cease being in order to become what I am.[98]

What immediately strikes one about this statement is its amalgam of Surrealist *mal du siècle*, a capitulation before the rational means to knowledge, and a search for poetic signs and messages.

Mediums, hallucinations, alchemy—the writings and statements of this period abound with them. In the magazine *Variétés*, at the time allied with Surrealism, there are articles on "Sorcery through the Centuries"[99] and "Superstition,"[100] as well as illustrations of "The Attributes of Sorcery."[101] In the Second Manifesto, Breton underlines the kinship of Surrealist activity with alchemistic operations:

> I should like to call attention to the fact that surrealist researches present a remarkable analogy of purpose to alchemistic researches: the philosopher's stone is nothing other but that which will permit the human imagination bitterly to revenge itself on all things.[102]

Here the Surrealist cult of the object and its doctrine of transubstantiation are announced. Soon pictures, drawings, texts make way for objects—devotional artifacts outside the range of any formal canon. Among the first of such objects produced by the Surrealists is a collection of glass balls, paperweights in which various artists have enclosed samples of their work. In 1926 the newly formed "Editions Surréalistes" advertises their introductory offer in *La Révolution Surréaliste*. The first of their "Collection de Boules de Neige" is by Picasso; more are promised by Man Ray, Tanguy, Malkine, Picasso again, and Arp.[103]

Philosopher's stone, crystal ball, alchemy: these are indications enough that the new objects were to bring revelations far beyond the mere formal or aesthetic. Even Louis Aragon, a more skeptical and analytic mind than Breton, uses the word "magic" to characterize the process of collage. He writes that collage is more closely akin to "opérations de la magie" than to painting.

Ball or sphere shapes appear in countless of Max Ernst's works, from the Cologne period on. They stand for planets, heavenly bodies, for the birth of an absolute mystery, and they materialized out of the artist's interest in astronomical treatises. There is a striking parallel between an image from *Histoire Naturelle, Three Little Tables Circle the Earth*, and the *Vision* of Claude-Nicolas Ledoux which is dedicated to Newton. And just as in one of Ledoux's designs, his *House of the Landkeeper*, a sphere,

84

140

140 André Breton. "Le message automatique." From *Le Minotaure*, no. 3–4, 1933.

141 Max Ernst. *On augmentera par des lessives bouillantes le charme des transports et blessures en silence.* 1929. Fontainebleau, Natalie de Noailles. (S/M 1436)

142 Max Ernst. *Petites tables autour de la terre, Histoire Naturelle,* Leaf 3, 1925. New York, Harry Torczyner. (S/M 792)

143 Claude-Nicolas Ledoux. *Vision.* Circa 1780.

144 Claude-Nicolas Ledoux. *House of the Landkeeper.* Circa 1780.

141

material shape of the sublime, has descended among plowing peasants, a sphere hovers through many landscapes of *La femme 100 têtes*.

In sum, then, to justify confronting images by chance and conjoining mutually incompatible levels of meaning, Breton now brought in the evidence of objective encounters—encounters that belonged, however, to the realm of the mysterious and marvellous. The poetic world of Lautréamont with its pairing of disparate images, experienced abstractly during the first phase of Surrealism, was now to be realized through a new Surrealist practice. The book *Nadja* illustrates this attempt to live the poet's receptive state on a daily basis. To document those inexplicable, acausal associations that tear a sudden gap in the pragmatic experience of one's surroundings, all those encounters which up to then had remained on paper only, Breton gives examples he himself has gone through. In *Nadja* he displays his Surrealist stigmata. He toys with the possibility of revelation. Written in the style of an eyewitness report, *Nadja* becomes a Surrealist tale of salvation. The objective linking of events, by themselves improbable, goes far beyond anything yet seen in terms of Surrealist poetic invention. The key difference is that the encounters experienced with the force of epiphanies

143

ÉLÉVATION DU CIMETIÈRE DE LA VILLE DE CHAUX.

144

145

145 Max Ernst.
Et son globe-fantôme nous retrouvera....
1929. Present location unknown. (S/M 1492)

146 Max Ernst.
Vivant seule sur son globe-fantôme, belle et parée de ses rêves: Perturbation ma sœur.
1929.
Fontainebleau,
Natalie de Noailles.
(S/M 1489)

146

85

in *Nadja* no longer depend on receptivity to "the miraculous"—they just happen.

At the time Breton had been deepening his involvement with the psychic phenomena that Freud had so stringently defined. One indication of this was his interest in such figures as Victorien Sardou and Hélène Smith, in parapsychology, and in the work of Flournoy and F.W.H. Myers. This concern brought him into touch with material which had long ago challenged mainstream psychiatry:

> The diffusion of the productions of Hélène Smith by the Swiss psychiatrist Théodore Flournoy at the turn of the century had played a prime role in this new approach to subconscious 'scribbling'.[104]

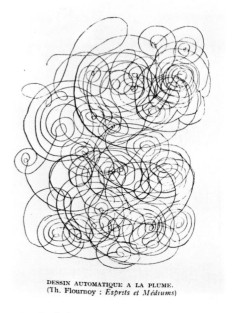

DESSIN AUTOMATIQUE A LA PLUME.
(Th. Flournoy : *Esprits et Médiums*)

147 André Breton. "Le message automatique." From *Le Minotaure*, No. 3–4, 1933.

His researches took him into treacherous waters, as he was quite aware they would. This being the case, we should give very close scrutiny to those passages in his writings which deal with apparently irrational, parapsychological phenomena. There can be no question of Breton's having jumped on the spiritist bandwagon. He was fascinated by the mechanisms the spiritists turned up, and by the rhetoric they used to describe them, but in making use of their approach himself he rarely attributed any transcendental significance to such phenomena. This is particularly clear in *Le message automatique*, where Breton urges that the exogenous principle, which in the spiritistic context is loaded down with "nauseating terminology," be saved for Surrealism. In other words, every spiritistically colored attempt to make contact with the Other World has to be kept separate from the aims of Surrealism. If the express goal of the spiritists is to set up a revealed medium as an exogenous authority, Breton concludes, the Surrealists' task must be to transfer this authority back into one's own finite person.

All these points lead inevitably to one thing, and that is the question of the authority, of the binding nature of Surrealist art for which Loplop is but one symbol. In the phase of the movement when collective experimentation became increasingly emptied of meaning, this question could not help but pose itself in terms of the unique contribution that each artist had to make. This is why the aesthetic question cannot be separated from the struggle for leadership which was raging, more or less openly, within the Surrealist group during those years. The reflexive figure of Loplop, in a sense, represented Max Ernst's answer to the limbo into which, as regards painting, Surrealist theory had obviously descended in the years before 1929–1930. The attacks of Morise and Naville show how negative the discussions of Surrealist art initially were. The artists themselves did not do much to change this. Not even the so articulate Masson came out anywhere in *La Révolution Surréaliste* with even a single sentence of theoretical support for the graphic analogy to "écriture automatique" which he practiced. And Max Ernst for years went out of his way to avoid discussing his techniques.

86

Now, however, came Dali. Not only did Dali throw out his chest as an artist, he struck the attitude of a theoretician concerned to justify his own productions in an autistic, private way. He was able to tie together, to derive causally within his paranoiac system, even his wildest formal inventions. This system encompassed the most heterogeneous things, but group activity, let alone integration in a group, was not among them. Apparently Dali's actionism spurred Max Ernst to formulate his own position, in his "Comment on force l'inspiration" ("Inspiration to Order"). The subtitle he gave to this essay, "Extraits du 'Traité de la peinture surréaliste'," indicates that his remarks were intended to go beyond that portion of them he published. Now, of course Max Ernst would not have decided to make these thoughts public simply because Dali garnished his work in painting with theoretical comment and justification. He probably thought it behooved him to enter the debate because some of Dali's central precepts had guided his own work from the beginning. This was so particularly of the mechanism of inspiration which Dali claimed for his own.

Dali set great store in activity; activity was the prime expression of his simulated madness. Passivity and with it automatism were relegated to the background, denied their rights. Nobody fought them harder than Dali, this late arrival to the movement. The "paranoiac-critical" method which he elucidated for the first time in his text, "La femme visible," proceeds on the certainty that everything a human being can experience can be located within a logically airtight system of reference. This procedure he describes as an active one, in contrast to the passive states conducive to automatic writing. In an article entitled "The Conquest of the Irrational," Dali writes:

> Pure psychic automatism, dreams, experimental dreaming, symbolically functioning surrealist objects, instinctive ideographism . . . seem to us today, in themselves, to be procedures incapable of evolution.[105]

From now on the Surrealists speak more and more, like Dali, of *activité*. Aragon, in his "Le Surréalisme et le devoir révolutionnaire" ("Surrealism and the Revolutionary Task")[106] defines what he calls the "critical activity" of the Surrealists; and Tristan Tzara contrasts in his "Essai sur la situation de la poésie"[107] poetry as an "activity of the spirit" to a poetry of stasis.

On the one hand is the notion of automatic writing, which entails an open, receptive state of mind—an approach no one embodies better than André Masson. On the other hand is Dali with his *activité* which precludes passivity completely. These opposites are brought together by Loplop–Max Ernst when he speaks of "activity/passivity." And we find him bringing them together as early as 1927, in a text which appeared by autumn of that year in *La Révolution Surréaliste*. Significantly he titles

his words, the first he had ever had printed in that journal, "Visions de demi-sommeil" (Visions Between Sleep and Waking).[108] Already in his choice of title he diverged from the passivity that then still predominated among the Surrealists. He was out quite obviously to set against the transcriptions of dreams which filled the columns of the Surrealists' journal the imaginations of a half-sleeping, half-waking state with their intermixture of conscious and free associations. From the beginning, the images that emerged from his subconscious mind had remained subject to correction and interpretation.

Dali's theoretic efforts now impelled Max Ernst to throw some light on his own procedures. This meant that he would have to talk publicly about the collage character of his methods for the first time. Of course, since Aragon had introduced Max Ernst in *La peinture au défi* as a "personality who chooses," he could not well continue to keep the secret of collage fully to himself. The game he played with the spectator, who had been kept in the dark about personal style and borrowings, now became a little fairer. Yet still he reveals no more than a few basic principles. He dissects no image. He avoids the kind of exhaustive subjective interpretation that Dali revels in. Paranoiac leaps, a closed causal system that robs Surrealist imagery of much of its strangeness, are not for him. All he gives his readers are a few scattered hints about the ways he deploys his material. Nor did he ever depart from this principle in later years: he always declined to talk about the sources of his collages and frottages.[109]

Knowledge of the context from which the elements of a collage have been taken remains incidental to the effect of the work. The original meaning of those elements in their pragmatic, illustrative surroundings, is something the final collage obscures. Hence collage-making does not mean adding separate images together to produce a visual sum; rather the process aims at autonomy. Collages are meant to look like genuine, nonderivatory images. And to this can be added a crucial observation: with Max Ernst this desire for total mystification was not relaxed until the Loplop suite. This is borne out by those passages in "Inspiration to Order" where he lets us in on some of his techniques.

Seeing Things Into Images: Max Ernst's Point of Departure

A significant role in that essay is played by a discussion of what have been called multiple or superimposed images. In 1929 or 1930 Dali had announced, as his own discovery, the imagination-provoking quality of textures and superimposed images. This is the point at which Max Ernst begins his explication. Not that he mounts a polemic against Dali; quite the contrary, he quotes him in the course of his remarks in a positive light. Surely there was no great question of priority in Max Ernst's view. What was more important to him than determining who had been there first was to clarify his own position with respect to Dali's.

88

"Inspiration to Order" gives us a very lucid insight into his own working procedures.

The strategy of "seeing things into" other things he names as the point of departure for all of his collages, frottages and paintings. After mentioning the "overpaintings" done in Cologne, he follows up with a second example that is directly related to the phase of his work under discussion here. He writes:

> To take another example, a Second Empire embellishment we had found in a manual of drawing came to display as we considered it a strong propensity to change into a chimera, which had about it something of bird and octopus and man and woman. My own drawing reproduced in this number illustrates this obsession. Here we are seemingly already in touch with what Dali was later to call the "paranoiac image" or "multiple image".[110]

This is a supremely interesting statement. Two aspects of it deserve to be underlined: first, the mention of an original source (the Second Empire pattern book), and second, his words about the transformation such images undergo once one begins to look at them long and with a

149

148 Max Ernst. *Chimaera.* Preliminary illustration for *This Quarter,* Surrealist Number, September 1932.

149 Max Ernst. *Loplop présente chimaera.* 1932. Bridgewater, Conn., Julien Levy. (S/M 1758)

concentration bordering on the obsessional. The results of what he saw into this particular ornament are printed along with the first published version of his essay, an English translation from the original French.[111] The drawing illustrated resembles the later Loplop in many ways.

In the course of his remarks Max Ernst describes the stylized plant-shape which had inspired him. Yet rather than printing that original ornament with his pen-and-ink additions, he printed as frontispiece to "Inspiration to Order" a new drawing that subsumed both original and additions. This is a hint, and the Loplop suite gives an opportunity to find out what it might mean. Though the illustration to his text is a

drawing that prevents us from identifying the changes he made in the original ornament, we can, with a glance around the Loplop gallery, locate the actual print itself. It turns up in *Loplop présente chimaera* (fig. 149, plate 5), the collage into which he pasted his "Second Empire embellishment" with additions in his own hand. This work reveals how his obsessive "seeing into" an image could gradually transform it, even obscure it altogether. The transformations he describes, the blendings of one image into another he lists, all suggest an activity thanks to which Max Ernst was able to lend material form to what initially had been a passive state. To the ornamental lithograph he added head and legs; he also expanded the outer contours of the flourish in a manner completely in keeping with its linear flow. Stale historic ornament became ambiguous creature, fully able to take on before our eyes all the significance Max Ernst attributed to it.

Among the meanings extracted from this stylized plant shape by long contemplation is that of the "pieuvre," the octopus, an animal that was one of the totems of Surrealism. In many depictions of Loplop, particularly the painted ones (for example, *Figure humaine*, fig. 150, plate 41) and *Loplop présente Loplop* (plate 42), the limbs become tentacles that grasp a possession. Here too it turns out that the "find" Max Ernst begins with was actually made within the framework of a definite and traceable formal conception. Hidden behind the reincarnations he notes in his essay are many further references to his œuvre. The *Figure humaine* (plate 43), for instance, is a threatening creature which manages to combine its octopuslike grasp with a play on an image of Blake's, *The Great Red Dragon*, an apocalypic apparition, one of the many such visions and references to the Revelation of Saint John that suffuse the entire œuvre. Max Ernst often sought inspiration in Blake and his syncretistic figures; nor is the name Blake missing in the list of his "Favorite Poets/Painters of the Past."[112] In the first and final images of *La femme 100 têtes* the Complete Man, a figure Max Ernst took from Blake's title page for *The Grave* of 1806, floats up and out of a world constantly threatened by final disaster. And the other obsessional images which arose in the artist's mind as he contemplated that nineteenth-century architectural pattern book, have a similar, symbolic function within the domain of Surrealist imagery. Their meanings cannot be said to have occurred to him by free association alone. They remain within the horizons of expectation set by his own work and that of the other Surrealists. Thus the chimera can be understood as an allegory of the intermediate character of the Surrealist aesthetic. (Machner's automatic drawing, which Breton found in the *Annales des sciences psychiques* of 1908 and reproduced in "Le message automatique," thus making it known to the Surrealists can be interpreted as a half vegetable, half animal chimera and related to certain painted versions of Loplop.) In this context, then, the chimera is none other than

150 Max Ernst. *Figure humaine.* Circa 1930. Philadelphia, Mr. and Mrs. Jack Wolgin. (S/M 1693)

151 William Blake. *The Great Red Dragon and the Woman Clothed with the Sun.* Circa 1806–09. Brooklyn Museum.

90

152 Machner. *Automatic Drawing.* From *Le Minotaure,* 1932.

Loplop, the artist's superego. And this chimera provides the unifying concept from which Max Ernst proceeds when describing the superimposition of images—he says it resembles bird, octopus, man, and woman. Moreover, the drawing that accompanied the English version of his "Comment on force l'inspiration" was entitled *Chimaera.*

I have already spoken in general about the role of this symbolic bird that fades into chimera, pointing out that the bird was one of the guises assumed by Loplop. Now the reference to the oneness of male and female ("à la fois...d'un homme et d'une femme") shows Max Ernst's fascination by the image of the androgyne. Indeed in the wider context of Surrealism, the description by Aristophanes in Plato's *Symposium* of the division of the Complete Human comes up again and again (cf. the legend to the first picture of *La femme 100 têtes*). One of the central themes of Symbolist art lives on here. Albert Béguin, in *Minotaure,* writes under the heading "L'androgyne" that,

> The dream of humankind of being able to escape the incomprehensible duality of their present state is but a form of that grand illusion which for centuries has attempted to create a world view in which all contradictions are resolved and brought into harmony.[113]

Even as late as 1955 Breton could still refer to the necessity of "reconstituting the primordial androgyny."[114]

Decorative plant forms appear frequently in the Loplop collages, usually in black and white. The originals Max Ernst chose for alteration are stylized and generally symmetrical. Only a few of these images are in color, and these came from a different source—botanical illustrations rather than architectural ones. Two of the most spectacular collages in the Loplop series bear only the title *Loplop présente* (fig. 153, plate 28, and fig. 155, plate 27). Their disposition is almost identical: an extremely schematic Loplop, reduced to a few scant lines, holds a flamboyant and richly colored image taken from a compilation entitled *Flore des serres et des jardins* (Ghent, 1847). Though I have emphasized that for Max Ernst the original material had to be aesthetically indifferent and as substantially neutral as possible, it surely would not be wrong in this case to assume that he was fascinated by the beautifully colored lithographs in this volume. The contrast is striking between the rich colors and the grey, graphic elements that emerge from them as from a shadow realm. Just these graphic passages must have invited Max Ernst to read visions into them. If we compare the original illustrations with the interpreted sections of them Loplop shows, it turns out that he drew in limbs, head, breasts, and snake, adapting his line to the style of the halftone elements in the original. The colored passages he did not retouch at all. He merely "set" the polychrome prints in much the same way as earlier collectors had costly gold or silver settings made for some natural wonder, like a nautilus shell. This effect of a curiosity cabinet

153

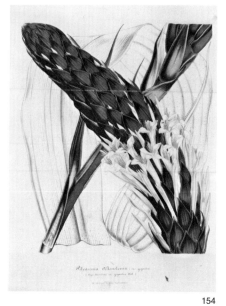

154

153 Max Ernst. *Loplop présente*. 1932. Private Collection. (S/M 1861)

154 From *Flore des serres et des jardins*. Ghent, 1847.

155

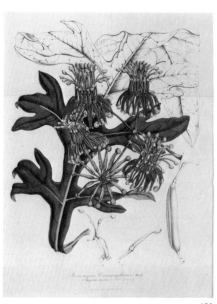

156

155 Max Ernst. *Loplop présente*. 1932. Chicago, Edwin A. Bergman. (S/M 1862)

156 From *Flore des serres et des jardins*. Ghent, 1847.

157 Max Ernst and Marie-Berthe Aurenche. *Loplop-Paradise*. 1931.

could arise because in the Loplop suite each separate collage element was granted autonomy, allowed to speak with its own voice.

Max Ernst himself never explained the associations triggered by these two exceptional colored plates. For interpretation we are thrown back on the visual use he made of them; and this turns out to be quite revealing. In the Loplop collage based on the illustration of *Pitcairnia Altensteinii*, for example, we recognize a paraphrase of the *Charmeuse de Serpents* or *Snake Charmer* by Rousseau (1907, Paris, Jeu de Paume). Woman, snake, and blossom evoke iconographic constellations, calling to mind Eve, Eurydice, or Cleopatra. (An interesting sequel to this is found in the Loplop paradise which Marie-Berthe Aurenche, Max Ernst's wife, conceived together with him at about this time.)

92

158 Henri Rousseau. *La charmeuse de serpents*. 1907. Paris, Musée du Louvre.

And as has already been traced in a series of other works, here too the plurality of meanings which Max Ernst projects into even the simplest decorative pattern is rooted solidly in the image. The tantalizing temptation of female out to capture male is a subject that appears early in Max Ernst's work—witness his involvement with Freud's *Gradiva* text. The motif was later to become one of the myths of Surrealism, and Max Ernst helped shape it with the murals he painted at Paul Eluard's house at Eaubonne.[115]

There is a passage in Breton's "Le château étoilé" that might have been written expressly about these Loplop images with their tempting and poisoned paradises:

> I love you so that I lose myself in the illusion of a window having been cut in a petal of a too opaque or too transparent thorn-apple; I am alone beneath the tree and at a sign which is prolonged so marvellously I shall follow you into the fascinating and fatal flower.[116]

Extensions of a flower shape to figure, to bird, to androgynous being or octopus, can be traced throughout the œuvre. Yet not only in terms of content do we find cross-references; the formal aspect of the print is also worth looking at—the fact of its being a floral arabesque. Max

160 Max Ernst at the execution of a mural for the Corso-Bar, Zurich. In the foreground, E. F. Burckhardt and Hans Curjel. Mural is now in Zurich, Kunsthaus. Photo Binia Bill, Zurich.

159 Max Ernst. *Loplop présente une femme-fleur*. Circa 1934. Destroyed by Max Ernst. (S/M 2135)

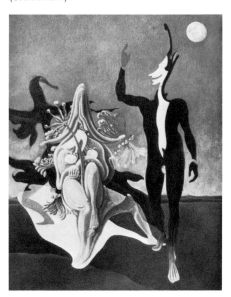

160

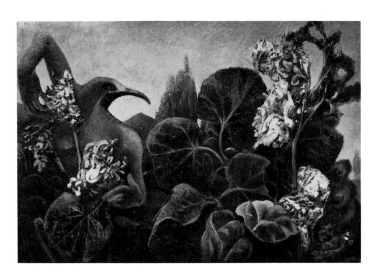

161 Max Ernst. *La nature à l'aurore.* 1936. Frankfurt am Main, Städelsches Kunst-institut. (S/M 2268)

Ernst probably chose this particular example to discuss in "Inspiration to Order" because it is so revealing. Reviewing the Loplop sequence we discover many other such retouched lithographs, and all of the kind that Max Ernst describes. Among these are *C'est la vie—le marchand d'Ucel* (plate 56), *Je t'imagine en présentant une autre* (plate 58), *Le prince consort* (plate 1), and *Loplop présente* (plate 60). Here the original prints served as more than mere points of departure for interpretation; they found their way into many other contexts as well. We have seen that Max Ernst did a pen drawing after the design mentioned in his "Traité"; a number of major paintings of this period can likewise be traced back to retouched patterns of this kind. *Figure humaine,* for instance (fig. 150, plate 41), shows a marked similarity to the image utilized in the Loplop collage *Je t'imagine en présentant une autre* (plate 58). The two Loplop paintings *Loplop présente deux fleurs* (fig. 190) and *Loplop présente Loplop* (plate 42) borrow from the aforementioned collage the fleshy, lobelike limbs. And these in turn are found twelve years later in Loplop's most monstrous progeny, the bird-painter apparition that flaps through *Le Surréalisme et la peinture.* A series of other painted Loplops, *L'homme et la femme* (S/M 1688) *L'homme* (S/M 1689), *Figure anthropomorphe* (S/M 1690), *Two Anthropomorphic Figures* (plate 39), and *Figure humaine* (plate 43) likewise ring changes on forms that may well have originally come from the collection of plates Max Ernst mentions in his "Traité," the colorful botanic illustrations also serving as points of departure for paintings. The illustration of *Stenocarpus Cunninghamii* found in *Loplop présente* (fig. 155, plate 27) Max Ernst made use of again in 1934, in the large wall painting he executed for the Corso Bar in Zürich (plate 45, now in the Kunsthaus, Zürich). A second painting, *Loplop présente une femme-fleur* (fig. 159), which he subsequently destroyed, was also based on this plate.

In all these examples the original ornament has been added to in the way Max Ernst describes—expanded into an ambiguous creature with

162 From *La Nature,* 1901, II.

94

human, animal, and monstrous traits. In principle the painted versions of the Loplop theme in which biomorphic distortions occur always return to these retouched craftsman's patterns. Thus the biomorphisms applied to the human figure that were so central to the period style of the late 1920s did not, in Max Ernst's case, spring from a process of gradual variation of contour until some new and vital set of proportions arose; with him, formal invention remained limited to an evaluation of given, if eccentric, natural forms.

In the 1930s, following on the Loplop sequence, these mixtures of animal, human, and plant shapes begin to abound. *Le jardin des hespérides* (S/M 2201), *La joie de vivre* (S/M 2263), and *La nature à l'aurore* (S/M 2270) are populated by hybrids of this kind. Here too we find Max Ernst combining his knowledge of the formal melds in art history (references to grotesques are obviously there) with his awareness of the pictorial conventions of science. Though the deformations and expansions that appear in these images may look "surreal," their details again and again reveal a precise knowledge and employment of plant forms, of carnivorous flowers and insects.

Sprouting shapes, magnetic fields, visions of visions seen through a microscope—from the most unexpected angles Max Ernst dug through to veins of form that the mine of high art had up to then never been made to yield. These finds he transformed into imagery in which the source of inspiration comes through only as a faint shimmer. As an example, suffice it to mention the series of *Nageur aveugle* paintings done directly subsequent to the Loplop collages.

163 From *La Nature*, 1901, II.

164 Max Ernst. *Nageur aveugle: effet d'attouchement.* 1934. Bridgewater, Conn., Julien Levy. (S/M 2147)

165 Max Ernst. *Nageur aveugle.* 1934. New York, The Museum of Modern Art. (S/M 2145)

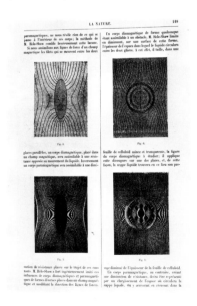

A wild, all-pervading, all-consuming vegetation engulfs cities, animals, mankind. In these visions the creator of *Histoire Naturelle* points to impending cataclysm. With this insatiable proliferation of nature the myth the Surrealists built on the praying mantis takes on a tone of cultural pessimism. More and more during these years, hope of revolutionary transformation gives way to a tragic view of the human situation. As Max Ernst turns to visions of apocalyptic—but beautiful —landscapes that anticipate the end of history, Breton simultaneously, in his *Cycle systématique de conférences sur les plus récentes positions du Surréalisme*, announces a ''Discours sur les ruines,'' a lecture on ruins.[117] The urban themes that had been so central to the narrative reorienta-

166 Max Ernst. ... *des éclairs du petit poignard de plaisir.* 1936. Illustration for André Breton, ''Le château étoilé.'' Reproduced in *Minotaure*, no. 8, 15 June 1936. Present location unknown. (S/M 2239, I)

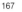

168

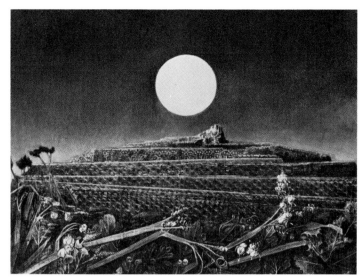

167 Max Ernst. *Jardin gobe-avions.* 1935.
Paris, Musée National d'Art Moderne,
Centre Georges Pompidou.

168 Max Ernst. *La ville entière.* 1935–36.
Zurich, Kunsthaus. (S/M 2220)

tion of Surrealism at the end of the 1920s begin to be swallowed up by imagined landscapes. In the ''Note to the Reader'' with which he introduced *La femme 100 têtes*, Breton had written: ''Surreality is a function of our will to estrangement [dépaysement].''[118] And this principle of estrangement Max Ernst had demonstrated in three plates at the beginning of the collage-novel—demonstrated in terms of a transformed landscape: ''The landscape changes three times.''

Yet what Breton meant by estrangement is felt perhaps most strongly in one of the finest Surrealist texts of all, his own ''Le château étoilé,'' a report on a philosophic-sensual climbing of Teide Mountain on Tenerife, a report which Max Ernst illustrated. Here, in what is perhaps the most ''advanced,'' most intellectualized mountain climb since Petrarch's ascent of Mont Ventoux, Breton confesses: ''I regret having discovered these ultrasensitive zones of the earth so late.''[119] (It is good to remember that as this was written, Max Ernst's work had entered the period of ''Jardins gobe-avions'' and ''Villes Entières''.) Breton describes a world dominated by lava flows, the insatiable *sempervivum* from which man can save himself only by boiling it, and the deadly blossom of the *datura*. Vision and introspection merge in the chilling statement: ''It was the first time in the face of *things never seen* that I had such a complete impression of *having seen them before.*''[120] And he adds that he owes this experience to Max Ernst's prefigurations. The ascent of Teide had been predicted, Breton says, by his friend's paintings. To this particular ''dépaysement'' Breton had been led by Loplop–Max Ernst, mountain guide.

97

Now if in our pattern from an architect's pattern book—interpreted by Max Ernst, interpretable for us—we have a point of departure for the anthropomorphic ambiguity of the Loplop period confirmed by the artist's own commentary, there is a further example from this period from which much can be read. In this case, too, a portrayal of Loplop holds the key (*Loplop présente*, fig. 169, plate 57). The retouched lithograph in this image may well have come from the same publication as Max Ernst refers to in his comments. And as with *Loplop présente chimaera* (fig. 191, plate 5), he does not reveal the secret of the original source until after having employed and varied it through an extensive series of works. His encounter with this print led to a cycle of paintings called *A l'intérieur de la vue: l'œuf* begun in 1928 (S/M 1294, 1295, 1564–1579).

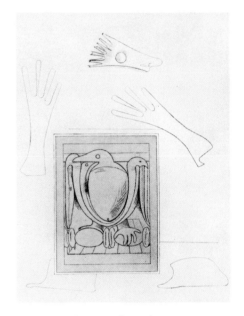

169 Max Ernst. *Loplop présente.* 1931. Paris, Private Collection. (S/M 1766)

The original motif is there in the overtones of the title—an egg and dart pattern was the triggering configuration this time. Max Ernst subjected the motif to changes of two kinds. Seeing a bird into the pattern, he added a bird's head to the main body of the form, and feet at the bottom. Yet here his reading suggested the use of not only additive means, a supplementing of existing forms—he employed negative means as well. Subtraction had played an important part in his work from the beginning, ever since the overpaintings in Cologne, in which he covered with tempera or gouache those passages of the original image that did not fit his conception. Now in *Loplop présente* (fig. 169, plate 57) we find him partially erasing lines that "cut across" his own vision—the second and third lines from the top have been interrupted. Both procedures, subtraction (here by erasure) and expansion, belong together, as he made clear in his "Traité" with the injunction to "limit and project what you see within yourself."[121]

Let us return to the relation between Max Ernst and the birdlike creature discussed earlier. That he identified with such a creature became clear in the *La femme 100 têtes* collages, long before the inception of Loplop. And the figure we meet there was preceded in turn by multifarious bird images in his earlier work. From 1920 on, birds of one shape or another occur continually in his collages, and by no means merely as decorative adjuncts—they stand among other things for provocative sexual activity. In the fourth issue of *La Révolution Surréaliste* André Breton writes, under the title "Why I am Assuming the Editorship of *La Révolution Surréaliste*":

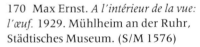

170 Max Ernst. *A l'intérieur de la vue: l'œuf.* 1929. Mühlheim an der Ruhr, Städtisches Museum. (S/M 1576)

> Whatever I do, no matter how much I oppose literal-minded suggestions—the public pleasure continues to expect from one of my friends only tall tales, from another poems in alexandrines, and from a third pictures in which birds in flight put in yet another appearance. . . . [122]

It is not hard to recognize Max Ernst in this third friend of Breton's. And it is precisely the public's expectations which Max Ernst ironically

171 Egg and dart from a pattern book for architects

172 Max Ernst. *Das schlafzimmer des meisters, es lohnt sich darin eine nacht zu verbringen. (The bedroom of the master, it's worth spending a night there.)* Circa 1920. Zurich, Werner Schindler. (S/M 399)

173 From the catalogue of the Cologne Institute for Teaching Aids. Detail. Cologne. 1914.

fulfills with his bird motif. If the development of this motif is traced through the years, we find that Loplop, or, as he is sometimes known, Hornebom, and later even *Schnabelmax* (Max the Beak) is anything but a cute piece of genre. A whole series of meanings is concealed behind his self-portrait as bird.[123]

Max Ernst, student of art history, began to work his mine of iconography during the Cologne Dada period, and over the years was to bring to the surface no end of allusions and innuendoes. The bird as allegory of lost innocence (cf. Franz von Mieris's *A Mother Chides her Daughter for having let a Bird Escape* or Claude Mathieu Fessard's etching *The Symbolic Cage* after Le Peintre, 1782), the eagle of Jupiter that absconds with Ganymede—references of this kind informed Max Ernst's imagery from the beginning as a matter of course. And these were supplemented at an early date by his reading of Freud.

Freud was of prime importance to the development of both Dadaist and Surrealist content. It is worth noting that Max Ernst was the first artist to make use of knowledge of Freud's writings to expand the thematic range of art. *Interpretation of Dreams* was his *legenda aurea*. The sexual symbols found in the manifest content of dreams appear in his work in countless variations. Thus when painting over the original image for *Das schlafzimmer des meisters es lohnt sich darin eine nacht zu verbringen* (The master's bedroom it's worth spending a night there) he left only those elements unobscured to which Freud attributes a hidden erotic meaning—fish, snake ("the most significant symbol of the male organ, the snake"),[124] table ("set tables . . . are likewise women"),[125] and bed ("since 'bed and table' constitute marriage, the latter is often substituted for the former in a dream").[126] Even the so frequent use of hats in the early collages—and later on, for that matter—points to a close reading of Freud: "Among articles of clothing the hat . . . is often clearly interpretable as genitalia, those of the male."[127] Only when we know the code does a title like *The hat makes the man* take on its full piquancy. Another example worth mentioning is the collage, *Le cygne est bien paisible*. The swan in the foreground, as Louis Aragon pointed

172

173

out in 1923, in his essay "Max Ernst, peintre des illusions," is another of the metamorphoses of the artist: "Lohengrin's swan is at one and the same time Jupiter [Max Ernst] out for love."

Yet Max Ernst's range of reference was not limited to *Interpretation of Dreams* and *Jokes and their Relation to the Unconscious*; Freud's broader cultural analyses had their share of his interest from the start. The influence of Freud's essay, "Obsessions and Dreams in W. Jensen's *Gradiva*,"[128] has already been noted and the chain of motifs traced which led from the early collages to the "Gradiva myth" of the Surrealists. Next to this essay, the prime Freudian text for Max Ernst seems to have been that on Leonardo da Vinci. There, under the title "A Childhood Memory of Leonardo da Vinci," Freud discusses mankind's age-old fascination with birds and the idea of flight:

> Why do so many people dream of being able to fly? Psychoanalysis can answer this question because flying or being a bird is merely a disguise for another wish, to the recognition of which more than a verbal and material bridge leads. If curious youngsters are told that a big bird like the stork brings babies; if the ancients represented the phallus with wings; if the most common word in German for the sexual activity of the man is *vögeln* [literally, 'birding'], then these are mere tiny fragments of a picture that teaches us that the desire to fly means nothing else in a dream but a longing to possess sexual prowess.[129]

Such references as these can be traced in the paintings and the collages of the Dada period, yet more important in the present context are the principles of method touched on in the Leonardo essay.

In the midst of the Loplop period we find, from the pen of Breton and Eluard, what is probably the most far-reaching and striking explication ever of the bird as alter ego—written just as that image began to dominate the work of Max Ernst.[130] And here the bird has definitely come to symbolize a specific creative method. In 1930 Breton and Eluard brought out their *L'Immaculée Conception*. In the chapter entitled, "Attempt at Simulating Interpretation Mania," just that chapter in which the authors mimic the speech and the compulsive thought-links of the paranoiac, the narrator begins to identify with a bird. There can be little doubt that here Breton and Eluard are speaking of none other than Max Ernst's figure of identity. It is interesting that of all the pathological modes of behavior they simulate, producing rich poetic imagery that would belie the morbidity of such states, the paranoid mode should have been chosen for Max Ernst. A part in this choice was certainly played by the significance that Dali attaches to the conscious, instrumental use of madness in his *La femme visible*; and another part by Breton's and Eluard's knowledge that in the Surrealist context, Max Ernst had been the first to apply this method.

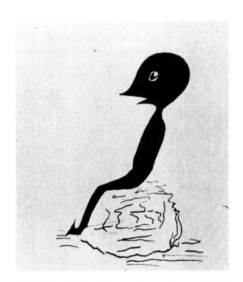

174 Wirt Sykes. *Master Proca.* From *British Goblins.* Boston, 1881. In André Breton, "The Legendary Life of Max Ernst." Reproduced in *View,* 1942.

Another text, which Breton dedicated to Max Ernst years later (1942), returns quite openly to this equation of artist with birdlike being.[131] To illustrate Max Ernst's physical resemblance to a bird, Breton publishes in his "Vie légendaire de Max Ernst" a reproduction of *Master Proca* from *British Goblins* by Wirt Sykes (Boston, 1881), the sketch of a phantom in whose bird head, as Breton says, "it is easy to recognize Max Ernst"—namely the bird with which the arch-sorcerer Cornelius Agrippa conducts a dialogue. Breton gives us a superb reference to Freud's essay on Leonardo as well. He goes so far even as to equate Leonardo, "the vulture's child," with Loplop–Max Ernst: "The vulture whose disquieting presence in Leonardo's *Virgin of the Rocks* had been detected, pursued its own course (it was already Loplop in the fifteenth century)."[132] This passage I think justifies us in giving a more comprehensive interpretation than has yet been suggested to the Loplop suite, and to that so dominating image itself. Here is a key to Max Ernst's involvement with Leonardo and to what he called "seeing into" forms and "hatching out" images. In our context—the artist's self-portrayal, his identification with a bird-creature and with a higher authority—Freud's essay on Leonardo takes on prime significance.

"A Childhood Memory of Leonardo da Vinci" appeared in 1919 in a second, expanded edition. One of the main additions to the book was doubtless the graphic diagram of *The Virgin, Child and St. Anne* which Oskar Pfister had sketched in 1913, after reading the first edition. In his diagram Pfister outlined the covert image which was to enable the

175 Announcement from *La Révolution Surréaliste,* 1927.

176 Announcement from *La Révolution Surréaliste,* 1927.

175

176

reader to check for himself the aptness of Freud's reference to Leonardo's vulture fantasies—a silhouette of that bird concealed in the skirts of the Madonna. Even in early Dada works Max Ernst hinted at his involvement with this text, as we can see from some of his titles of the early 1920s. *Die Anatomie Selbdritt* is an obvious pun on the German title of Leonardo's painting, *Die Heilige Anna Selbdritt*; and within another, longer title of the period it is probably not mistaken to see in the tag, "invisible bird of day" a reference to Pfister's picture puzzle, in which the vulture analyzed by Freud actually emerges from the folds of the Virgin's garment.

Though Leonardo's *Virgin, Child and St. Anne* on which Freud bases his analysis, is not a *santa conversazione* in the strict sense, we nevertheless can bring in the title, *Santa conversazione* which Max Ernst gave to a collage of the time, as underlining its proximity to the painting in Freud's essay. For the first time in Max Ernst's work the bird discovered in the Virgin's skirts actually appears superimposed on a female figure. Apparently it was also meant as a play on Freud's reference to "the most common word in German for the sexual activity of the man." Just as Pfister had extracted the hidden image from Freud's text and rendered it visible once and for all time, Max Ernst now began to employ his new motif of bird in woman's lap in picture after picture. The most famous example of this is of course *La Belle Jardinière* of 1923. The motif sketched in his *Santa conversazione* collage comes up again in *La parole*, a collage for Paul Eluard's book *Répétitions*—and it comes up this time, unusually, in a "cultural context." To an Eve taken from a reproduction of Dürer's engraving *Adam and Eve* (1504) Max Ernst adds

177 Oskar Pfister. *Picture Puzzle*. 1919. Illustration for Sigmund Freud, "A Childhood Recollection of Leonardo da Vinci."

178 Max Ernst. *Santa conversazione*. 1921. Paris, Louis Aragon. (S/M 425)

179 Max Ernst. *La belle Jardinière*. Also: *Creation of Eve*. 1923.

180 Max Ernst. *La parole*. Also: *Femme-oiseau*. 1921. Preliminary illustration for Paul Eluard, *Répétitions*, Paris, 1922. Bern, E. W. Kornfeld. (S/M 441)

178

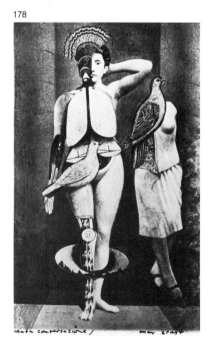

179

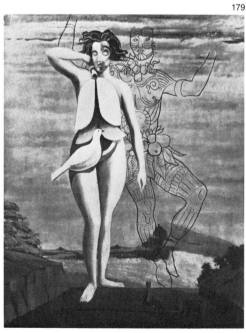

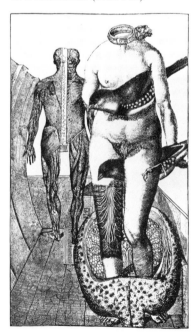

102

181 Max Ernst. *La vierge corrigeant l'enfant Jésus.* 1926. Vienna, Leopold Hawelka. (S/M 1058)

182 Max Ernst. *La vierge corrigeant l'enfant Jésus devant trois témoins: André Breton, Paul Eluard et le peintre.* 1926. Brussels, Mme. Jean Krebs. (S/M 1059)

183 Arnold Böcklin. *Sea Calm.* 1887. Bern, Kunstmuseum.

Leonardo's bird; and if that invisible bird is fully visible here, Dürer's Eve has disappeared, become unrecognizable.[133]

Freud's essay on Leonardo possibly also directed Max Ernst's attention to a painting by Böcklin, *Sea Calm.* The seagull trinity in this painting seems echoed in the bird monuments of the late 1920s.

Finally, another and otherwise well-nigh inexplicable image of Max Ernst's, *La vierge corrigeant...* can perhaps best be understood in terms of the equation of Baby Jesus with Baby Vulture and Leonardo with Loplop–Max Ernst. Here the blasphemy, the hubris which the "god-like" Leonardo and Max Ernst succumb to, is punished. In a text entitled "What is Surrealism?" which appeared in 1934 in the catalogue to the exhibition of that name at Kunsthaus, Zürich, Max Ernst writes:

> As a last superstition, a sad remnant of the myth of Creation, Western culture has been left with the fairy tale of the artist's creativity. It was one of Surrealism's first revolutionary acts to have attacked this myth with objective arguments and in the sharpest form, probably destroying it forever. . . .

A pencil sketch exists for the painting *La vierge corrigeant...* which is unusual, since Max Ernst very rarely did sketches for, or drawings after, his paintings. Just such a drawing exists for the *Santa conversazione* collage which shows Pfister's vulture, which leads me to suspect a reference to that diagram in the drawing entitled *La vierge corrigeant...*

In the special issue of *Cahiers d'Art* which Max Ernst helped to design, he quite ostensibly placed this drawing on the same page as *Max Ernst à l'âge de cinq ans, vu par Philippe Ernst, son père.*[134] This portrait by his

182

183

father is related in turn to a childhood experience which the artist reports in his *Biographical Notes:*

> *The Secret of the Telegraph Wires.* They move violently when you watch them through the window of a train in motion and suddenly stand still when the train stops. To solve this mystery, he slips out of the house one afternoon. Barefoot, red nightgown, blond curls, blue eyes, a whip in his left hand (i.e. a broomstick with a piece of string). The little rascal attracts the attention of the Kevela pilgrims just passing by. 'It's the Christ Child,' they whisper, awestruck. The boy believes them, walks in their midst, then leaves them at the railroad crossing to pursue the

184 Max Ernst. *La vierge corrigeant l'enfant Jésus devant trois témoins: A.B., P.E. et le peintre.* From *Cahiers d'Art,* Max Ernst Special Issue, 1937.

La fusion systématique des pensées de deux ou plusieurs auteurs dans une même œuvre (autrement dit la « collaboration ») peut, elle aussi, être considérée comme parente du collage. Je cite comme exemples deux textes issus de la collaboration entre mon grand ami Paul Eluard et moi: le premier extrait de *Les Malheurs des Immortels* (1922), le second d'un livre resté inachevé qui se proposait de trouver de nouvelles techniques dans la pratique amoureuse: *Et suivant votre cas* (1923).

I. *Des éventails brisés.*

Les crocodiles d'à présent ne sont plus des crocodiles. Où sont les bons vieux aventuriers qui vous accrochaient dans les narines de minuscules bicyclettes et de jolies pendeloques de glace ? Suivant la vitesse du doigt, les coureurs aux quatre points cardinaux se faisaient des compliments. Quel plaisir c'était alors de s'appuyer avec une gracieuse désinvolture sur ces agréables fleuves saupoudrés de pigeons et de poivre !

Il n'y a plus de vrais oiseaux. Les cordes tendues le soir dans les chemins du retour ne faisaient trébucher personne, mais à chaque faux obstacle, des sourires cernaient un peu plus les yeux des équilibristes. La poussière avait l'odeur de la foudre. Autrefois, les bons vieux poissons portaient aux nageoires de beaux souliers rouges.

Il n'y a plus de vraies hydrocyclettes, ni microscopie, ni bactériologie. Ma parole, les crocodiles d'à présent ne sont plus des crocodiles. (Extrait de « Les Malheurs des Immortels ».)

II. *La série des jeunes femmes.*

La femme couchée sur une surface plane, une table par exemple, recouverte d'une couverture pliée en deux.

Lui présenter l'objet en le plaçant au dessus de la tête et dans son rayon visuel. Abaisser l'objet progressivement pour que la femme le suive du regard, soulève la tête d'abord, puis la fléchisse, le menton venant en contact avec la poitrine.

Rester ainsi un petit instant et revenir tout doucement à la position de départ. Il est préférable que l'objet soit brillant et de couleur vive.

Asseoir la femme sur la table, la laisser disposer les bras et les jambes à son gré.

Attirer son attention avec l'objet placé au dessus de sa tête, le déplacer, l'abaisser vers la droite, continuer le mouvement vers le bas, puis remonter vers la gauche.

Toujours tenir l'objet assez éloigné pour que la femme ne puisse le saisir. Ne lui abandonner que pour la récompenser de ses efforts. (Extrait de « Et suivant votre cas ».)

Max Ernst à l'âge de cinq ans, vu par Philippe Ernst, son père.

III. IDENTITÉ INSTANTANÉE

À en croire la description de sa personne contenue dans sa carte d'identité, Max Ernst n'aurait que 45 ans au moment où il écrit ces lignes. Il aurait le visage ovale, les yeux bleus et des cheveux grisonnants. Sa taille ne dépasserait que légèrement la moyenne. Quant aux signes particuliers, la carte d'identité ne lui en accorde pas; il pourrait par conséquent, en cas de poursuites policières, facilement plonger dans la foule et y disparaître à tout jamais. Les femmes, par contre, lui trouvent un visage jeune encadré de cheveux blancs et soyeux, ce qui, à leur avis, « fait distingué ». Elles lui reconnaissent du charme, beaucoup de « réalité » et de séduction, un physique parfait et des manières agréables de danger de pollution, d'après son propre aveu, lui est devenu une si vieille habi-

La Vierge corrigeant l'enfant Jésus devant trois témoins : A. B., P. E. et le peintre.
Coll. privée. 195 × 130

44

secret of the telegraph wires. Gets caught and taken home. Daddy blows his top. 'I'm the Christ Child.' Apologies, reconciliation. Then Father Philippe begins painting his son as the Boy Jesus, standing on a cloudlet in a red nightgown, with an elegant cross (in place of the whip) and hand raised in benediction.[135]

His father actually did paint this portrait of his son and it has survived. The subsequent identifications of Max Ernst–Boy Jesus and Leonardo–Boy Jesus–Baby Vulture can be traced back to this experience. We may assume that when Max Ernst came across Freud's essay on Leonardo years later, he immediately recognized the affinities.

An additional proof that Max Ernst was aware of Pfister's drawing is provided by a short essay he published in 1934 in the journal, *Intervention Surréaliste*. Entitled "The Danger Arising for a Government when it Ignores the Tenets of Surrealism," it contains these words:

> Leonardo's celebrated vulture, coaxed out of hiding centuries later by a student of Freud—might it not be slowly consuming the liver, kidneys, and dreams of a people whose sin and punishment consist in no longer being able to believe in their dreams?"[136]

This passage, by the way, allows us to place within the context of the vulture fantasy a major work of the late 1930s—*The Angel of the House (L'ange du foyer)*. This apocalyptic beast, half-human and half-bird, flapping across the earth spreading fear, is undoubtedly an offspring of that vulture which, as Max Ernst says, will devour the nation that has renounced its dreams. (Possibly the monumental scale of this theme in Max Ernst's work can be traced to his confrontation with the stage curtain Picasso designed for Romain Rolland's *Le 14 Juillet* in 1936. A further point of reference for this nightmarish iconography might be seen in Böcklin's *The Plague* of 1898.)

We have seen that among the most surprising and precise answers given by the equation of artist with bird is that which leads us to Freud's essay on Leonardo. Two aspects of it deserve emphasis. First, a knowledge of this text led Max Ernst to conjoin a memory from his own

185 Arnold Böcklin. *The Plague*. 1898. Basel, Kunstmuseum.

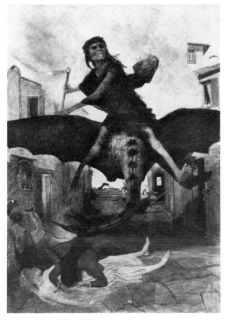

186 Max Ernst. *L'ange du foyer*. 1937. Paris, Private Collection. (S/M 2284)

187 Pablo Picasso. *Composition with Minotaur*. 28 May 1936. Paris, Musée Picasso.

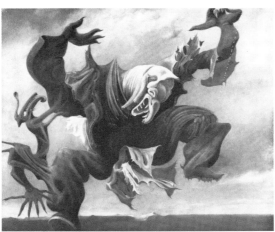

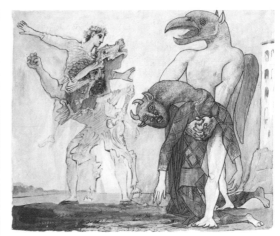

childhood with a memory of Leonardo's. The identity of the Christ Child with Leonardo, Vulture's Child which Freud was able to glean from his reading of *The Virgin, Child and St. Anne* fits perfectly with Max Ernst's own childishly blasphemous hubris. His discovery of Freud's essay could not help but reawaken this memory in him. And Loplop as higher authority, as superego, consciously refers to this identification.

The second point in Freud's essay which came to have great significance for Max Ernst is undoubtedly Freud's remark about the entanglement of images, an intermingling that goes so far that "…in many places it becomes hard to say where Anne stops and where Mary begins."[137] Read in the context of Cologne Dada, this statement must have made Max Ernst sit up and take notice. It recalls one of the finest "wingéd words" that Dada ever produced, namely Kurt Schwitters's description of Anna Blume. Just as in Leonardo's *St. Anne* we can no longer tell where Anne stops and Mary begins, Anna Blume is not so easy to make out either: "You can be read vice versa just as well. / And you, the most wonderful woman of them all,/Are the same from behind as from in front: A———N———N———A."[138] Schwitters's poem contains a number of other references to Freud's essay on Leonardo. He writes for instance of "red dresses . . . sawn in folds," and in his riddle,

1. Anna Blume has a bird,
2. Anna Blume is red.
3. What color is the bird?

we might see a further reference to the circumstance that "…in many places it becomes hard to say where Anne stops and where Mary begins."

These words, from 1919 or 1920, had an additional and quite immediate significance for Max Ernst's work: they recall the community of effort so important at the time. In the series of pieces he executed together with Hans Arp—the *Fatagagas*—as well as in his collaborations with Johannes Baargeld, the idea was to subordinate each artist's contribution to the whole such that his personal touch was outshone by a new and ideal "communality." Max Ernst's literary practice is likewise full of examples of this. The poems for *Les malheurs des immortels* (1922) also had recourse to this principle of a "mise en commun," a shared making which reached from Breton's and Soupault's *Les champs magnétiques* to the *cadavres exquis* of the entire group and to Breton's and Eluard's *L'Immaculée Conception* of 1930.

Seeing Into and Hatching Out

During the months in which Max Ernst evolved the figure of Loplop we can detect, in a number of images, the motif of entanglement which underlies Freud's interpretation of Leonardo. The works are collectively

106

entitled *A l'intérieur de la vue: l'œuf.* This series took its formal inspiration from one of the ornamental patterns which were later to be incorporated into the Loplop collages. The images, which are a paradigm of Max Ernst's strategy of "seeing into" and "hatching out," illustrate the theme of a bird family; some of them (e.g. figs. 170 and 188, both entitled *A l'intérieur de la vue: l'œuf*) clearly represent a trinity. These can be compared to Leonardo's *Virgin, Child and St. Anne,* as a number of equivalencies show, references that were apparently conscious on Max Ernst's part. These images are rife with the kind of mergings of form to which Freud's observation well applies that it becomes difficult to say "where Anne stops and where Mary begins."

Yet this reworking of an egg and dart ornament gives us more than a paradigmatic illustration of a certain passage in Freud; it is an aesthetic approach that brings Max Ernst into close proximity with both Freud and Leonardo. Evidence for it can be found in his "Inspiration to Order," which apparently was written largely under the influence of his encounter with these two great artists and thinkers. He speaks there of ornamental prints, explaining very clearly how he went about altering material which itself already contained figurative suggestions. And there is a further, very central statement of his, made much later, which sheds light on the Loplop period.

In 1930 Max Ernst had a small part in Buñuel's film, *L'âge d'or.* About an experience he had during the filming he writes:

> ...in the Billancourt studio I discovered sheets of plywood which were covered irregularly with paint and plaster. They had been used in the sets to represent walls. Once again I stood before the famous wall of Leonardo da Vinci which had played such a central part in my "Visions between Sleep and Waking." Buñuel gave me these panels and I used them as the ground for *Europe After the Rain* and *Loplop Introduces a Young Girl, Loplop Introduces the Sea in a Cage,* etc. where the plaster relief is still visible.[139]

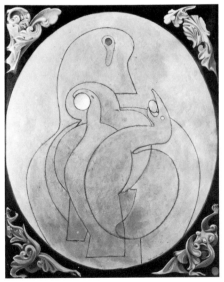

188 Max Ernst. *A l'intérieur de la vue: l'œuf.* 1929. Houston, Texas, Menil Foundation. (S/M 1577)

This description once again characterizes the passive/active tension so crucial to Max Ernst's work.

Found material as the point of departure and alteration of that material to lend it structure—a duality of this kind was noted again and again when describing the Loplop collages. And now, taking another look at the collage with the worked-over "Second Empire embellishment," we may detect an interesting detail. A second field appears in this composition: a field cut out of marbled paper of the kind once used for the endpapers of books. The pattern on the paper evokes the mental image of a stone wall. Now can't this "playing field" which Max Ernst has juxtaposed with the retouched lithograph be seen as an allusion to Leonardo's *Trattato* and to his own "wall experience" with the plywood panels in the Billancourt studio?[140] This is what I meant by calling the

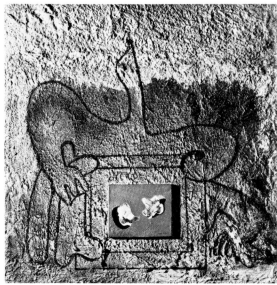

189

190

189 Max Ernst. *L'Europe après la pluie I.* 1933. Zurich, Private Collection. (S/M 1881)

190 Max Ernst. *Loplop présente deux fleurs.* 1930. Milan, Private Collection. (S/M 1703)

motif in the Loplop composition a reference to the theoretical considerations outlined in "Inspiration to Order."

In order to find documentary evidence for Max Ernst's concern with Leonardo we were forced to go to a late text—in the first version of his "Traité" fragment he had not revealed the historic reference. This reluctance may well have had something to do with that statement of Breton's in the Second Manifesto which we cited above, and in which Breton forbade his disciples the use of historical models: "As far as our revolt is concerned, none of us is in need of antecedents."[141] In the revised and considerably expanded version of his "Traité" which appeared four years later, Max Ernst buttressed his remark about an "intensification of the capacity of the mind to be stimulated" with long quotations from Leonardo's writings. A year after that text was published, Breton explicitly mentioned Leonardo's wall for the first time. In *Le message automatique* he writes: "Leonardo da Vinci is repeatedly quoted as having recommended to his students in search of an original and personal subject, to gaze long at an old, crumbling wall."[142] We may gather from the phrase "is repeatedly quoted" that Leonardo's recommendation must have been a common subject of discussion in Surrealist circles at that time.

The two possibilities introduced by the collage in question—a reworked pattern (the Second Empire ornament) and a projection screen for mental images (the marbled endpaper)—recapitulate the possibilities which Alexander Cozens, in his *A new Method of Assisting the Invention in Drawing Original Compositions of Landscape* of 1785, had cited as two equally valuable sources of inspiration. "The blot as an alternative to the pattern book. Is it an accident that the pattern book just referred to, Cozens's models for clouds and skies, should illustrate both

108

possibilities together?"[143] Max Ernst describes these possibilities in his "Traité" and illustrates them in *Loplop présente chimaera* (fig. 191, plate 5). In the marbled endpaper we have a "blot as an alternative to the pattern book," to that pattern book namely from which he took the ornamental lithograph that led to his chimera.

Reference should also be made to a further point in the later version of Max Ernst's essay. He describes his confrontation with Leonardo's wall as having happened not for the first time: "Once again I stood before the famous wall..." and he recalls the part it had already played in his "Visions between Sleep and Waking." In "Visions de demi-sommeil" he reports on three encounters: The first from his childhood when, between the ages of five and seven, scenes had appeared to him on a wooden panel painted in imitation of mahogany. In his "Comment on force l'inspiration" he returns to this obsessive projection of mental images into amorphic patterns or shapes whose objective content is thereby subjectively alienated. His "Visions between Sleep and Waking" as yet contained no reference as to how this manner of projection could be used to enhance, to "force," inspiration. Why he withheld reference has been noted. All this now changes: with "Comment on force l'inspiration" his censorship relaxes. He gives out the first information ever on his practical procedures. In the course of his remarks he recalls the early Dada pieces made in Cologne. He realizes that the collage aesthetic had been founded in the overdetermination brought about by mind-boggling images from the fields of technology and science. The original images had become malleable; in new combinations they could be made to represent things yet unseen. Thus from the beginning his working method was based on the principle of projecting personal, imagined meanings into existing, "meaningless" images. This subjective approach, which denies the factual significance of pictorial conventions, was also to become central to the new writings of Aragon, Breton, and Crevel, texts in which the narrative mode again comes into its own. These contain many indications of how reality might even be blotted out by some hallucinatory vision. To mention only one example, from Breton's *Nadja*:

> Only a few days ago Louis Aragon called my attention to the sign of a hotel in Pourville which bore in red letters the words: MAISON ROUGE composed in such characters and disposed in such a manner that seen at a certain angle from the road "MAISON" disappeared and "ROUGE" read as "POLICE".[144]

191 Max Ernst. *Loplop présente chimaera.* 1932. Bridgewater, Conn., Julien Levy. (S/M 1758)

Encoding and Decoding

What Breton illustrates here is the phenomenon of optical interference. In *Nadja* he describes the moods and expectations that make such visions possible and even unavoidable. Here is a subjective forcing of reality; it prefigures the delusion of relation (or paranoia) which Dali was to push as

far as it would artistically go. Dali made good use of the principle of double and multiple images, compositions that present several alternative readings. In themselves such images are complete and clearly defined, yet the eye plumbs their different aspects only gradually, one after the other.

The stage had been set for this style of puzzlement by the verism which had again begun to dominate Surrealist art by the end of the 1920s. Yet what Dali called his "paranoiac-critical" method was not much more than a superheated version of a practice known from the work of such earlier artists as Arcimboldo and Momper, or the double images of the Romantic era, and not least from the popular genre of optical illusions and gags. The makers of picture postcards in particular rang fascinating variations on this motif, as the collection of Paul Eluard illustrates in hundreds of examples. The magazine *La Nature* frequently ran samples of such optical illusions, and Gaillot's lithographs showing "Arts et métiers" and "Figures à double aspect" enjoyed a wide circulation at the time. *La Nature* also printed the famous *Choléra morbus* by Gallieni, a picture puzzle for the creation of which a well-nigh paranoid fear of illness has been held responsible. The legend to this image goes as follows:

> We see here children vigorous and fresh petting a dog and playing. Imagination, often rendered supersensible by a terrible fear of epidemics, pictures them already in the aspect of death.[145]

Double images of this kind—Arcimboldesque heads, say, like those in the *Libro di variete maschere, quale servono a pittori, sculptori e a uomini ingenosi* by René Boyvin after compositions by Rosso of 1560—such images played in the work of Max Ernst only a temporary role, during the Loplop period. We find them in some of the photograms for *Mr. Knife and Miss Fork* and in the frottages for the volume entitled *Je sublime*. Yet basically this alternating vision, the optical apposition of images, can be said to have concerned him only marginally. His tactic of "seeing into" or introspection-projection as outlined in "Comment on force l'inspiration" was developed with entirely different effects in mind. The result he was after, unlike Dali, depended on what he called a melting into one another or fusion of images. Moreover, he lacked the technical prerequisites for the creation of such anamorphoses—the kind of verisimilitude of detail they require for their effect was something he had lost interest in by this time. Following the criticism of Morise and Naville, he worked out an open textural syntax, and from that point on interwoven suggestions of form, both fluid and inseparable, became paramount in his work.

Having said this, we arrive at the crux of Max Ernst's Surrealist aesthetic. I have suggested at several points in this essay that Max Ernst always defended himself against interpretations of his work. In so doing he distanced himself from pictures that present—as Dali in his concurrent writings said they should—a completely closed system of superim-

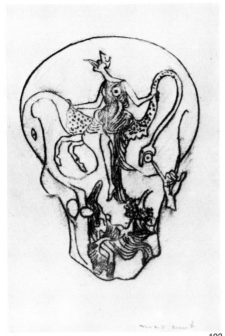
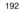
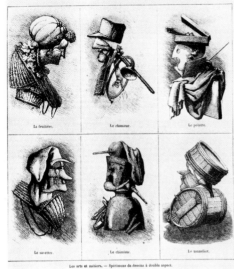

192

193

194

192 Gallieni. *Le choléra morbus*. From *La Nature*, 1885.

193 Max Ernst. For Benjamin Péret, *Je sublime*, 1926. (S/L 161)

194 From *La Nature*, 1885.

195 From "Postcard Collection Eluard." Paris, Private Collection.

195

posed images each of which, however, can be read for itself. Max Ernst's own pictures refuse to yield to compulsive interpretation, paranoiac-critical or otherwise. Here we might again cite that statement in the Leonardo essay—"that in many places it becomes hard to say where Anne stops and where Mary begins"—this time as a self-commentary on the part of Max Ernst. What it expresses here is the relation between encoding and decoding, ambiguity and clarity.

With this, Max Ernst's critical reading of Freud takes on a fabulous significance. We have seen that Max Ernst was fascinated by Freud's acumen, his capacity for mental association, his interpretive drive. These corresponded to a deep instinct of his own. I quoted at the beginning from the *Biographical Notes* what he had remarked under the year 1906—that a kind of mania to explain had possessed him to see the death of his favorite bird, Hornebom, in causal relation to the birth of his sister Loni. The shock had gone deep, he said, adding:

> Yet in the boy's mind there remains a voluntary if irrational confounding of the images of human beings with birds and other creatures; and this is reflected in the emblems of his art.

Here again is a reference to the inseparability of bird and human that takes us back to the Leonardo essay. It furthermore suggests that Max Ernst raised this mixing or confounding of mental images to a principle; how clearly this state is reflected in the "emblems of his art" has been shown in many examples.

Max Ernst's task was not the same as Freud's. It was not primarily a matter of finding means to assimilate, in painting, Freudian method—it was a matter of gaining distance on what he had read, even of resisting it. What seems important in this regard is his description of his experience as a "voluntary if irrational confounding of images." Freud's observation about not knowing for certain where Anne stops and Mary begins—an observation which the great man cannot have found analytically satisfactory—becomes for Max Ernst the point at which to begin saying what he has to say. He did not equate, in other words, the almost dizzying acumen of Freudian analysis with Surrealist expression in art. He was indeed fascinated by the mechanism of explanation set in motion by dreams or neuroses, yet these states, in his eyes, obviously possessed a poetic meaning which interpretation, as soon as it set up to solve them, must disperse. In contrast to Freud or to Dali, inspiration and association of ideas were to brook no constriction by pragmatic aims.

Inexplicability as Surrealist Statement

Against logically satisfying, hermetically perfect explanations he set the irritating openness of his images. And really these mingled images are of a nature that is perfectly in keeping with Leonardo's teachings—im-

ages in which the question remains open "where Anne stops and where Mary begins." William Rubin has remarked in this connection:

> Dali wrongly interpreted his double images as illustrations of Leonardo's text on provoking the imagination, which he now proclaimed to be the source of his practice. ... even in the more successful instances, Dali's double images could not but serve to delimit rather than to enrich the pictorial experience. The less realistic, less specific morphology of Arp and Miró, for example, allowed and even provoked myriad readings, since its forms connoted much but denoted little.[146]

Evocations of form and irritating openness of content characterize Loplop's world. This raises the question of how, if at all, we can distinguish Surrealist works from those which are merely emblematic and difficult to construe. It is important, I think, that some division between true Surrealist image and rebus be observed.

Ernst Gombrich, in discussing the interpretation of pictures, asks a question that really ought to be taken to heart by anyone who sets out to describe the content of a Surrealist work. It goes thus: "How much meaning did the artist mean?"[147] It is not a simple question, because it asks us to resist the need to interpret that we so often feel before a work of art and so often succumb to. And while resisting we should remember that apparently in the art of the twentieth century there are works which actually postulate an obscure and thus annoying relation between their appearance and their meaning. Can such works of art be finally explained at all? Can what characterizes them be grasped in that act of interpretation which Erwin Panofsky calls "iconological" and places as the third level above "pre-iconographic description" and "iconographic analysis?" In many cases it would appear to me that the intention behind a work by de Chirico, Max Ernst, Masson or Duchamp, simply cannot be divined. It would seem as though the question of meaning had been not only purposely garbled but not even asked in the first place. We are faced by a wall of intentional knownothingism; content, as artists have not tired of stating, does not interest them.

Max Ernst too wriggled out of every attempt to attribute a straight message to his pictures. He categorically refused to have his works explained as offshoots of his subconscious mind, revelatory of drives and repressions which—by analogy, say, to latent dream content—it was the task of analysis to render out of a manifest, opaque swirl of imagery. And though he began with Freud, took from Freud the model of encoding and compressing, he let these stand as factors of stimulating irritation.

An early request to take this waiver of meaning *as* meaning is found in the writing of de Chirico. In an essay written between 1911 and 1915 and entitled "The Mystery of Creation" he states:

> The inspiration for a work, the conception of a picture should be something that has no meaning in itself, no subject either, and from the point of view of human logic "does not say anything at all".[148]

And in 1919, in his essay "On Metaphysical Art" he adds the words that could serve as a program for an art that confronts the reality principle with the principle of shock.[149] Basing his remarks on Schopenhauer's definition of madness, de Chirico says that an insane person is someone who has lost his memory, someone in whom the continuous chain of recollection has broken. De Chirico demonstrates this destruction of causality in the metaphysical still lifes that stand at the inception of Surrealism. What he has attempted to depict there is the moment of fearful confusion when the chain breaks that ties memory to memory and renders them coherent. That moment was all. The centrifugal force exerted by the conjoined, incoherent elements in the painting had to be stronger than the opposing force of interpretation. And what after all is interpretation but an inability to leave strangeness be? The job of the art historian or critic is to discover meaning. The history of art history lends legitimacy to this need. Max Ernst, who studied the subject, began with this realization. Apparently Freud's essay on Leonardo served him as a fascinating—and repellent—model of total knowledge.

The task looks different again in the context of Surrealism as a whole. The irreparable break in the chain becomes the condition for the "incurability" of collage, for the resistance of that technique to analysis and thus to reintegration in the normal state of things—collage elements seem surrounded by some dense, isolating medium. Max Ernst's reference to a fusion of images opens our eyes to a definition of collage which makes the question of a "plastique surréaliste" (Morise) seem more profound than at first sight. When man is experienced as a discontinuous, fragmented being, the painful experience of one's own limitedness can lead to a compensating and unlimited combination of possible images. Like Leonardo, who when defining invention assumed a difference between *scienzia* and *prescienzia*, Max Ernst confronted existing images of reality with the expanded images of Surrealism. What Leonardo called *scienzia*, the *notizie delle cose possibile, presente e preterite* served Max Ernst as material to proceed on. The material in his case was catalogues of merchandise and the descriptions attached to scientific illustrations. To things such as these Leonardo contrasted *prescienzia*, an imagination of things that might possibly come into being.

A coincidence: At the time Loplop–Max Ernst was working out a method that would encompass both Leonardo and Freud, Paul Valéry published his various texts on Leonardo. Among them was the "Introduction to the Method of Leonardo da Vinci" with which Breton and Tzara are known to have concerned themselves as early as 1919.[150] Citing Leonardo as witness, Valéry observed that most of the changes seen within a particular scheme of thought and imagination occur at points where incompatible and unexpected methods and concepts are introduced into that scheme. Hence his demand that thought be allowed to take every conceivable—and inconceivable—turn.

Plates

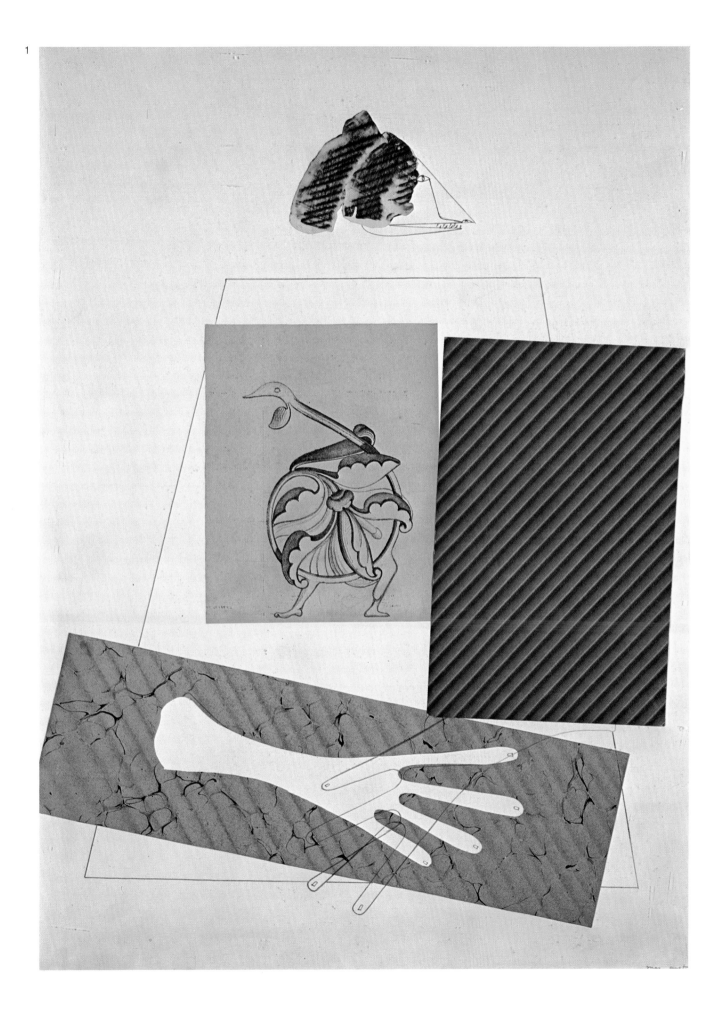

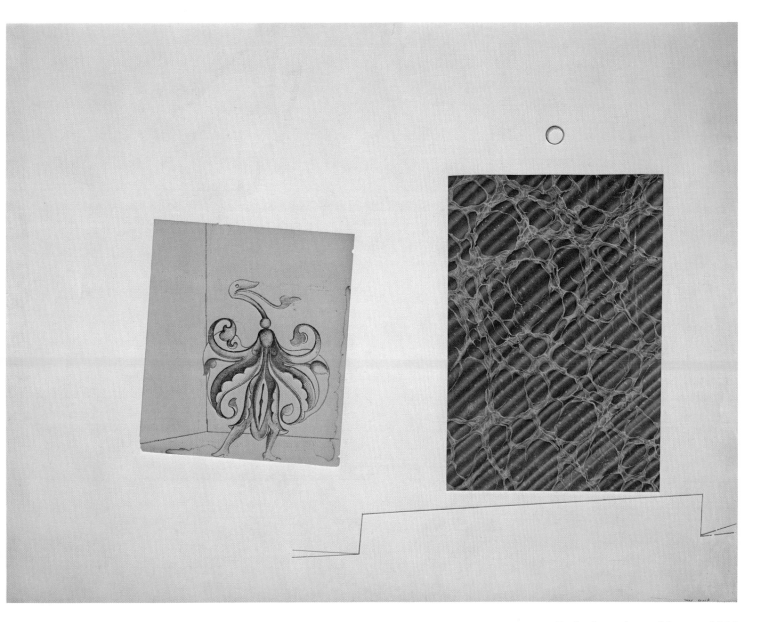

5 *Loplop présente chimaera,* 1932

4 *Loplop présente,* 1931

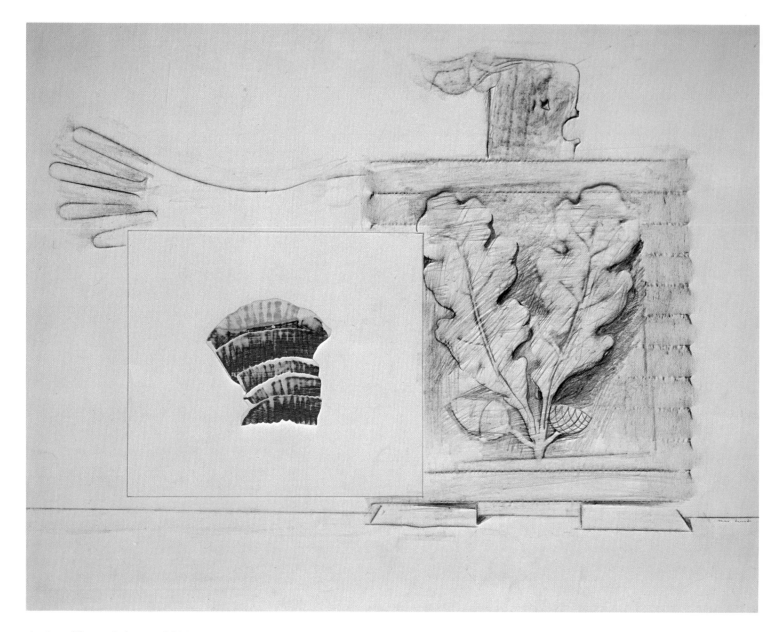

6 *I am like an Oak . . .*, 1931

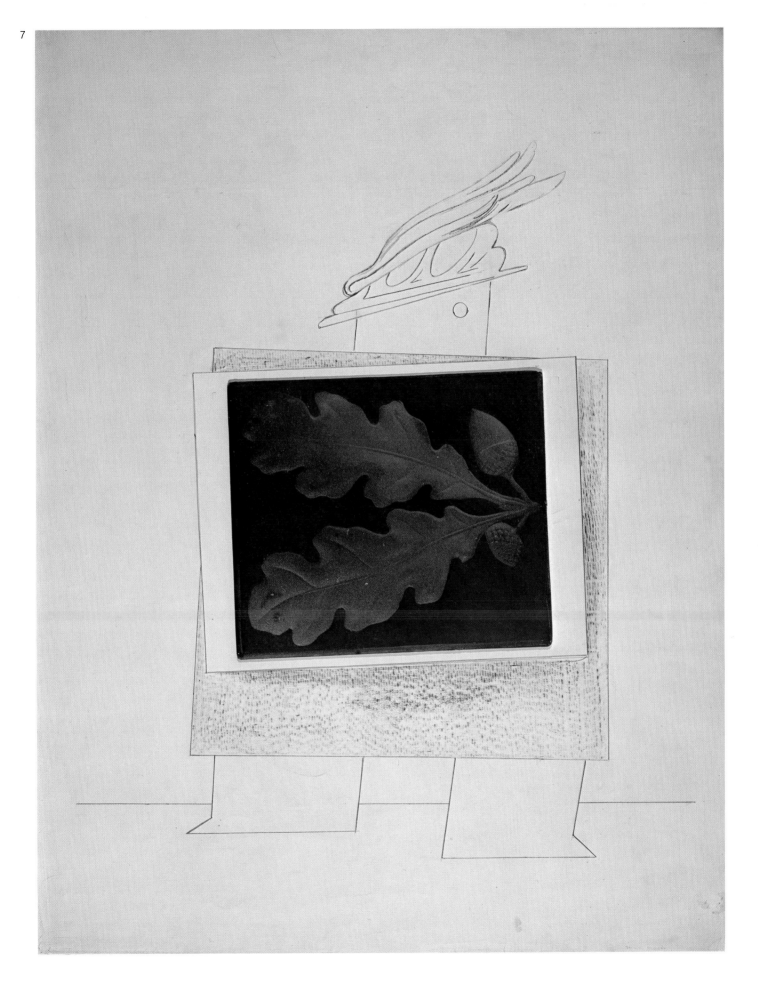

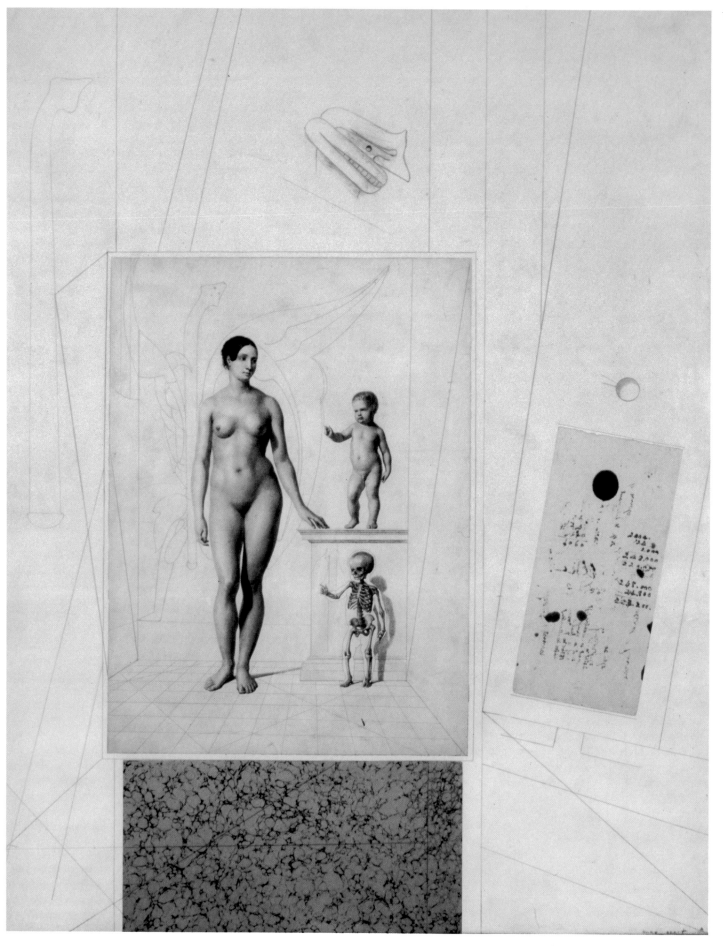

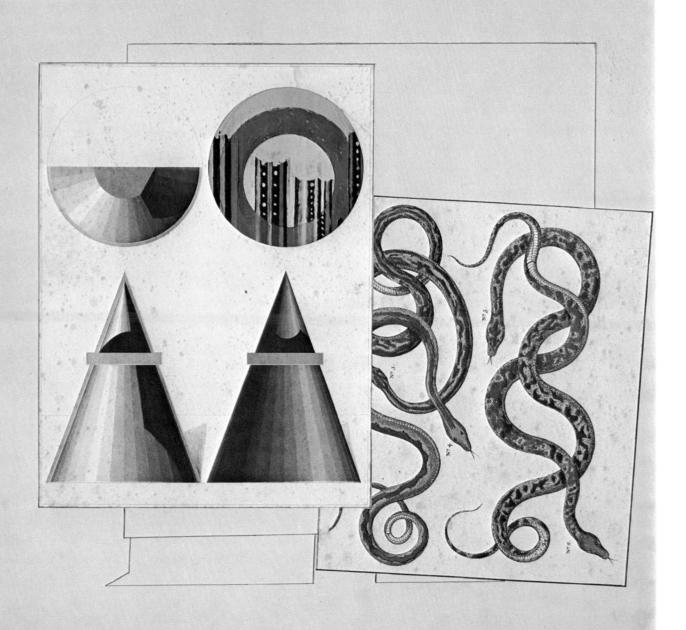

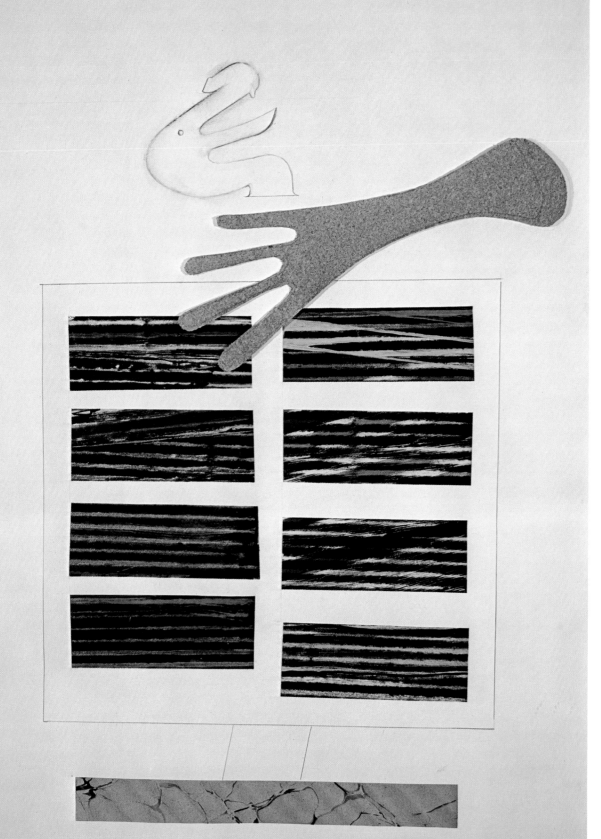

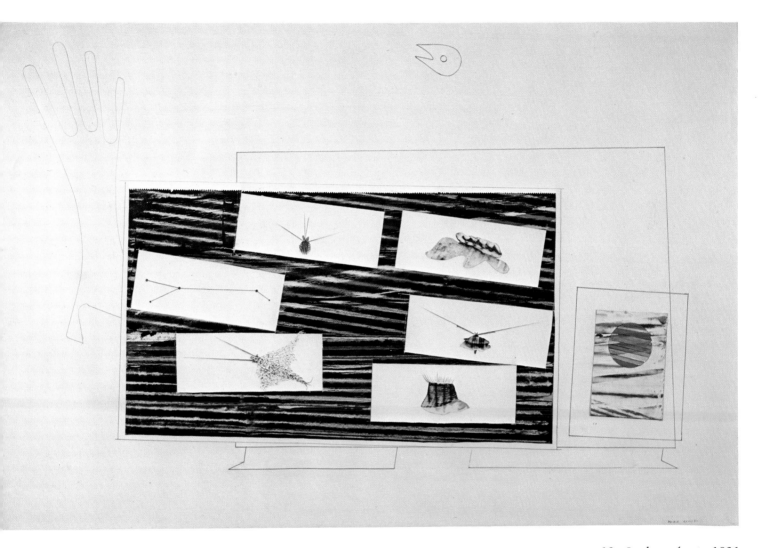

13 *Loplop présente*, 1931

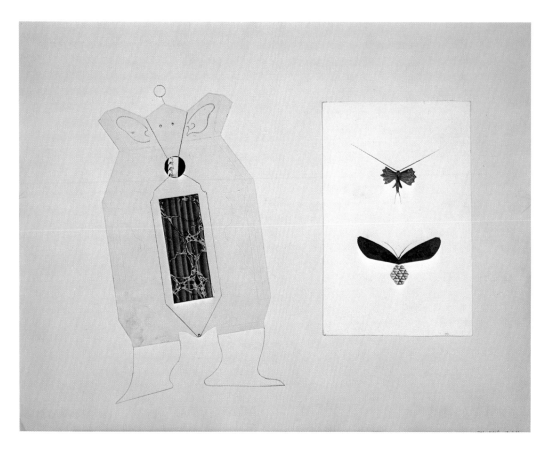

14 *Loplop aux papillons,* circa 1932

15 *Main humaine et papillons pétrifiés,* 1931

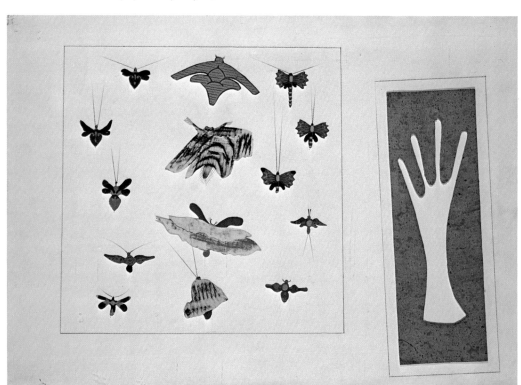

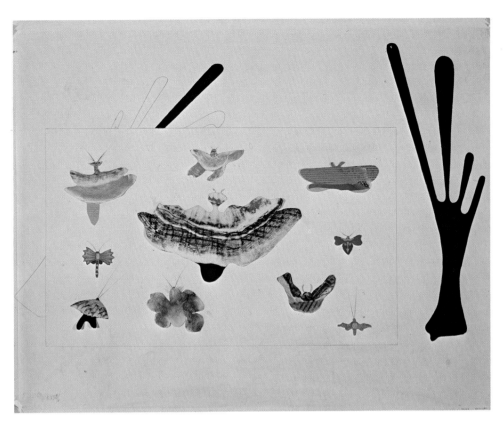

16a *Butterfly Collection*, 1931

16b *Butterflies*, circa 1931

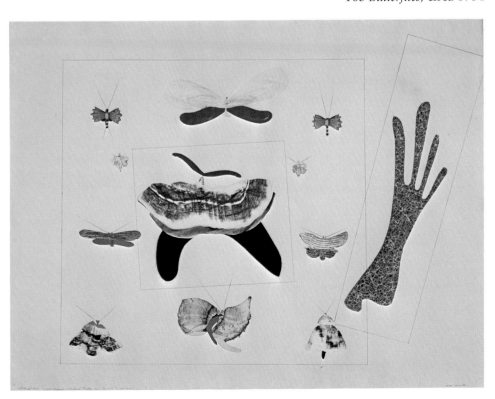

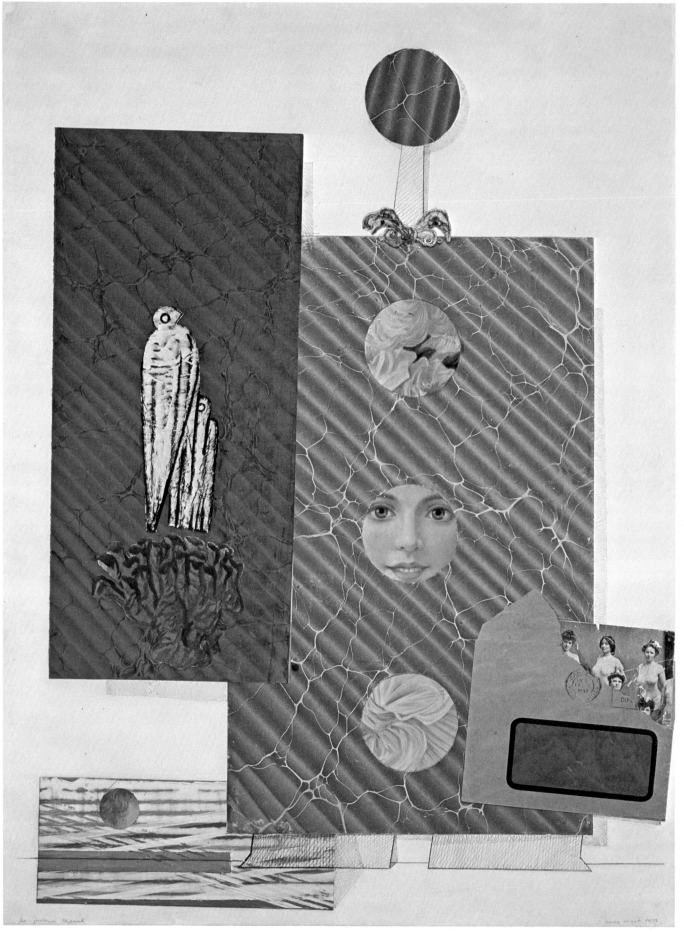

18
Untitled
1931

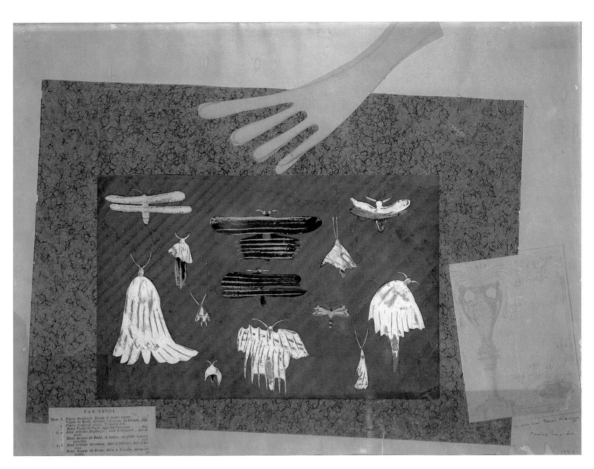

19
Loplop présente
1931/32

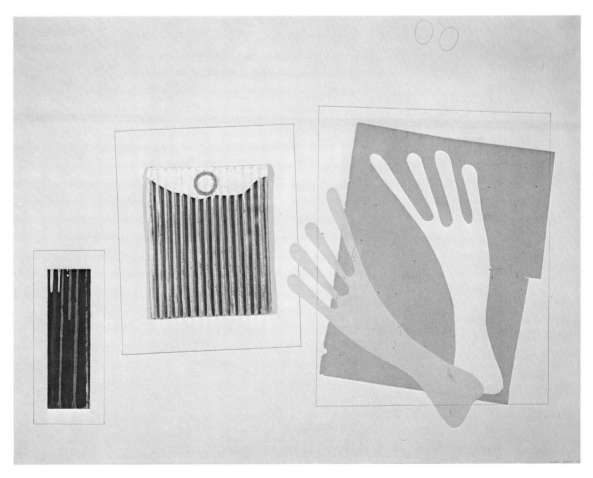

17
Le facteur Cheval
1932

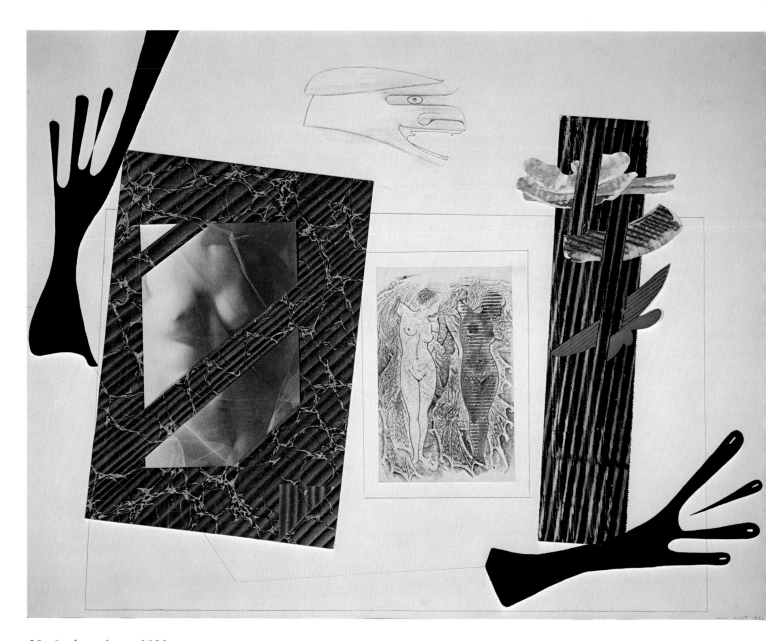

20 *Loplop présente*, 1932

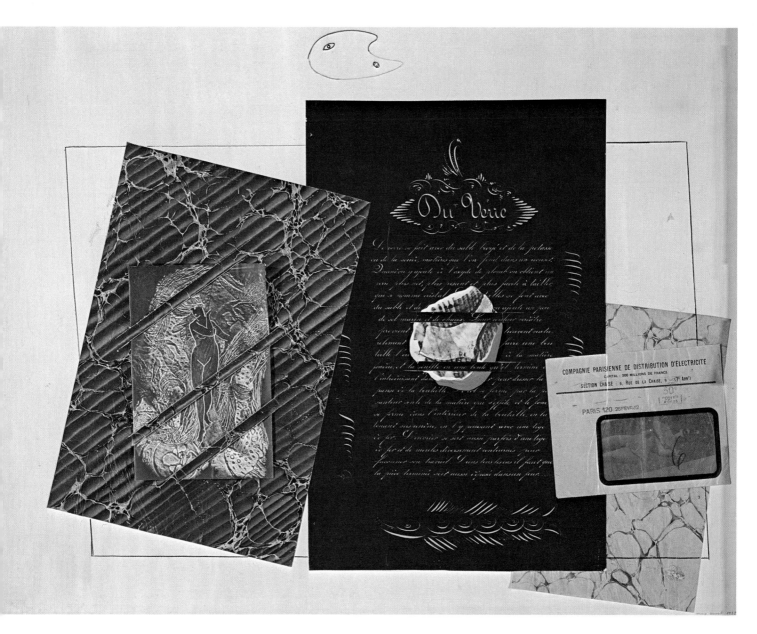

21 *Du verre*, 1932

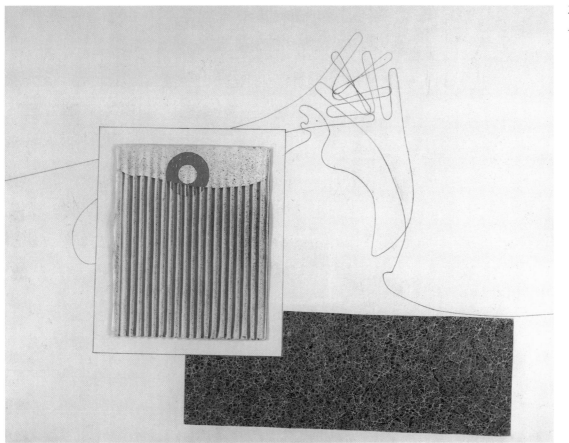

22
Forêt et personnage
1931

23
Loplop présente
1931

24
Loplop présente une fleu
also: *Figure*
anthropomorphe
et fleur coquillage,
1930

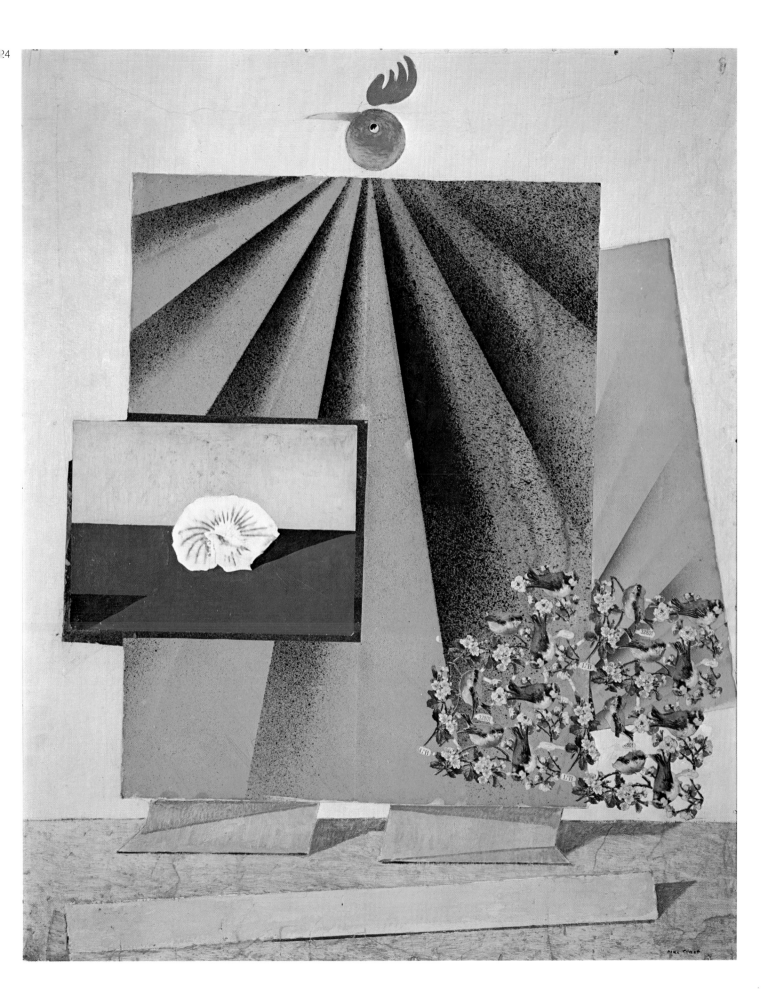

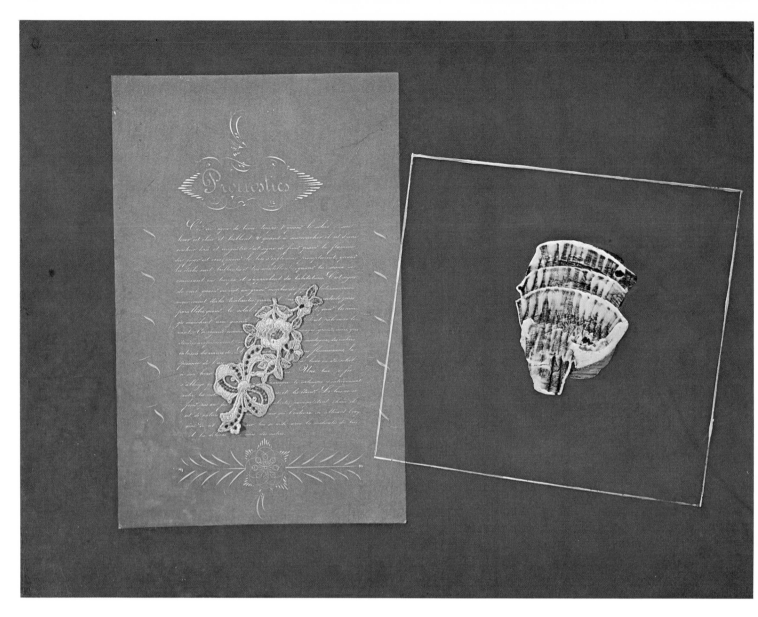

25 *Pronostics*, 1932

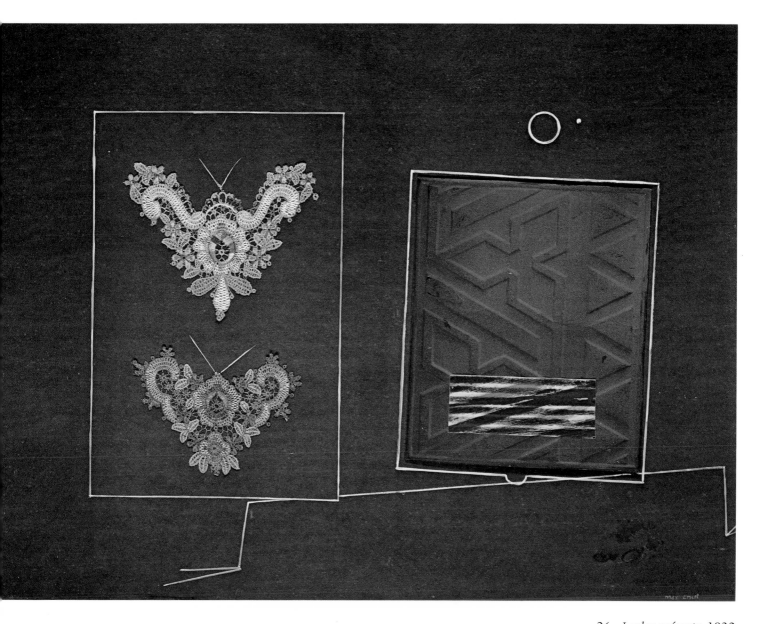

26 *Loplop présente*, 1932

27 *Loplop présente*, 1932

28 *Loplop présente*, 1932

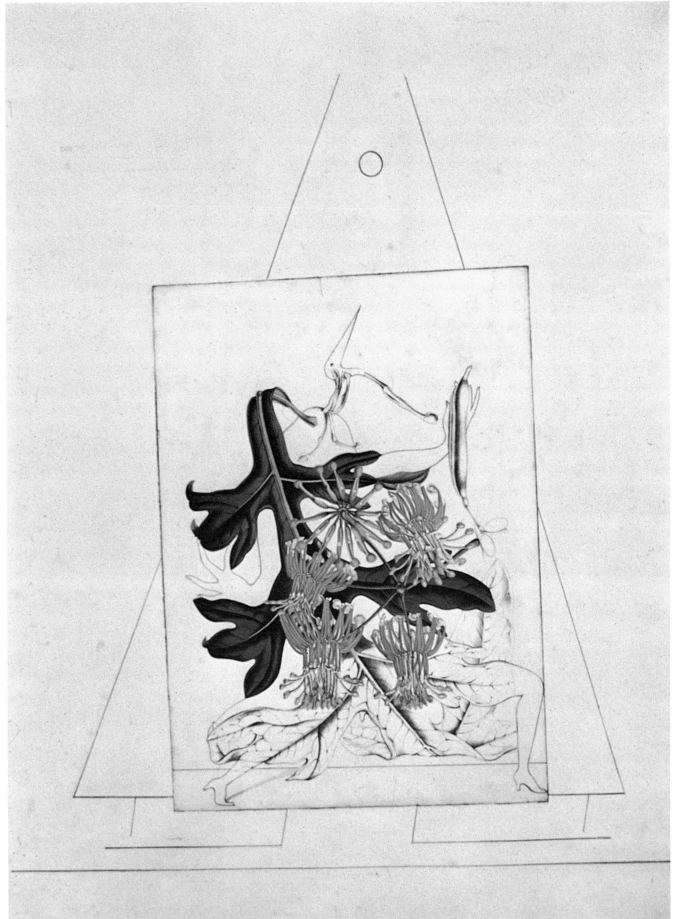

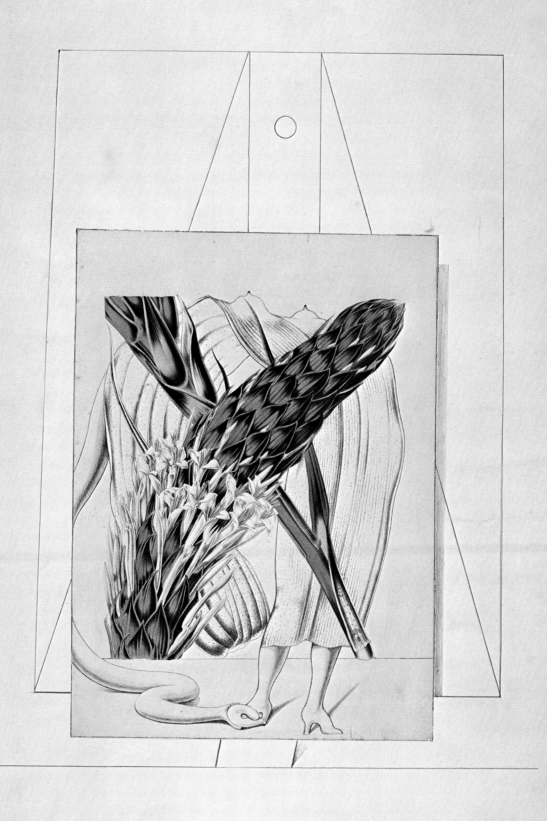

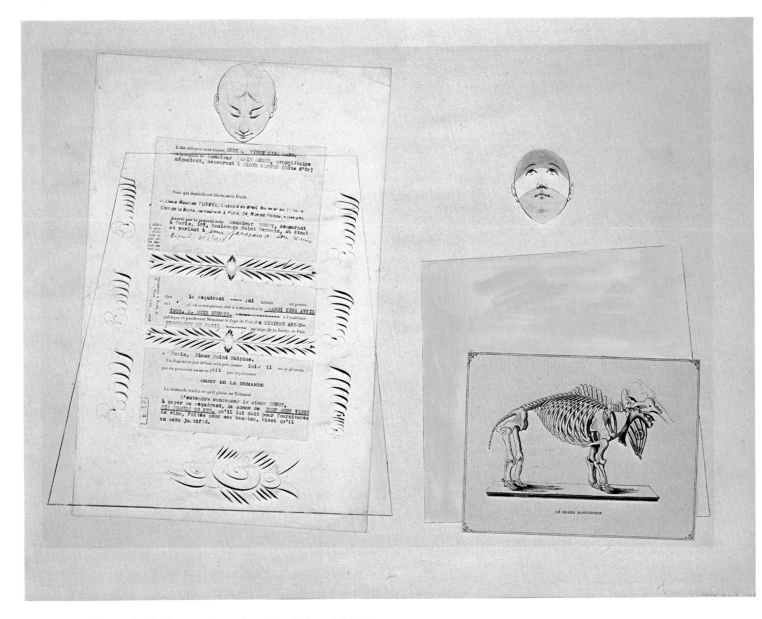

29 *Le grand mastodonde* also: *Loplop présente Paul Eluard*, 1932

30
Le chant du pinson
1933

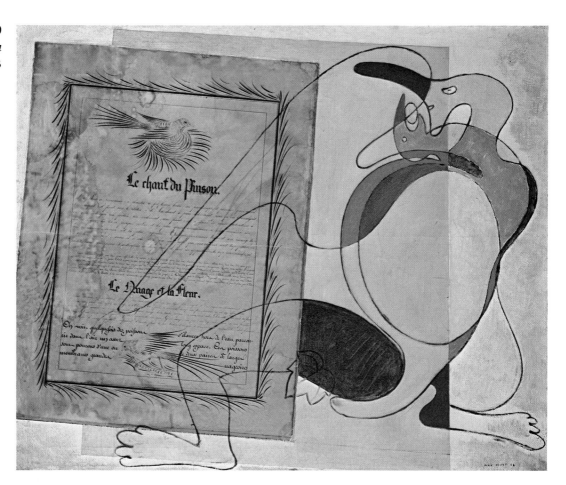

31
Hommage à une enfant
nommée Violette
1933

32
Untitled
1935

33
Colombes et corail
also: *Oiseaux et madrépore*
1932

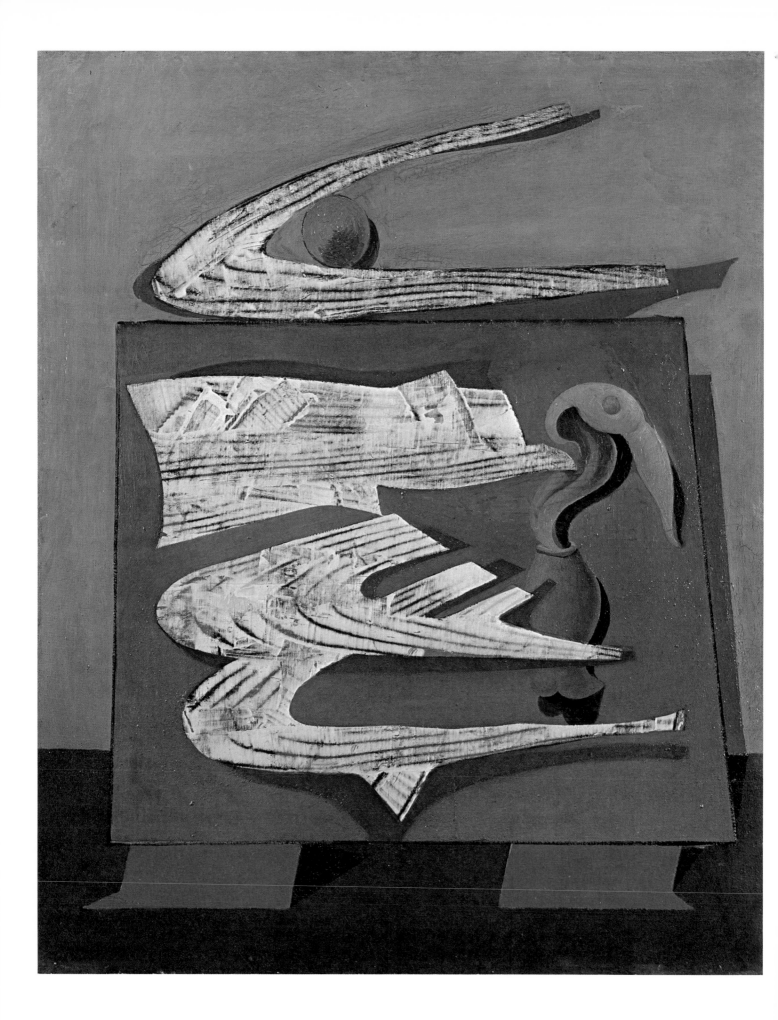

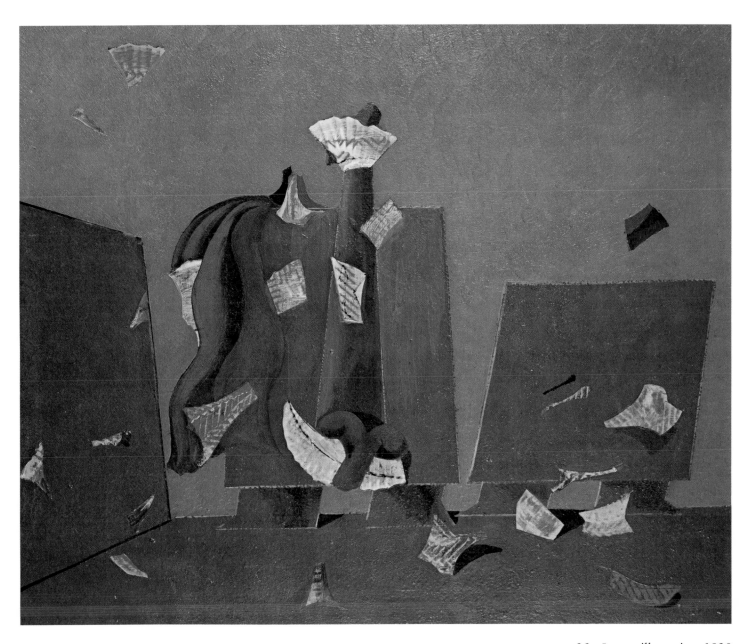

38 *Les papillons*, circa 1930

35 *Matin et soir*, 1930

36 *Anthropomorphic Figure*, 1930

37 *Loplop de mauvaise humeur*, 1929

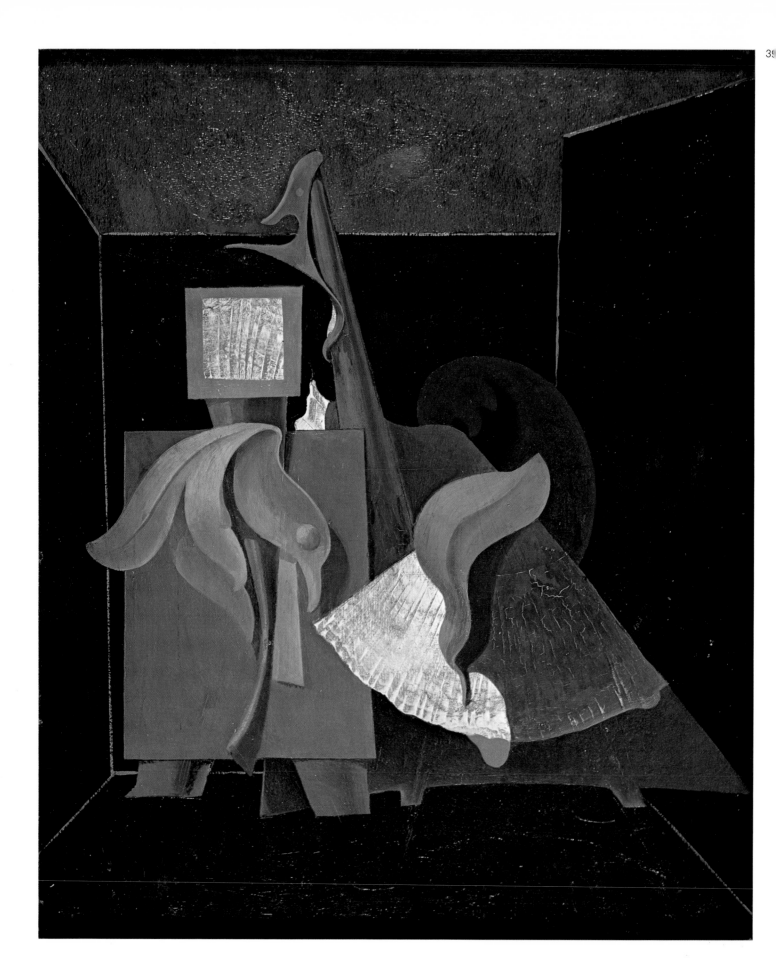

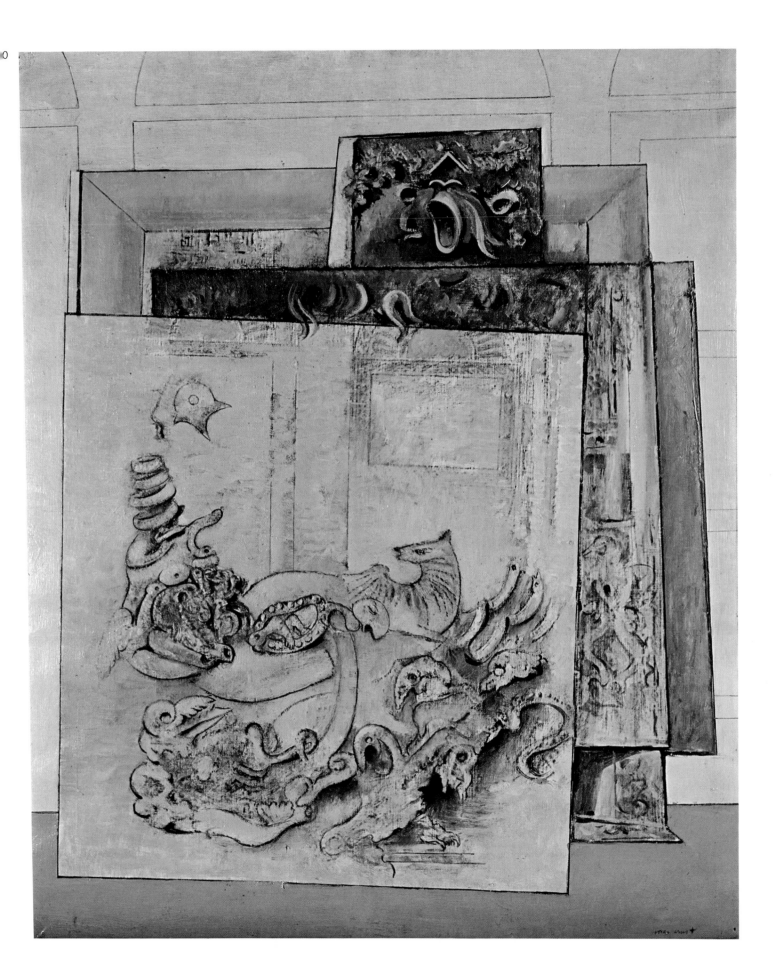

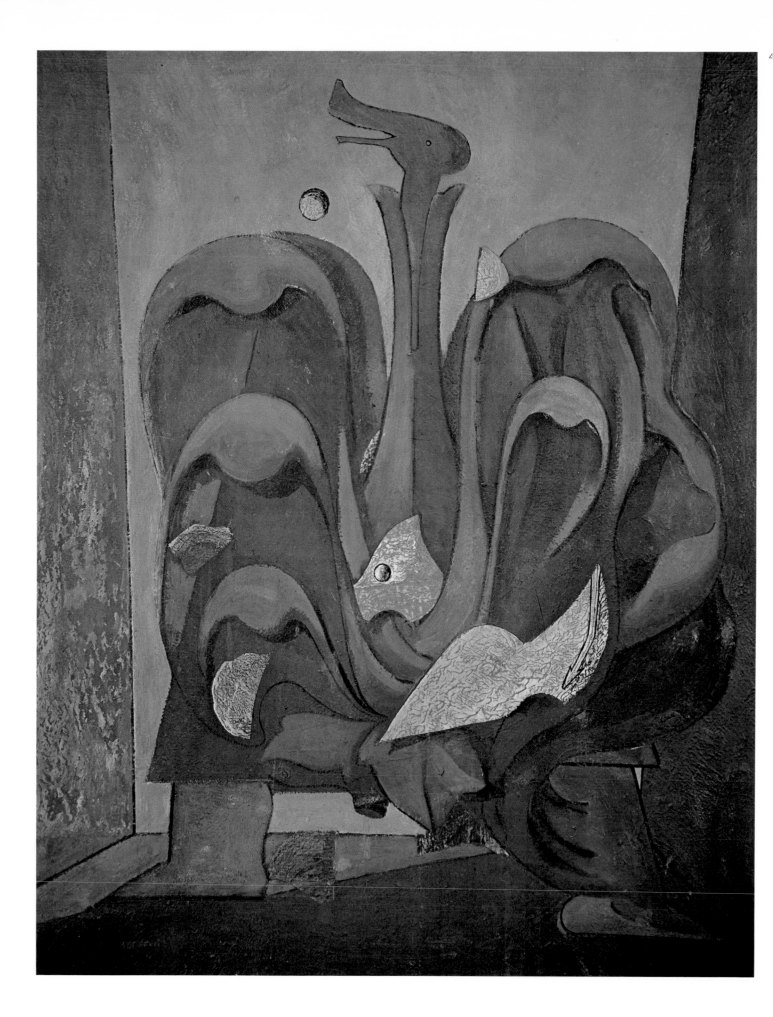

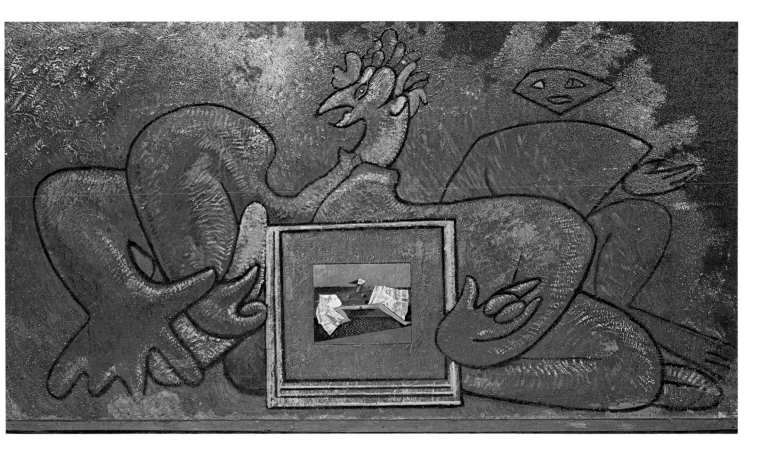

42 *Loplop présente Loplop* also: *Chimère,* 1930

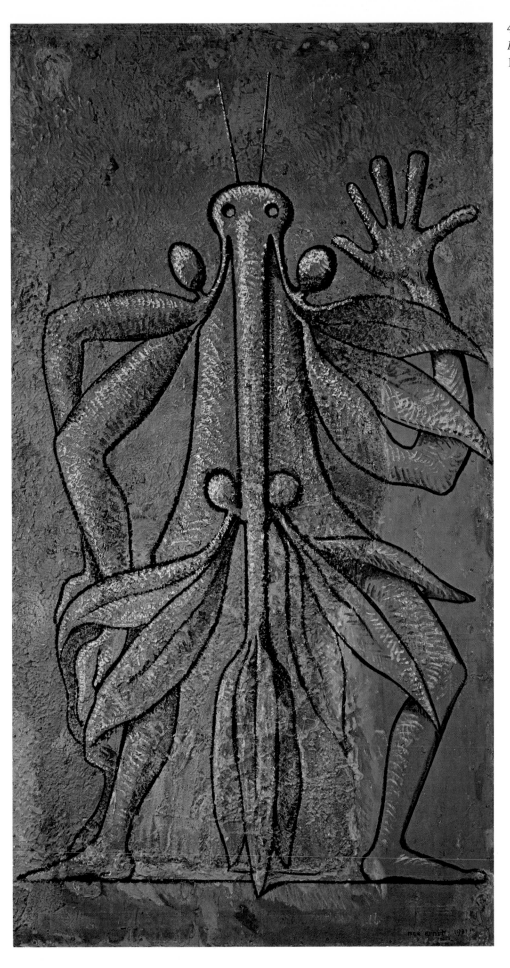

Loplop présente une jeune fille
1930

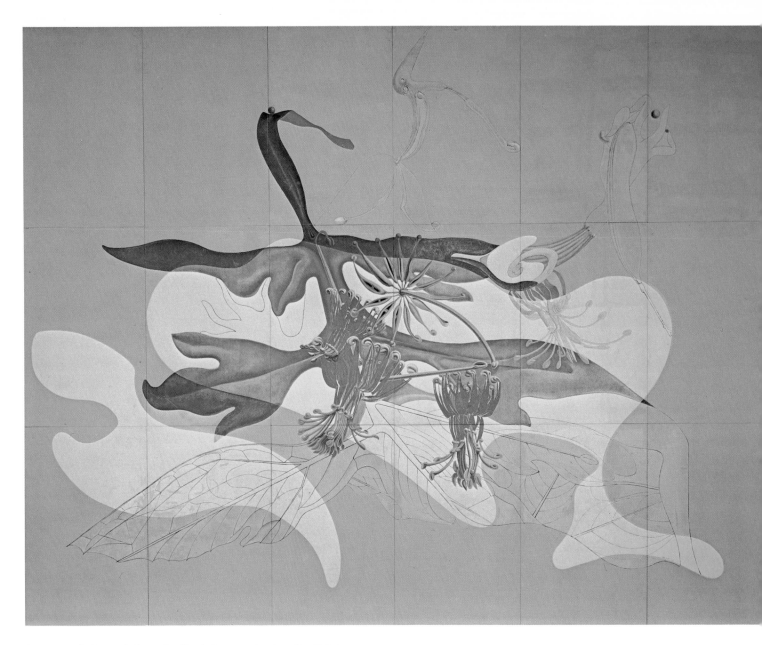

45 *Mural* also: *Pétales et jardin de la nymphe Ancolie,* 1934

46 *Le portrait,* 19

max ernst

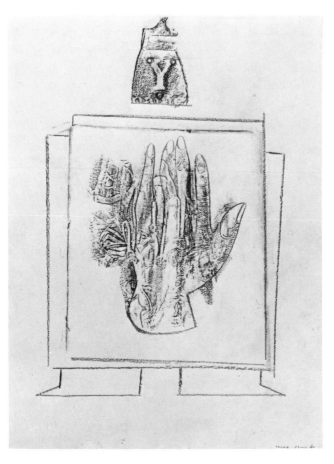

47 *Loplop*, 1930

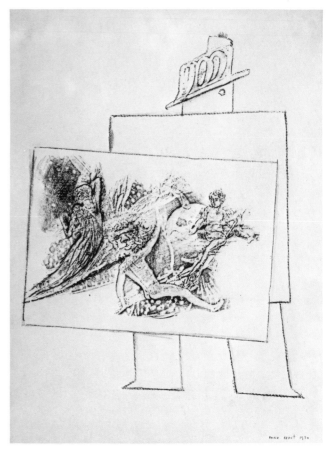

48 *Loplop présente*, 1930

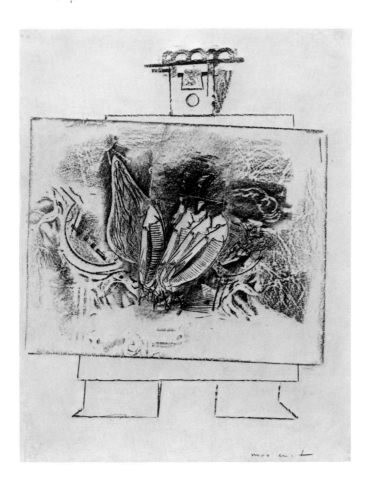

49 *Loplop présente*, 1930

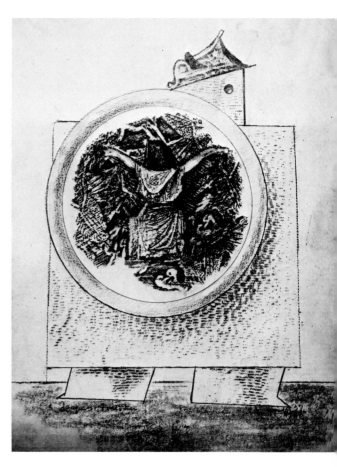

50 *Loplop présente la Marseillaise*, 1930

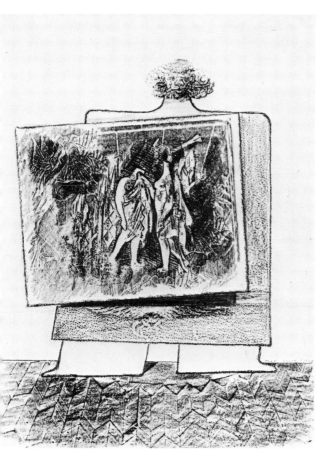

51 *Loplop présente*, 1930

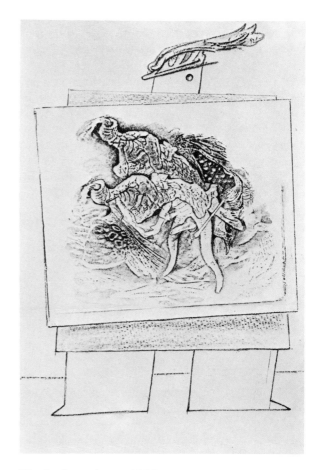

52 *Loplop présente*, 1930

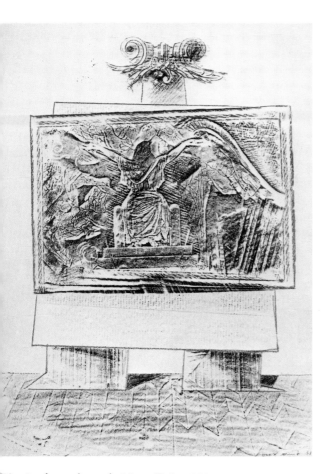

53 *Loplop présente la Marseillaise*, 1931

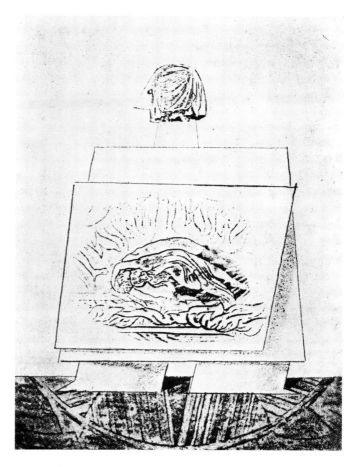

54 *Loplop présente*, 1931

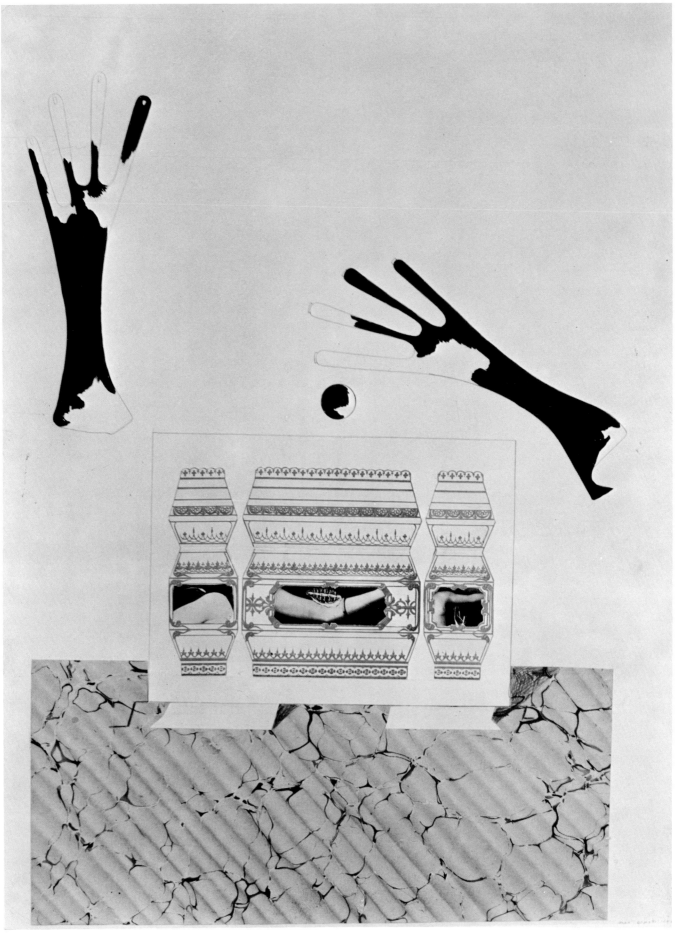

56 *C'est la vie – le marchand d'Ucel,* 1931

57 *Loplop présente,* 1931

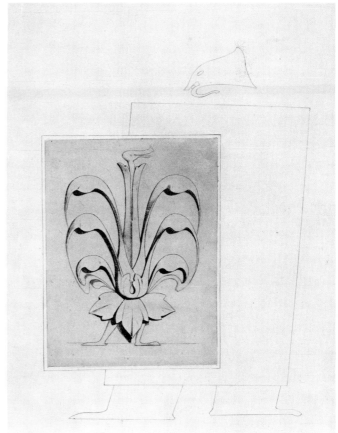

55 *Loplop présente Loplop,* 1931

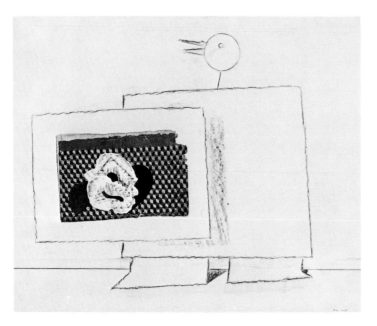

59 *Loplop présente une fleur*, 1931

60 *Loplop présente*, 1931

61 *Jeune homme debout*, 1931

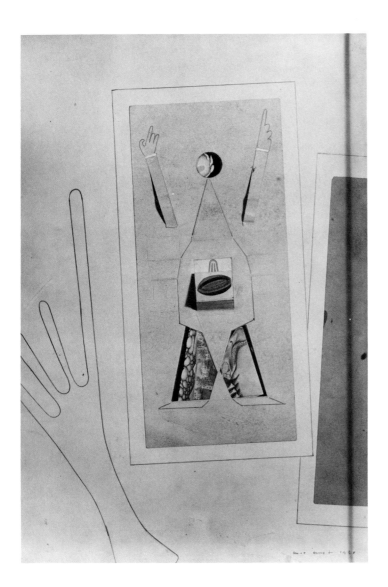

62 *Bonnes vacances*, circa 1931

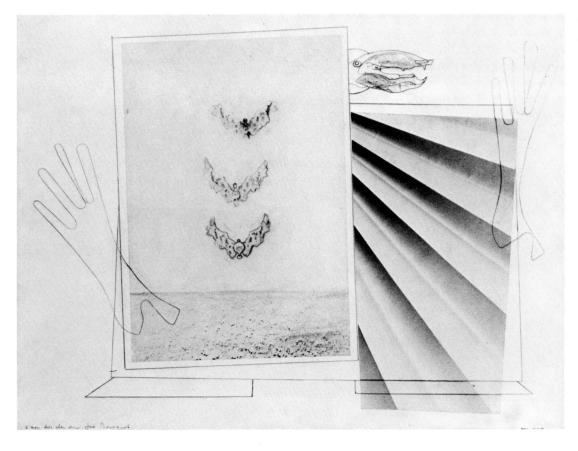

63
Figure humaine et fleur
1931

64
Loplop présente
1931

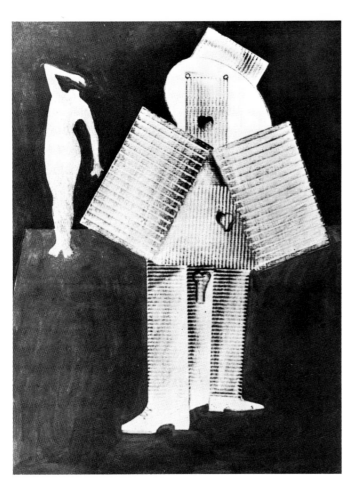

66 *Figures* also: *Chevalet anthropomorphique*
and: *La Femme 100/sans têtes,* 1929

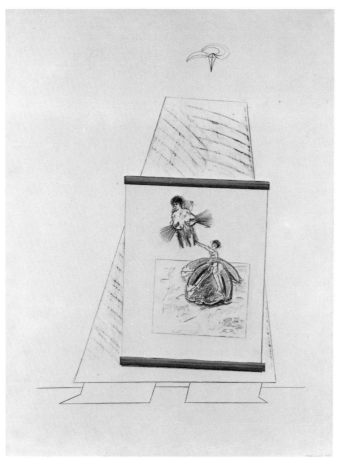

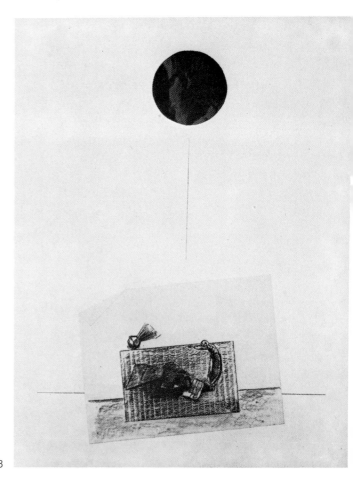

67 68

69 *Untitled,* 1932

Loplop présente Bons-Mots
1932

71
Bon-Mot
1932

*Loplop présente
les membres
du groupe surréaliste
(Au Rendez-vous
des Amis), 1931*

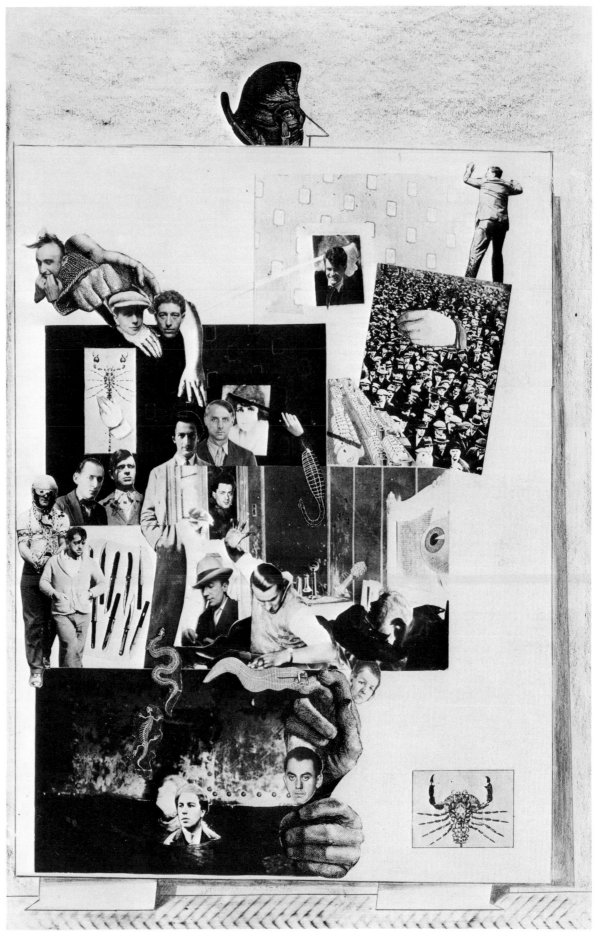

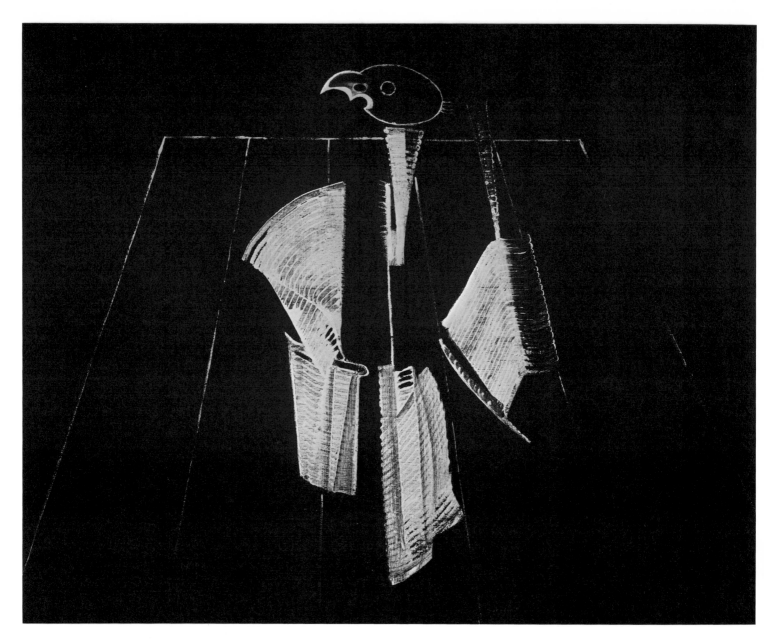

73 *Loplop, le Supérieur des oiseaux* also: *Oiseau de neige,* 1928

74
L'homme et la femme
1930

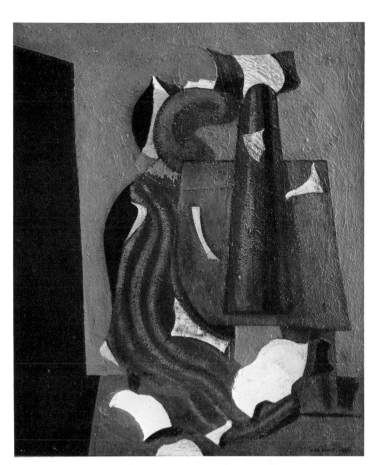

75 *Figure humaine d'insectes,* 1931

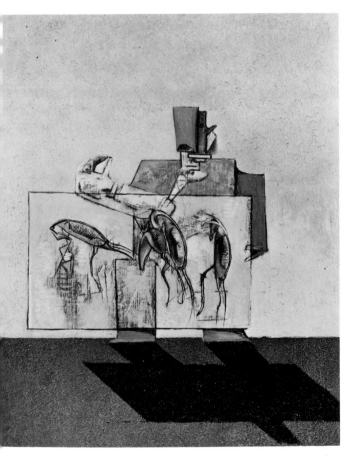

76 *Le toréador,* 1930

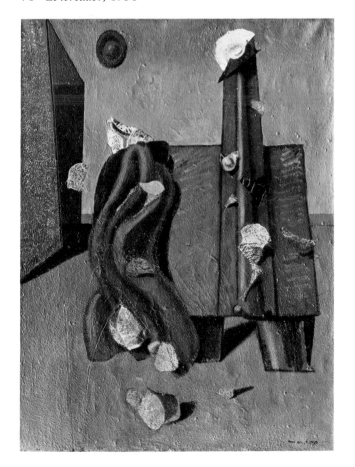

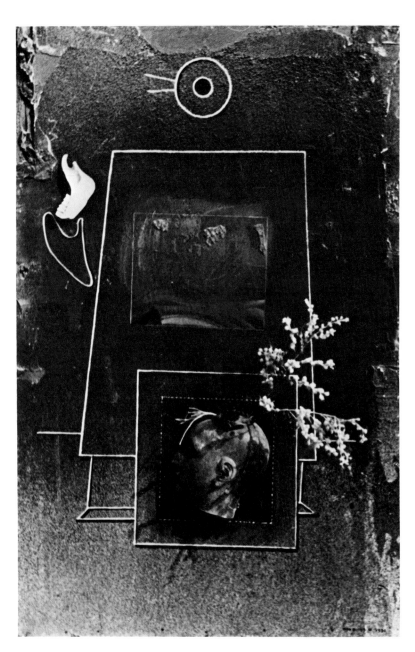

77 *Loplop présente*, 1930

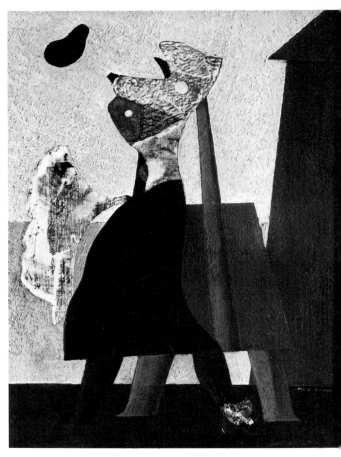

78 *L'homme et la femme*, circa 1929/30

79 *Vision*, 1931

Appendix

Notes

1 André Breton, "The Legendary Life of Max Ernst—preceded by a brief discussion on the need for a New Myth," *View* (New York), 2d ser., no. 1, 1942, p. 7.

2 Loplop figures began to appear about 1928 (plates 73 and 66) and by 1930 had become common (plate 35, S/M 1688ff). By 1933, Max Ernst's involvement with the subject had largely ceased (plate 31). At the end of the thirties the motif crops up again in the drawings done at the Les Milles camp, where Max Ernst was interned as an enemy alien. The showing and presentation of forms remains a recurrent motif, appearing for instance in the sculpture *Roi jouant avec la reine* of 1944; the iconography of the painting *Rêve et Révolution* (1947) likewise plays with the painter's utensils. A series of combine paintings done in the sixties takes over from early Loplop collages their general disposition and the picture-within-a-picture motif (cf. the catalogues *Max Ernst—Le Musée de l'homme suivi de La Pêche au Soleil levant*, Galerie Alexandre Iolas, Paris, 1965, and *Max*

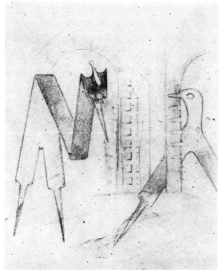

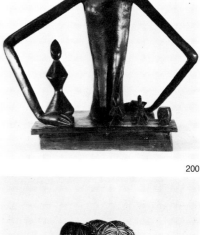

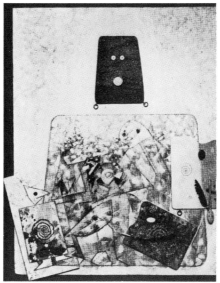

196 Max Ernst. *Figure humaine (Les Milles)*. 1939. New York, Private Collection.

197 Max Ernst. *Les apatrides*. 1939. Krefeld, Ernst O. E. Fischer.

198 Max Ernst. *Le roi jouant avec la reine*. 1944.

199 Max Ernst. *Ubu, père et fils*. 1966. Athens, Alexander Iolas.

200 Max Ernst. For "Le rire des poètes." 1969.

Ernst—Le Néant et son Double, Galerie Alexandre Iolas, Paris, 1968). The motif also occurs frequently in the lithographs for Georges Ribemont-Dessaigne's *La ballade du soldat* of 1972 (Spies/Leppien 218).

3 Max Ernst, "Comment on force l'inspiration (Extraits du 'Traité de la peinture surréaliste')," *Le Surréalisme au Service de la Révolution* (Paris), no. 3, May 1933, pp. 43–45.

4 Max Ernst, "Inspiration to Order," *This Quarter* (Paris), vol. V, no. 1, September 1932, pp. 79–85.

5 I am indebted to Marie-Laure Tardieu and Michel Leiris for having pointed this connection out to me. Another coincidence seems worth mentioning. In 1929, the year Max Ernst first introduced Loplop, the erotic story *Le con d'Irène* appeared. Though it was published anonymously, Max Ernst knew that Louis Aragon was the author. Besides any number of evocations and invectives, we find in this text the passage: "Culs fientes vomissures lopes lopes..." Many of the blasphemies in this text recall the legends in Max Ernst's first collage-novel, *La femme 100 têtes*. It was Germain Viatte who pointed out this particular passage to me. Aragon's text came out in a second, likewise anonymous edition under the title *Irène* (Paris, 1968). The passage quoted is on p. 10.

6 *Dans le bassin de Paris, Loplop, le supérieur des oiseaux, apporte aux réverbères la nourriture nocturne* (S/M 1428); *Loplop et l'horoscope de la souris* (S/M 1458); *Loplop, l'hirondelle, passe* (S/M 1472); *Loplop, l'hirondelle, revient* (S/M 1474); *Loplop, le supérieur des oiseaux, effarouche les derniers vestiges de la dévotion en commun* (S/M 1475); *Loplop et la Belle Jardinière* (S/M 1478); *Et Loplop, le supérieur des oiseaux, s'est fait chair sans chair et habitera parmi nous* (S/M 1485); *La femme 100 têtes irait jusqu'à sourire en dormant pour que Loplop sourît aux fantômes* (S/M 1523); *Loplop, ivre de peur et de fureur, retrouve sa tête d'oiseau et reste immobile pendant douze jours, des deux côtés de la porte* (S/M 1524); *Pour évoquer le septième âge qui succède à la neuvième naissance, Germinal aux yeux indivisibles, la lune et Loplop décrivent des ovales avec leur tête* (S/M 1526); *L'œil sans yeux, la femme 100 têtes et Loplop retournent à l'état sauvage et recouvrent de feuilles fraîches les yeux de leurs fidèles oiseaux* (S/M 1553); *Loplop, le sympathique anéantisseur et ancien supérieur des oiseaux, tire quelques balles de sureau sur quelques débris de l'univers* (S/M 1563). The rich narrative disguise in which Loplop appeared in *La femme 100 têtes* was to remain limited to that collage cycle. The Loplop collages per se and the painted Loplops did without the scenic backdrop.

7 *Cahiers d'Art* (Paris), Special Max Ernst Number, 1937, p. 24.

8 *Dictionnaire abrégé du Surréalisme* (Paris, 1938), p. 11.

9 Max Ernst, "Notes pour une biographie," *Ecritures* (Paris, 1970), p. 56.

10 Max Ernst, "Biographische Notizen (Wahrheitsgewebe und Lügengewebe)," in *Max Ernst*, exhibition catalogue (Cologne and Zürich, 1962–63), p. 23.

11 *Cahiers d'Art* (Paris), Special Max Ernst Number, 1937, p. 63.

12 Ibid., p. 68.

13 Ibid., p. 68.

14 Ibid., pp. 68–9.

15 See also Werner Spies, "Carnet Paris—Carnet Dinard—sechs Monate im Werk Pablo Picassos (18. Juni—17. Dezember 1928)," in *Pablo Picasso—Sammlung Marina Picasso* (Munich, 1981), pp. 95–131.
 The bird motif turns up frequently during this period. In 1926 the "Galerie surréaliste" opened in Paris. The preface to the catalogue of the exhibition devoted to Man Ray and "Objets des Iles" contains the following collection of statements on this motif: "Then I saw how at the sound of a bell a nun was thrown into a barrel who had given venereal disease to the Bird of the Prodigal" (Giorgio Baffo); "Tranquil bird flying upside down, birdlike, that nests in air" (Guillaume Apollinaire); "Scissors of law, shatter like glass on the eyelashes of birds!" (Robert Desnos); "There is the white bird in the temple of the great marmoset with hues of fire" (Diderot); "We were much attached to this bird which, for us, was something like the genius of the house" (Lautréamont).

16 The thirteen titles were given in the catalogue as follows: 23. *Loplop*. 24. *Loplop et Loplop*. 25. *Loplop présente un cœur en cage*. 26. *Loplop présente la mer*. 27. *Loplop présente*

une cage. 28. Loplop présente la mer en cage. 29. Loplop présente deux pétales. 30. Loplop présente trois feuilles. 31. Loplop présente une fleur. 32. Loplop présente une jeune fille. 33. Loplop présente la petite Thérèse de l'Enfant Jésus. 34. Loplop présente le portrait de Marie-Berthe Max Ernst (appartient à Mme Max Ernst). 35. Loplop présente Loplop (fantôme particulier, attaché à la personne de Max Ernst, parfois ailé, toujours sexué).

17 Louis Aragon, *La peinture au défi* (Paris, 1930), p. 26.

18 Ibid., p. 26.

19 For a more detailed discussion of this point, see Werner Spies, *Max Ernst Collagen—Inventar und Widerspruch* (Cologne, 1974).

20 Max Ernst, "Comment on force l'inspiration," op. cit., p. 43.

21 A number of the other works shown in this first retrospective of the collage/papier collé genre at Goemans are not so easy to categorize. Several of those reproduced in the catalogue—*Théâtre* by Man Ray, *Tribune* by El Lissitzky, *Encore une tasse de thé* by Alexander Rodchenko, *Danseuse espagnole* by Joan Miró—are examples of collage along the lines of Cubist papiers collés in which a graphic, constructivist character and an interest in material variety predominate. The untreated background of the paper in these works contributes highly to an effect of depth.

22 *Cahiers d'Art* (Paris, 1932), p. 302 (author not named). This mention of the Loplop collages in *Cahiers d'Art* was virtually the only one to be made during those years. Another discussion of Cubist "plastic" papiers collés can be found in an article by Tristan Tzara entitled "Le papier collé ou le proverbe en peinture" (*Cahiers d'Art*, 1931, pp. 61—74), which was illustrated with a series of works by Picasso, Gris, Braque, Laurens, Schwitters, and Marcoussis. Max Ernst was overlooked completely here, though three years later Tzara devoted an entire article to him (Tristan Tzara, "Max

201 Man Ray. *Théâtre*. From Louis Aragon, *La peinture au défi*, 1930.

202 Joan Miró. *Danseuse espagnole*. From Louis Aragon, *La peinture au défi*, 1930.

Ernst et les images réversibles," *Cahiers d'Art* [Paris, 1934], pp. 165—71). Surely the faintness of the reaction to the Loplop sequence can be explained in part by the fact that many of the collages were bought up very quickly, in 1931, by the American dealer Julien Levy, and thus left Europe. As Max Ernst noted: "Julien Levy acquiert une partie des papiers collés et en fait la première exposition dans sa galerie de New York" ("Notes pour une biographie," *Ecritures*, op. cit., p. 57). Loplop collages were exhibited during the thirties, besides at Vignon and Julien Levy galleries, at Galerie Pierre (Paris, 1932), Mayor Gallery (London, 1933), Galerie Pierre Colle (Paris, 1933), at the exhibition *Was ist Surrealismus?* (Kunsthaus, Zürich, 1934), the *Exposicion sur-*

realista (Santa Cruz de Tenerife, 1935), and in *Fantastic Art, Dada, Surrealism* (New York, 1936−37). Only seven of these works, however, were illustrated in publications of the thirties, and in the literature, there is nothing to be found on individual Loplop collages. Only on ''Bon-Mot'' (plate 71) do we find an accompanying text, by Paul Eluard, printed in the special issue of *Cahiers d'Art* devoted to Max Ernst (op. cit., p. 76). This text cannot really be called a commentary, however−the way image and text impinge recalls Eluard's and Max Ernst's first collective project, the collage-and-text combinations of *Répétitions* (Paris, 1922).

23 See also Werner Spies, *Inventar und Widerspruch*, op. cit., p.41 ff. (''The serial working process as opposed to general combinability'').

24 See also Werner Spies, *Inventar und Widerspruch*, op. cit., p.102 ff. (''The Inventory: Schism between world of art and world of appearances, visualized and rendered widely accessible for the first time'').

25 Mondrian was likewise fascinated by Max Ernst: ''When Mondrian was asked who in modern art he particularly favored since he so vociferously condemned his imitators, he replied without hesitation and to the surprise of his listeners: Max Ernst'' (Hans Richter, *Begegnungen von Dada bis heute* [Cologne, 1973]). One major work of Max Ernst's American period, *Vox Angelica*, was to express his involvement with Mondrian with especial poignancy; there Mondrian's grid, a supraindividual conception of order, is confronted by and fleshed out with personal reference. The private sphere is opposed to the prestabilized harmony of Mondrian and, as I have been able to show, to that of Leibniz as well (cf. Werner Spies, ''Die Arche des Max Ernst,'' *Max Ernst* [Basel, 1975], unpaginated).

26 See also Werner Spies, *Inventar und Widerspruch*, op. cit., p.64 ff. (''Photography: The work as reproduction of itself''; ''Collages as maquettes. The work process concealed'').

27 See also Werner Spies, *Die Rückkehr der Schönen Gärtnerin−Max Ernst 1950−1970* (Cologne, 1971), p.121 ff.

28 The scheme bears the obvious earmarks of advertising. Tristan Tzara touched on this when he wrote in ''Le papier collé ou le proverbe en peinture'' (*Cahiers d'Art* [Paris, 1931], p. 64): ''Aucun phénomène de la vie moderne n'a gagné autant d'étroits rapports avec l'esprit, que cet étrange monstre: la réclame. Toutes les ingéniosités, tous les rites consacrés, de nouvelles superstitions, sont nées et vivent une vie propre et populaire, s'enracinent et meurent, se transforment indéfiniment.'' And Tzara suggests the poetic possibilities of this new fetishism which painters and poets had employed: ''...ces gens dis-je, peintres ou poètes, n'importe, s'aperçurent les premiers des moyens que le nouveau fétichisme, la publicité, mettait à leur disposition.''

29 Cf. the illustration in *La Révolution Surréaliste* (Paris), no.3, April 1925, p.13.

30 Günter Metken, ''Sich die Kunst vom Leib halten. Loplop, die Staffeleifigur Max Ernsts,'' *Pantheon* (Munich), vol.36, April/May/June 1978, pp.144−49.

31 Louis Aragon, *La peinture au défi* (Paris, 1930), p.15.

32 Max Ernst, ''Comment on force l'inspiration,'' op. cit., p.44.

33 André Breton, ''Second Manifeste du Surréalisme,'' *La Révolution Surréaliste* (Paris), no.12, December 1929, p.15.

34 *La Révolution Surréaliste* (Paris), no.6, March 1926, pp.16−17.

35 Breton himself seems to suggest the correspondence. In a footnote to the Second Manifesto of Surrealism he tells us how texts or drawings were produced cooperatively, saying that each person involved would contribute only one element−''sujet, verbe ou attribut, tête, ventre ou jambes'' (subject, verb, or attribute; head, torso, or legs) (op. cit., p.15).

36 Georges Bataille, ''Le gros orteil,'' *Documents* (Paris, 1929), pp.297−302.

37 André Breton, ''Avis au lecteur,'' in Max Ernst, *La femme 100 têtes* (Paris, 1929).

38 André Breton, ''Introduction au discours sur le peu de réalité'' (1924), in *Point du jour* (Paris, 1934), p.22.

39 Louis Aragon, *La peinture au défi*, op. cit., p.19.

178

203 Max Ernst. *Oiseau.*
Circa 1924. Paris,
Ruth Tillard-Arp. (S/M 672)

40 Cf. Werner Spies, *Inventar und Widerspruch,* op. cit., p. 210 f. ("Ariadne's Thread and Dripping"). Also Werner Spies, "Der Surrealismus in den USA. Dokumente einer Faszination," in *Max Ernst—Retrospektive 1979* (Munich, 1979), pp. 97–120.

41 His grattages were made on a horizontal surface, usually a table. The canvas, rather than being mounted on stretchers, remained loose; he would drape it over the objects from which he wished to take rubbings and nail it down at the corners. The moment when Max Ernst more or less gave up his easel can be pinpointed in his œuvre. It consisted in a symbolic act—the assemblage of wooden parts called *Oiseau* (figure 203) which, as Max Ernst told me, was originally a part of a larger sculptural group entitled "Bird Cemetery." It was made at a point in time when he had begun using indirect techniques that no longer required an easel. His wooden sculptures were made of set pieces from a studio grown obsolete—canvas stretchers and parts of a dismantled easel. This procedure may be compared to the Dada easel-assemblages of 1919 on, which I have mentioned above as being forerunners of Loplop.

42 Tristan Tzara, "Le papier collé ou proverbe en peinture," op. cit., p. 62.

43 Carola Giedion-Welcker, *Plastik des XX. Jahrhunderts. Volumen- und Raumgestaltung* (Stuttgart, 1955), p. 126.

44 Salvador Dali, "Apparitions aérodynamiques des 'Etres-Objets'," *Minotaure* (Paris), no. 6, 1935, p. 33.

45 Max Ernst, "Comment on force l'inspiration," op. cit., p. 44.

46 Julius von Schlosser, *Die Kunst- und Wunderkammern der Spätrenaissance* (1923) (Braunschweig, 1978), p. 188.

47 Shortly thereafter Picasso was to put real butterflies into an assemblage. This prompted André Breton to state: "C'est en 1933 pour la première fois qu'un papillon naturel a pu s'inscrire dans le champ d'un tableau, et qu'aussi il a pu le faire sans qu'aussitôt tout ce qui l'environne tombât en poussière, sans que les représentations bouleversantes que sa présence à cet endroit peut entraîner fissent en rien échec au système de représentations humaines dans lequel il est compris." "Picasso dans son élément," *Minotaure* (Paris), no. 1, 1933, p. 10.

48 Louis Aragon, "Max Ernst, peintre des illusions," 1923, in *Collages* (Paris, 1980), p. 31.

49 Dali too, in about 1929, began introducing paradoxes of this order into his small-format paintings. He pasted chromolithographs on the canvas and painted around them in a style so perfectly adapted to the prints that the transition from print to oil was undetectable. Here, too, we can speak of a negation of the collage effect. Aragon, in *La peinture au défi,* had this to say about these paintings: "Ce qui défie probablement le mieux l'interprétation c'est l'emploi du collage par Salvador Dali. Celui-ci peint à la loupe; il sait imiter à ce point le chromo, que l'effet est immanquable: les parties de chromo collées passent pour peintes alors que les parties peintes passent pour collées. Veut-il par là dérouter l'œil, et se réjouit-il d'une erreur provoquée?" (Op. cit., p. 26).

50 André Breton, "Centenaire Arnim—fragment de l'Introduction à la réédition française des Contes Bizarres," *Le Surréalisme au Service de la Révolution* (Paris), no. 6, May 1933, pp. 5–9.

51 André Breton, "Le message automatique," *Le Minotaure* (Paris), no. 3–4, 1933, p. 178.

52 Cocteau used the expression in *Cahiers d'Art,* in connection with Picasso: "Les raisins de l'art ne pipent plus les oiseaux. L'esprit seul reconnaît l'esprit. Le trompe-l'esprit existe. Le trompe-l'œil est mort." (*Cahiers d'Art* [Paris, 1932], p. 125).

53 André Breton, *Les vases communicants,* 1932; quoted from the 1970 Paris edition, p. 50. Cf. plate III, p. 51.

54 Max Ernst, in "Enquête," *La Révolution Surréaliste* (Paris), no. 12, December 1929, p. 72.

55 Max Ernst, "Danger de pollution," *Le Surréalisme au Service de la Révolution* (Paris), no. 3, December 1931, pp. 22–25.

56 Werner Spies, *Inventar und Widerspruch* ("Transformation of the individual collage within the œuvre"), op. cit., p. 111 and passim.

57 Ibid. ("The White Silhouette—an apparition-like contrast. Echo effect of forms"), p. 192.

58 Georges Bataille, "Le bas matérialisme et la gnose," *Documents* (Paris), vol. 2, 1930, pp. 1–8.

59 Louis Aragon, "Contribution à l'avortement des études maldororiennes," *Le Surréalisme au Service de la Révolution* (Paris), no. 3, December 1931, pp. 22–24.

60 André Breton and Paul Eluard, "Notes sur la Poésie," *La Révolution Surréaliste* (Paris), no. 12, December 1929, pp. 53–55.

61 Louis Aragon, "Contribution à l'avortement des études maldororiennes," op. cit., p. 24.

62 André Breton, "Le message automatique," op. cit., p. 55.

63 The title page of the first issue of *La Révolution Surréaliste* (Paris, December 1924) already bore a montage of three Surrealist group photographs. And on page 7 of the same issue we find Germaine Berton, the anarchist who assassinated Plateau, surrounded by the Surrealists. A further montage appeared in the last number of *La Révolution Surréaliste* (Paris, December 1929, p. 73), Magritte's *Je ne vois pas la (femme) cachée dans la forêt*, framed by sixteen passport photos of the members of the group.

64 *Le Surréalisme au Service de la Révolution* (Paris), no. 4, December 1931, p. 36.

65 The snake motif, like that of the octopus or squid, is prominent in Surrealist art and writing. There are references to both in Breton's work as well. In *Nadja*, for instance, we read: "Ce film, de beaucoup celui qui m'a le plus frappé, s'appelait: L'Etreinte de la Pieuvre" (*Nadja*, op. cit., p. 30 f.). To underscore this, Breton included a page of the film program in his novel (*Nadja*, op. cit., plate opposite p. 46).

66 This crowd picture is comparable to the photograph entitled *Volksmenge* which Franz Roh and Jan Tschichold published in *foto-auge* (Stuttgart, 1929, plate 26). Max Ernst owned a copy of this book, in which several of his own pieces were illustrated.

67 Max Ernst, "Comment on force l'inspiration," op. cit., p. 45.

68 Christian Zervos, "De l'importance de l'objet dans la peinture d'aujourd'hui (III)," *Cahiers d'Art* (Paris), 1930, p. 283.

69 E. Tériade, "Une nouvelle heure des peintres," *Cahiers d'Art* (Paris), 1930, p. 169 ff.

70 In *La Révolution Surréaliste* (Paris), no. 12, December 1929, pp. 65–76.

71 Pierre Naville, "Beaux Arts," *La Révolution Surréaliste* (Paris), no. 3, April 1925, p. 27.

204

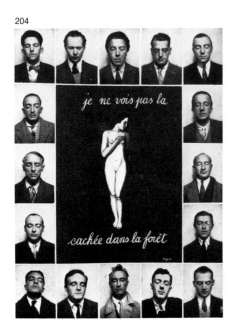

205

204 *Je ne vois pas la (femme) cachée dans la forêt.* From *La Révolution Surréaliste*, no. 12, 1929.

205 Title page of *La Révolution Surréaliste*, no. 1, 1924.

206 From André Breton, *Nadja,* 1928.

207 Man Ray. *Photogram.* From Franz Roh and Jan Tschichold, "foto-auge," 1929.

206

207

72 André Breton, "Genèse et perspective artistique du surréalisme" (1941), in *Le Sur-réalisme et la Peinture* (Paris, 1965), p. 64.

73 Max Morise, "Beaux Arts—Les Yeux enchantés," *La Révolution Surréaliste* (Paris), no. 1, December 1924, pp. 26–27.

74 Ibid., p. 26.

75 On this subject, see also Françoise Will-Levaillant, "L'analyse des dessins d'aliénés et de médiums en France avant le Surréalisme," *Revue de l'Art* (Paris), no. 50, 1981, pp. 24–39.

76 Ibid., p. 28.

77 Ibid., p. 36. Breton's position on automatic writing and verism is one of the most fascinating problems that Surrealism has to offer. He recanted again and again in later years on his rejection of automatic writing in the late twenties. In 1941 Breton wrote "Genèse et perspective artistique du surréalisme," first published in 1945 in *Labyrinthe* (no. 5, pp. 10–11 and no. 6, pp. 4–5) and reprinted in *Le Surréalisme et la Peinture*, new edition revised and corrected 1928–1965 (Paris, 1965). In this text Breton makes clear reference to the language of mediums, adding: "L'automatisme, hérité des médiums, sera demeuré dans le surréalisme une des deux grandes directions" (p. 68). Here he again ranks automatism high on the scale. The other possibility open to Surrealism, a tendency to *trompe-l'œil*, is seen more critically: "L'autre route qui s'est offerte au surréalisme pour y parvenir, la fixation dite 'en trompe l'œil' (et c'est là sa faiblesse) des images de rêve, s'est avérée à l'expérience beaucoup moins sûre et même abondant en risques d'égarement" (p. 70).

78 Max Morise, op. cit., p. 26.

79 Ibid., p. 26.

80 Ibid., p. 26.

81 Ibid., p. 27.

82 Ibid., p. 27.

83 Max Ernst, "Comment on force l'inspiration," op. cit., p. 45.

84 Louis Aragon, *La peinture au défi*, op. cit., p. 28.

85 Max Ernst, "Comment on force l'inspiration," op. cit., p. 45.

86 Christian Zervos, "Picasso à Dinard. Eté 1928," *Cahiers d'Art* (Paris), 1929, p. 5.

87 André Breton, "Genèse et perspective artistique du surréalisme," op. cit., p. 64 f.

88 Max Ernst, *Die Nacktheit der Frau ist weiser als die Lehre des Philosophen* (Cologne, 1970), unpaginated. Max Ernst had formulated similar thoughts in 1967, as follows: "The foolishness that grown-ups called education was no match for the boy's mind. Resisting it filled him with a feeling of secret joy. This had a decisive meaning for his later life—it opened almost unlimited opportunities for him to find wonderful friends among people who thought the same way, among outlaw angels and devils, wherever destiny and world events took him. This explains the so-called 'diversity' of his work. If a painter knows what he doesn't want, fine. But if he wants to know what he *does* want, it's all over. A painter is lost when he finds himself. The fact that he has succeeded in not finding himself is what Max Ernst considers his sole honor." (Quoted in *Max Ernst*, exhibition catalogue, Munich, 1967.)

89 Cf. Werner Spies, "Das Psychodrama im Atelier," in Klaus Gallwitz (ed.), *Maler und Modell*, exhibition catalog (Baden-Baden, 1969), unpaginated. For more on the subject of stylistic continuity and change, see: Werner Spies, "Picasso und seine Zeit—Zerstörung und Dauer," in *Pablo Picasso—Sammlung Marina Picasso*, op. cit., p. 9 ff.

90 On the fateful aspect of this self-identification of Picasso's with the Minotaur, see: Werner Spies, "Der Kontinent mit Namen Picasso," in *Pablo Picasso—Der Zeichner*, ed. Jean Jouvet, Zürich, vol. 1, 1982, p. 9 ff. In a certain sense, it would seem fruitful to compare Picasso's "Minotaure" with Max Ernst's "Le Lion de Belfort" and the other identification figures of *Une Semaine de Bonté*.

91 *Das Junge Rheinland*, Düsseldorf, 1919.

92 Sigmund Freud, *Das Unbehagen in der Kultur*, 1930, quoted from *Werkausgabe*, Frankfurt am Main, 1978, p. 416.

93 William S. Rubin, *Dada and Surrealist Art*, New York, 1968, p. 149 ff.

94 André Breton, *Le Surréalisme et la Peinture*, op. cit., p. 42 f.

95 André Breton, "Second Manifeste du Surréalisme," op. cit., p. 4.

96 Cf. Werner Spies, *Inventar und Widerspruch*, op. cit., p. 172. ("Breton's *Nadja*. Coupling of text and visual document. The structure of the inchoative").

97 On this André Breton writes: "Il faut, je pense, n'avoir jamais été seul, n'avoir jamais eu le temps de céder à cette merveille d'espoir qui est de faire surgir de la totale absence la présence réele de l'être aimé, pour ne pas, au moins théoriquement, caresser de l'œil cet objet entre tous anonyme et déraisonnable, cette boule, vide en plein soleil, qui, dans l'ombre, recèle tout." ("Le message automatique," op. cit., p. 56).

98 André Breton, *Nadja* (Paris, 1928), p. 7. References to this ghost or phantom are found earlier, in the legends to *La femme 100 têtes*. I have pointed out its relation to the "roman noir" and the rhetoric of horror in *Inventar und Widerspruch* (cf. op. cit., p. 171 ff.). It is interesting to note that at the same time as Max Ernst began using narrative images from nineteenth-century shockers in his collage cycles, René Crevel, in his book *Etes-vous fous?* (Paris, 1929), similarly began to quote and imitate the novelistic style of the period.

99 "La sorcellerie à travers les âges," *Variétés* (Brussels), 1929, pp. 393–96.

100 "Attributs de sorcellerie," op. cit., pp. 399–402.

101 "La superstition," op. cit., pp. 429–32.

102 André Breton, "Second Manifeste du Surréalisme," op. cit., p. 13.

103 An advertisement in *La Révolution Surréaliste* (Paris), no. 7, June 1926, announced that Ball No. 1, entitled "Hommage à Picasso," had just come out, and that it had been issued in a numbered edition of 100.

104 Françoise Will-Levaillant, op. cit., p. 31.

105 Salvador Dali, "La conquête de l'irrationel" (1935), quoted from *Oui* (Paris, 1971), p. 17.

182

106 Louis Aragon, "Le surréalisme et le devenir révolutionnaire," *Le Surréalisme au Service de la Révolution* (Paris), no. 3, 1931, p. 2 ff.

107 Tristan Tzara, "Essai sur la situation de la poésie," *Le Surréalisme au Service de la Révolution* (Paris), no. 4, 1931, p. 15 ff.

108 Max Ernst, "Visions de demi-sommeil," *La Révolution Surréaliste* (Paris), no. 9–10, 1927, p. 7.

109 Werner Spies, *Inventar und Widerspruch*, op. cit. (particularly chapters III, IV and V).

110 Max Ernst, "Comment on force l'inspiration," op. cit., p. 44.

111 Max Ernst, "Inspiration to Order," op. cit., p. 77.

112 "Max Ernst's Favorite Poets/Painters of the Past," *View* (New York), 2d ser., no. 1, 1942.

113 Albert Béguin, "L'androgyne," *Minotaure* (Paris), no. 11, 1938, p. 11.

114 André Breton in *Médium* (Paris), no. 4, 1955, p. 4.

115 Cf. Werner Spiess, *Die Rückkehr der Schönen Gärtnerin*, op. cit., p. 53 ff.

116 André Breton, "Le château étoilé," op. cit., p. 29.

117 Paris, June 1935.

118 André Breton, "Avis au lecteur," op. cit.

119 André Breton, "Le château étoilé," op. cit., p. 27.

120 Ibid.

121 Max Ernst, "Comment on force l'inspiration," op. cit., p. 43.

122 André Breton, "Pourquoi je prends la direction de la Révolution Surréaliste," *La Révolution Surréaliste* (Paris), no. 4, 1925, p. 1 f.

123 To the name Loplop was added Hornebom and, later, Schnabelmax.

124 Sigmund Freud, *Civilization and Its Discontents*, vol. 21, in *The Complete Psychological Works of Sigmund Freud*, James Strachey, ed. (London, 1942), p. 362.

125 Ibid., p. 360.

126 Ibid.

127 Ibid., p. 361.

128 Cf. note 115.

129 Sigmund Freud, "Eine Kindheitserinnerung des Leonardo da Vinci," *Werkausgabe in zwei Bänden*, Vol. II: *Anwendungen der Psychoanalyse* (Frankfurt am Main, 1978), p. 182. Werner Hofmann pointed out the possible relation between Max Ernst's theme, "A l'interieur de la vue" and Freud's essay on Leonardo. Cf. "Max Ernst und die Tradition," *Ausstellung Max Ernst "Das innere Gesicht"–Die Sammlung de Menil* (Hamburg, 1970), pp. 14 and 15.

130 Freud's "Leonardo essay" will have been familiar to the Surrealists by that time, since a French translation was available. In a full-page advertisement in *La Révolution Surréaliste* (no. 9–10, October 1927 and again in no. 11, March 1928) we find two references to "Un Souvenir d'Enfance de Léonard de Vinci." The second of these includes a calligram on four Freud texts which puts the visual seal of approval, so to speak, on four new Surrealist publications.

131 The title *L'Immaculée Conception* turns up as early as 1923 as the name of a painting (S/M 498). In 1929, one year before the appearance of Breton's and Eluard's coproduction, it was given a place of honor in *La femme 100 têtes*. In the first chapter of that book the legend "L'immaculée conception manquée" appears three times, right at the beginning. As the chapter proceeds, this spotless birth which has misfired three times is given another chance. Here Max Ernst makes use of the visual message of the title as an emblem of his "aesthetic of the short-circuit" (cf. Werner Spies, *Inventar und Widerspruch*, op. cit., p. 190 ff.).

132 Cf. note 1. Breton has confused Leonardo's *Virgin of the Rocks* with *The Virgin, Child and St. Anne* on which Freud's essay is based.

133 On these motifs, see Werner Spies, *Die Rückkehr der Schönen Gärtnerin*, op. cit.

134 *Cahiers d'Art* (Paris), Special Max Ernst Number, 1937, p.44.

135 Max Ernst, "Biographische Notizen (Wahrheitsgewebe und Lügengewebe)," op. cit.

136 Max Ernst, "Du danger qui existe pour un gouvernement d'ignorer les enseignements du surréalisme," *Intervention Surréaliste* (Brussels), 1934, p.65.

137 Sigmund Freud, "Eine Kindheitserinnerung des Leonardo da Vinci," op. cit., p.174.

138 Kurt Schwitters, *Das literarische Werk* (Cologne, 1973), vol. I, p.58f.

139 Max Ernst, "Entretien avec Robert Lebel", *Ecritures* (Paris, 1970), p.427.

140 Once again, as he writes, Max Ernst found himself confronted by Leonardo's wall. The mechanism of inspiration which he associates with Leonardo probably challenged him all the more since he had discovered fascinating examples of it in a field he was then very much concerned with. Max Ernst was the first artist to study psychopathological art in detail. As he once told me in conversation, he was even considering writing an analysis of it himself, a plan which, however, was rendered superfluous in his eyes when Hans Prinzhorn's epoch-making *Bildnerei der Geisteskranken* (Artistry of the Mentally Ill) appeared in Berlin, in 1922. This book brought about the reassessment of psychopathological art which Max Ernst had had in mind when he made his Dada collages and montages. In Prinzhorn we find passages that recall Max Ernst's *Going Beyond Painting* as much as does Leonardo's *Trattato*—passages such as this: "Less 'natural' is another group of visual impressions which tend to encourage us to read faces and figures into them. ... Every wall splashed with mortar, pieces of which have flaked off, every wallpaper with ambiguous patterns, every wooden panelling, and finally every surface that is 'enlivened' by irregularities or blemishes ... suggests playful interpretations. ... What can happen to patterns in the wallpaper just before you fall asleep, and particularly if you are running a fever, most of us know from experience. ... Which means that all of these interpretative experiences, even to a normal mind, very easily take on something of the weird and uncanny." (Hans Prinzhorn, op. cit., pp.25−6). Prinzhorn himself makes reference to the writings of Leonardo.

141 André Breton, "Second Manifeste du Surréalisme," op. cit., p.2.

142 André Breton, "Le message automatique," op. cit., p.56.

143 Ernst H. Gombrich, *Kunst und Illusion* (Stuttgart, 1978), p.208.

144 André Breton, *Nadja*, op. cit., p.52.

145 "Figures à double aspect," *La Nature* (Paris), 1st demi-volume, 1885, p.64.

146 William S. Rubin, *Dada und Surrealist Art*, op. cit., p.231f.

147 Ernst H. Gombrich, "Ziele und Grenzen der Ikonologie," in *Bildende Kunst als Zeichensystem* (Cologne, 1979), p.379.

148 Giorgio de Chirico, "Das Mysterium der Kreation" (1911−15), quoted from the German edition of the collected writings: Wieland Schmied, ed., *De Chirico—Wir Metaphysiker* (Berlin, 1973), p.16.

149 Giorgio de Chirico, "Über die metaphysische Kunst," ibid., p.42ff.

150 We find references on the part of Breton to Valéry's "Méthode de Léonard de Vinci" as early as a letter he wrote to Tristan Tzara on 8 November 1919. And on 26 December of that year, Breton again mentions the text in a letter to Tzara, calling it "une belle chose démoralisante." Cf. Michel Sanouillet, *Dada à Paris* (Paris, 1965). The letters are printed in the appendix, pp.451−54.

184

List of Plates

47 *Loplop.* 1930. 30.5 x 23 cm. New York, Ronnie Elliott. (S/M 1715)

48 *Loplop présente (Loplop Introduces).* 1930. 31 x 22.8 cm. USA, Private Collection. (S/M 1716)

49 *Loplop présente (Loplop Introduces).* 1930. 26.6 x 20.6 cm. Krefeld, Ernst O. E. Fischer. (S/M 1717)

50 *Loplop présente la Marseillaise (Loplop Introduces the Marseillaise).* 1930. 30 x 21.5 cm. Stuttgart, Galerie Valentien. (S/M 1718)

51 *Loplop présente (Loplop Introduces).* 1930. 31 x 25 cm. Bridgewater, Conn., Private Collection. (S/M 1719)

52 *Loplop présente (Loplop Introduces).* 1930. Dimensions unknown. Present location unknown. (S/M 1722)

53 *Loplop présente la Marseillaise (Loplop Introduces the Marseillaise).* 1931. 33 x 24.5 cm. USA, Private Collection. (S/M 1723)

54 *Loplop présente (Loplop Introduces).* 1931. Dimensions unknown. Present location unknown. (S/M 1752)

55 *Loplop présente Loplop (Loplop Introduces Loplop).* 1931. Dimensions unknown. New York, Private Collection. (S/M 1790)

56 *C'est la vie—le marchand d'Ucel (That's Life—the Merchant of Ucel).* 1931. 29.4 x 22.1 cm. Chicago, The Art Institute. (S/M 1755)

57 *Loplop présente (Loplop Introduces).* 1931. 64 x 48.5 cm. Paris, Private Collection. (S/M 1766)

58 *Je t'imagine en présentant une autre (I Imagine You While Introducing Another).* 1931. 59 x 49 cm. Athens, Alexander Iolas. (S/M 1756)

59 *Loplop présente une fleur (Loplop Introduces a Flower).* 1931. 49 x 64 cm. Present location unknown. (S/M 1773)

60 *Loplop présente (Loplop Introduces).* 1931. 49.8 x 64 cm. Hanover, Private Collection. (S/M 1761)

61 *Jeune homme debout (Young Man Standing).* 1931. 45 x 30.5 cm. Paris, Private Collection. (S/M 1768)

62 *Bonnes vacances (Happy Holiday).* Circa 1931. 64 x 50 cm. Rome, Galeria La Medusa. (SM 1791)

63 *Figure humaine et fleur (Human Figure and Flower).* 1931. Rome, Private Collection. (S/M 1772)

64 *Loplop présente (Loplop Introduces).* 1931. 50 x 64 cm. Athens, Alexander Iolas. (S/M 1792)

65 *La fleur d'oranger (The Orange Blossom).* 1931. Dimensions unknown. Paris, Private Collection. (S/M 1793)

66 *Figures.* Also: *Chevalet anthropomorphique* and: *La femme 100/sants têtes (Figures.* Also: *Anthropomorphic Easel* and *The Hundred-Headed/Headless Woman).* 1929. 27 x 21.5 cm. Dimensions unknown. (S/M 1387)

67 *Loplop présente (Loplop Introduces).* 1932. 62 x 49 cm. Stuttgart, Private Collection. (S/M 1860)

68 *Loplop présente (Loplop Introduces).* 1932. 65 x 57.5 cm. Houston, Texas, Menil Foundation. (S/M 1850)

69 *Untitled.* 1932. 49 x 63.5 cm. London, The Mayor Gallery. (S/M 1851)

70 *Loplop présente Bons-Mots (Loplop Introduces Bons-Mots).* 1932. 48.5 x 62 cm. Hanover, Galerie Dieter Brusberg. (S/M 1867)

71 *Bon-Mot.* 1932. 54×65 cm. Present location unknown. (S/M 1865)

72 *Loplop présente les membres du groupe surréaliste (Au Rendez-vous des Amis 1931) (Loplop Introduces the Members of the Sur-* realist Group *[At the Meeting of the Friends, 1931]).* 1931. 50 x 33.2 cm. New York, The Museum of Modern Art. (S/M 1806)

73 *Loplop, le Supérieur des oiseaux.* Also: *Oiseau de neige (Loplop, Bird Superior.* Also: *Snowbird).* 1930. 79 x 99 cm. Paris, Private Collection. (S/M 1272)

74 *L'homme et la femme (The Man and the Woman).* 1930. 65 x 54 cm. Paris, Private Collection. (S/M 1697)

75 *Figure humaine d'insectes (Human Insect-Figure).* 1931. 45.8 x 38 cm. Private Collection. (S/M 1795)

76 *Le toréador (The Toreador).* 1930. 79.5 x 60 cm. Paris, Private Collection. (S/M 1698)

77 *Loplop présente (Loplop Introduces).* 1930. Dimensions unknown. Present location unknown. (S/M 1704)

78 *L'homme et la femme (The Man and the Woman).* Circa 1929—30. Laren, Holland, Mathilde Visser. (S/M 1696)

79 *Vision.* 1931. 64.8 x 53.3 cm. Present location unknown. (S/M 1797)

Further illustrations which are part of the Loplop series and which appear in the text.

83 *Frottage.* 1930. Dimensions unknown. Paris, Private Collection.

159 *Loplop présente une femme—fleur (Loplop Introduces a Woman—Flower).* Circa 1934. Dimensions unknown. Destroyed by Max Ernst. (S/M 2135)

190 *Loplop présente deux fleurs (Loplop Introduces Two Flowers).* 1930. 120 x 120 cm. Milano, Private Collection. (S/M 1703)

Index

94243

N
6888
.E7
S65

SPIES, WERNER
 MAX ERNST, LOPLOP.

DATE DUE

DEC 08 1997	
MAY 07 2001	
MAR 01 2011	

GAYLORD PRINTED IN U.S.A.